VAN GOGH

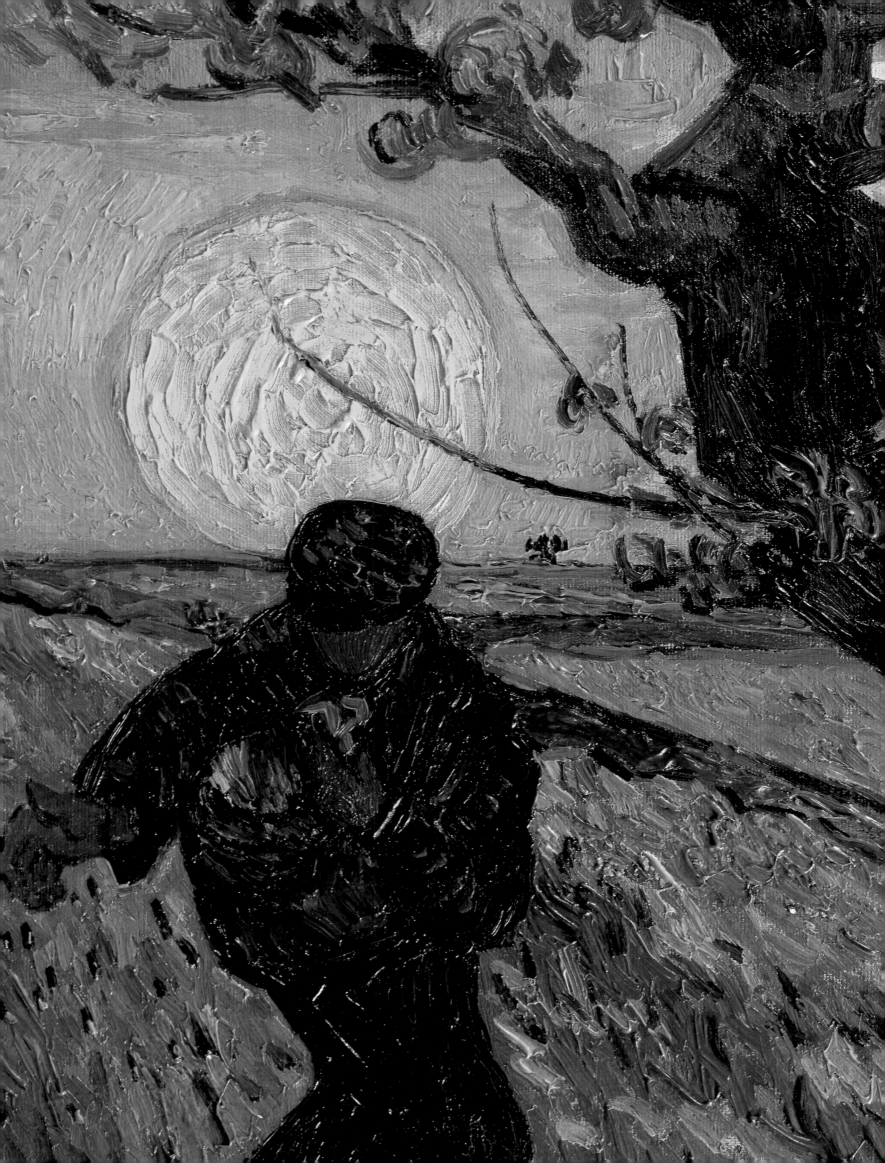

PASCAL BONAFOUX

VAN GOGH

Translated by Alexandra Campbell

HENRY HOLT AND COMPANY
NEW YORK

Frontispiece illustration:
The Sower, 1888
Oil on canvas, 32 x 40 cm
van Gogh Foundation, Amsterdam

Van Gogh

Lucidity and light

The surgeon's bloody scalpel cannot indefinitely continue to dissect the very thing that constitutes the genius of a great painter.' A biography is no more beyond reproach than the scalpel denounced by Antonin Artaud. This was known to Vincent van Gogh who in April 1882 wrote to his brother Theo: 'There certainly is an affinity between a person and his work, but it is not easy to define what that affinity is, and on that question many judge quite wrongly.' Biography is an implicit recognition of the view expressed by Sainte-Beuve: 'To come to know one more man, to come to know him well, particularly if this man is a prominent and famous individual, is a great thing and who could disregard it.' The 'great thing' in Vincent's case is a recital of doubts, misjudgements, setbacks, misery, loneliness, exile, bouts of ill health and crises. And this recital cuts out his work.

Vincent to Theo: '. . . the work of an artist and his private life are like a woman in childbirth and her baby. You can look at her child, but you may lift her chemise to see if it is blood-stained.' I shall not lift any chemise. A hypothesis of Vincent's: 'The earth was supposed to be flat. It was true; it is still flat today, from Paris to Asnières for instance. Only this does not prevent science from proving that the earth is actually round. A thing nobody contests today. Now, at the moment, despite this, people believe that *life is flat* and progresses from birth to death. However, that too, *life is probably round*, and much superior in extent and capacity to the hemisphere that is at present known to us.' The life of Vincent is one of those that are round and do not merely progress from birth to death.

Second-Lieutenant Milliet's recollection of Vincent: 'He did not have an easy character and when he was in a rage, he appeared mad. But this made little impression on me: in my wandering soldier's life, I have seen and heard others . . .' Adeline Ravoux recalled: 'He spoke little, but, so simple and good, a gentle smile always on his lips, he had a great deal of charm. No one could have supposed that he suffered from mental imbalance.' In Arles rage, in Auvers charm. Neither the memories of Paul-Eugène Milliet nor those of Adeline Ravoux, Vincent's models, reveal the quality of their multicoloured portraits or of the painter for whom they posed in Arles or in Auvers. '. . . he appeared mad . . .' observed the one; 'No one could have supposed . . .' claimed the other. And it is of no importance. Theo's assessment of Vincent: 'One would say that there are two men in him, one admirably gifted, charming and gentle, the other egoistic and ruthless. They appear turn by turn, so one hears him reasoning now like the one, now like the other, with arguments equally for and against. It is a pity that he is his own worst enemy because he makes life difficult not only for others but for himself.' Vincent the enemy . . .

An observation of Proust's can usefully be kept in mind: 'A book is the product of a different self to the one we show in our daily habits, in company, in our vices.' Substitute only 'a canvas' for 'a book'. Nothing else changes. A question remains: which self of Vincent's to portray? How should one reply? Vincent to Theo: 'They will always, either in or outside the family, judge me or talk about me from different points of view, and you will always hear the most different opinions about me.' One hears

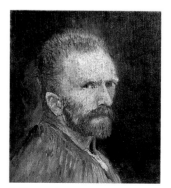

Self-portrait
1886

5

them still. To silence them requires the simple recognition that the essential is told in few words: Vincent Willem van Gogh, born in Groot Zundert (Netherlands) on 30 March 1853, died in Auvers-sur-Oise (France) on 29 July 1890. His *oeuvre* comprises some 900 canvases and over 1000 drawings and watercolours, his correspondence more than 800 letters. 'It has always seemed to me that when an artist shows his work to the public, he has the right to keep to himself the inward struggle of his own private life (which is directly and fatally connected with the peculiar difficulties involved in producing a work of art).'

'Considering, if you like, the time in which we live a great and true renaissance of art, the worm-eaten official tradition still alive but really impotent and inactive, the new painters isolated, poor, treated like madmen, and because of this treatment actually becoming so, at least as far as their social life is concerned . . .' Bitter and heart-rending words from Vincent who, isolated, poor, treated like a madman, stands out as a painter among painters . . . And loneliness, poverty and madness were the terrible tolls that as a painter he had to pay. The life of Vincent van Gogh was a martyrdom and a sacrifice to painting. For the painter to paint, the man had to die. 'How strange it is, that it must be so. We, ourselves, see such a thing as very simple and natural – something logical – and then we are more or less astonished because others cannot see the motives which brought us to see such a thing. And one would almost conclude that some people have cauterised certain sensitive nerves within them – especially those, which combined, are called conscience.'

The aim of this book is not only to recount the life of Vincent van Gogh. It is also to interpret his 'conscience'. Because for Vincent 'conscience is . . . the highest reason – the reason in the reason'. Because this conscience was extreme and implacable, it accepted violence, the uselessness of wallowing in repeated tales of misfortune. As far as the latter are concerned, they are not items of information, but have their place in tragedy. A basic difference of genre . . .

'Life itself, too, always turns towards a man an infinitely vacant, discouraging, hopeless, blank side

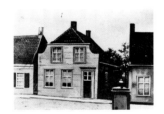

House in Groot Zundert where Vincent was born

on which nothing is written, no more than on a blank canvas.' Such a life, and the telling of it, was not the business of Vincent van Gogh and the colours on his canvases. It was through this life that he painted, as he painted in spite of it. The 'conscience' of Vincent: 'I want to reach the point where people say of my work: this man is endowed with a very fine sensibility. Despite my so-called coarseness or on account of it, do you understand?' It is no longer to Theo alone that this question is addressed: 'Do you understand?'

To fall asleep in life,
to waken by means of life, to know death,
leaves us destitute, tormented in spirit,
bruised of flesh.

René Char

Bleak childhood. Bleak and haunted. The adolescent Vincent van Gogh bore the same Christian name as some of his ancestors. What did he know of a Vincent van Gogh, born in 1674, died in 1746, who had a son who then had two, one of whom was called Vincent? Did he know that that Vincent was in Louis XV's Cent-Suisses? Did he know that he was the great-uncle of his grandfather who was also called Vincent? Yet another Vincent van Gogh was his uncle, the art dealer, 'supplier to the collections of their majesties the King and Queen'. There had been Vincent van Goghs for two centuries. And his father, Theodorus, was a pastor like his grandfather. And his brother, born on 1 May 1857, bore the same Christian name, Theodorus.

In the cemetery in Groot Zundert, there is a headstone bearing the name of Vincent Willem van Gogh. And the date beneath the name is the same as the date of birth: 30 March 1852. Only the year is to change. A year to the day before Vincent's birth, his mother, Anna Cornelia Carbentus, brought into the world a stillborn child.

Vincent van Gogh, adolescent, did not have to be just anybody, he had his genealogy. An unknown one. And mourning marked the date of his birth. He spent time in prayer. Not a day passed without reading the Bible in the house of Theodorus van Gogh. In the Protestant community of

Groot Zundert, the parishioners, like everyone in Brabant, called their pastor 'domine'. Humble, charitable, placid, Theodorus van Gogh, 'Pa', could he have been other than 'domine'? The stiffness and reserve of his manner debarred him from a successful career. An unimpressive preacher, he could not aspire to the most important parishes ... The reformed community of Groot Zundert could muster only a small flock for their pastor, half being Catholics. There was no choice for him but to submit to poverty, which he did with dignity. Moe, his elder by three years, sewed, embroidered and mended. A cheerless, austere, quiet tediousness punctuated by births. 1855: birth of a first daughter, given the same name as Moe: Anna Cornelia; 1857: birth of Theo; 1859: birth of Elisabeth Huberta; 1862: birth of Wilhelmina Jacoba; 1867: birth of Cornelis.

G root Zundert. A few low-built houses, some seeming to huddle under the thatch, along the side of a road. A countryside of open fields and heaths overhung with mists that lay against the slopes. Heavy, loose soil. Paths furrowed with ruts. Heather. At the parish school, Vincent learnt, for what it was worth, to read, write and count. The domine did not for long accept that his elder son should have to put up with a teacher who drank and he employed a governess. Then on 1 October 1864, he sent Vincent to board with Jean Provily in Zevenbergen, where he had his first experience of loneliness. There he learnt – indifferently – French, German, English. His studies fared no better at the Hannik Institute in Tilburg. Pa was not prepared to go on meeting the costs of unsuccessful schooling. On 19 March 1868, Vincent returned to Groot Zundert, not yet sixteen, but his studies were over. Taciturn, solitary, without talent or vocation, Vincent had to be found a job which would relieve Pa and Moe from the burden of continuing to support him.

Uncle Cent had handed over his gallery, Goupil & Cie, Plaats 14, The Hague, to his former partners. He had retired, weary, to Princenhage, on the outskirts of Breda. His erstwhile employee, M. Tersteeg, who had been promoted to director – he was twenty-four years old – could hardly refuse to employ Vincent. On 30 July 1869, Vincent took up his duties. It was his job at The Hague to sell prints, engravings, etchings, lithographs, which Goupil & Cie handled in Berlin, London, Brussels, New York. The headquarters of the firm, established in 1827, were in Paris, 9 rue Chaptal. Goupil still runs two shops, one in boulevard Montmartre, the other in place de l'Opéra, and enjoys its international reputation thanks to the quality of the techniques used in reproduction of masterpieces. Vincent lodged with the Roos family and led an austere, regular, orderly life, governed by duty and necessity, limited to the Roos and church and the Scheveningen beach on Sunday. Docile and zealous, Vincent was a punctual, discreet, courteous employee, honest and scrupulous. M. Tersteeg assured Uncle Cent of this when he wrote to him. And the years passed: 1869, 1870, 1871.

1872. In Helvoirt, he was reunited with his family for the summer, the Revd Theodorus van Gogh having been appointed there at the beginning of the previous year. The parish of Helvoirt did not guarantee an income any higher than that of Groot Zundert. The studies Theo was pursuing in Oisterwijk were not to last long, any more than Vincent's had done. On his way to Oisterwijk Theo went through The Hague to visit Vincent. He spent a few days with him at the Roos' and wrote to him shortly after. Vincent replied: 'Thank you for your letter, I am glad to hear that you arrived safely. I missed you the first few days ...' Vincent was never to stop missing Theo and, for eighteen years, was never to stop writing to him.

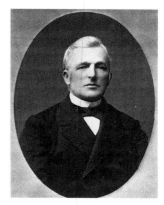

Theodorus van Gogh

Uncle Cent put in a word for Theo as he had done for Vincent. And Theo, like Vincent, was taken on by Goupil & Cie. Starting early in 1873, he had the same job in Brussels as Vincent at The Hague. Vincent's words of advice about Goupil & Cie: 'It is such a splendid house, the longer you are in it the more ambition it gives you. The beginning is perhaps more difficult than anything else, but keep heart, it will come out all right.' Why should Theo not keep heart? The example set by his elder brother was encouraging. That same month of January 1873, Vincent was given a salary rise of ten florins. He now earned fifty florins per month, plus a bonus of fifty florins. And he was offered promotion, to a job in the London office which sold to dealers only. This step up the ladder, which meant abandoning his country, was not to be refused. Vincent left for England. He stopped in Helvoirt to say goodbye to his family and passed through Paris, the gallery headquarters, on the way, doubtless to get instructions. In a few days he managed to visit the Salon, the Louvre, the Luxembourg museum. In March, just twenty, he was in

London. The Goupil gallery, run by Mr Obach, was in 17 Southampton Street. Vincent managed without difficulty to find lodgings in the suburbs, but the cost was eighteen shillings a week exclusive of laundry and meals, which he had to eat in town. He urgently had to find somewhere else, the more so as the young Germans in the same lodgings spent without counting the cost when Vincent went out with them. In August, he moved to Mrs Ursula Loyer's house at 87 Hackford Road, Brixton, in south London. Vincent wrote to Theo: 'How I should like to talk with you about art, but now we must write about it often; *feast your eyes to the utmost on beautiful things*, most people *pay scarcely any attention to them*. Try to walk as much as you can and keep your love for nature, for that is the true way to learn to understand art more and more. Painters understand nature and love her and *teach us to see her*.' Two months later: 'I received a guilder from you for a pair of cuff-buttons.' Vincent was twenty-one. Theo was seventeen. Already Vincent was beginning to talk only of painting, Theo to send Vincent money. It was not for the purchase of cuff-buttons that he was, in the years to come, to send more.

Mrs Loyer, with whom Vincent boarded, was the widow of a clergyman. Her takings from her lodgers were supplemented by her meagre income from a school she ran for the very young. She had a daughter of nineteen, Eugénie. Vincent, who was reading Michelet's *L'Amour* with fascination, wrote to tell Theo of his belief 'that man and wife can be one, that is to say one whole and not two halves, yes, I believe that too'. Vincent, who boated on the Thames, read Keats, discovered the paintings of Turner, Gainsborough, Reynolds and Constable, met only with indifference from Miss Loyer who claimed to be already engaged. Vincent, rejected and sore at heart, went back to Helvoirt.

House of the
Revd Mr Jones

A few months later, he wrote to Theo from London, where he had returned with his sister Anna who was looking for a job as a reader or teacher, having failed to find one in Holland: 'I think that life is pretty long and that the time will arrive soon enough in which another "shall gird thee and lead thee where thou wouldst not".' Vincent began to realise that life was escaping his control. At his lodgings in Ivy Cottage, 395 Kennington New Road, as at Goupil's, he was a changed man, subject to sudden rages. A state of mind liable to jeopardise Goupil & Cie's dealings with its London clients could not long be tolerated. 'To act well in this world one must be dead to selfish aims.' A quotation from Renan, copied by Vincent in French as a postscript to a letter to Theo. Vincent began to give up selfish aims. But to achieve what in the world? Vincent had not found the answer.

Vincent was summoned to Paris. He arrived there in May 1875. No one doubted that at the headquarters of Goupil & Cie, he would be put back on the straight and narrow. The news of Uncle Jan's death, of Pa's nomination to Etten, his mental distress and loneliness, served as a pretext to read and re-read the same religious works: the Bible, the Psalms, the Epistles, the Canticles, the *Imitation of Christ*. Every Sunday, Vincent went to hear the sermons of Pastor Bersier. Gradually he struck up a friendship with a young man who, like himself, was living abroad, an eighteen-year-old Englishman who had the room adjacent to his at Montmartre, who, like him, worked for Goupil, and who, like him, kept himself to himself. Together they visited the Luxembourg museum. Vincent showed him his favourite pictures. They dined together in his room. And he regularly read to him from the Bible. In his letters, Vincent began to echo the Holy Scriptures: 'Indeed the simple-minded know many things that are unknown to the wise.' In his daily life, Vincent began to want to divest himself: '. . . we must especially take care to have plain food, for it is written "give us this day our daily bread".' Despite the respect they owed Vincent, it became impossible for Messrs Boussod & Valadon who, as Goupil's nephews, had taken over the firm, to keep on an employee dedicated more to prayer than to the sale of engravings. On his return from Etten – Pa had been appointed there at the end of October – M. Boussod informed Vincent of his dismissal. '. . . write to me often for I long to hear from you in these days.' A plea from Vincent to Theo. A plea that was never to cease. 'We feel lonely now and then and long for friends . . .' Vincent was never to cease to feel alone.

Vincent replied to advertisements appearing in the English papers he read. And his letters remained unanswered. At last, on the eve of his departure from Paris, a teacher in Ramsgate made him the offer of a probationer's post, without payment, but with board and lodging provided. After two weeks spent in Etten with his family, Vincent

went to Ramsgate. Mr Stokes was away and his son stood in for him. Vincent, who was now twenty-three, had the task of teaching French, 'rudiments' of mathematics and spelling, to twenty-four boys between the ages of ten and fourteen and under the supervision of an under-master of seventeen. Vincent was in charge of their washing and dressing as well as their outings to the beach. In a letter dated 17 June 1876, Vincent told Theo of his true purpose in England. He wanted to find 'a position between clergyman and missionary in the suburbs of London among the working people'. To this end, he had written to and called on a minister. He now had to wait. To be a London missionary, 'I think it must be a peculiar profession . . . one must go around among the labourers and the poor to preach the Bible, and if one has some experience talk with them, find foreigners who are looking for work or other persons who are in difficulties and try and help them, etc.' The minimum age was twenty-four. He had to wait a year. . . At Isleworth, to which Mr Stokes had moved his school, Vincent read the Bible to the boys morning and evening every day. And Stokes continued not to pay him. In July, a Methodist minister, the Revd Mr Jones, invited Vincent to join his boarding school also in Isleworth, to teach the Holy Scriptures. Vincent left Stokes. To pray and lead prayer, to sing and lead the singing of the Canticles, was to begin to be a missionary.

At last, on Sunday 5 November 1876, for the first time, Vincent preached. 'When I was standing in the pulpit I felt like somebody who, emerging from a dark cave under ground comes back to the friendly daylight . . .' Vincent's purpose, to come back to the daylight, was decided. The Old and New Testament were for Vincent the means to his end which was also an exercise in self-discipline. Exhaustion. Long days, long weeks. Until one o'clock, he gave lessons; afterwards he accompanied Mr Jones in his duties or substituted for him in a London of cant, beer and black bread; he gave individual classes; finally, at night, he prepared his sermons. On Sundays he preached at Petersham, at Turnham Green. His poor English did not greatly worry him. The man in the parable who said, 'Have patience with me and I will pay you everything,' whom he quoted, served as his ex-

cuse. To pay everything . . . an unyielding rule that Vincent made his own. Imperfect mastery of the language precluded eloquence, the power to persuade.

At the end of the pastoral year, Vincent returned to Etten in a state of exhaustion. His mysticism, his fiery spirit, worried Pa. Vincent agreed not to return to England. 'As to the religious work, I still do not give it up.' Uncle Cent, approached for help again, got him a job as a clerk at the Blussé & van Braam bookshop in Dordrecht, thanks to the agency of Mr Braat whose son worked for Messrs Boussod & Valadon in Paris. 'I go there at eight o'clock in the morning and leave at one o'clock at night.' Vincent wore the austere clothes of a Quaker. Two engravings, of *Christus Consolator*, given by Theo, hung in his room in Talbrugstraatge where he lodged with Mr Rijken. Vincent created anxiety there by not coming down to dinner. He read and transcribed the Bible in his room, as he also did at the bookshop. 'Oh! might I be shown the way to devote my life more than is possible at present, to the service of God, and the gospel. I keep praying for it and I think I shall be heard, I say it in all humility.'

In May, in Amsterdam, Vincent managed to persuade his uncles of the strength of his vocation, of his unshakeable will to 'become a Christian and a Christian worker'. And just as he affirmed his faith, he affirmed his certainty that, 'The knowledge of and the love for the work and life of men like Jules Breton, Millet, Jacque, Rembrandt, Bosboom and so many others, may become a source of new thoughts. What a resemblance there is between the work and life of father and that of those men.' The life of the pastor and the life of the painter were invested with the same driving force.

On his twenty-fourth birthday, Vincent went to Groot Zundert. That night he pondered over the tomb on which he could read Vincent van Gogh – 30 March 1852. Was he musing on the words of Renan, 'dead to selfish aims', or the prayer 'Who will deliver me from the body of this death?' he had earlier copied out?

At the beginning of May he settled in Amsterdam. Uncle Jan, an admiral and a widower, had him to stay. Uncle Stricker, a pastor, advised him. Uncle Cor, an art dealer, helped him. It fell to Vincent to pass the extrance examination for the

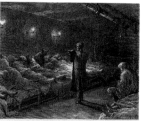

A preacher reading the Holy Scriptures in a night shelter (G. Doré)

Faculty of Theology at Amsterdam. Embarking on a task which required unswerving determination, he chose as an epigraph words he attributed to Corot: 'It only took forty years of hard work and of thought and attention.' The words of a painter. Day by day painting increasingly became his point of reference. On 21 May: 'This morning I saw in church a little old woman, probably one who provides foot-stoves in church, who reminded me so much of that etching by Rembrandt, a woman who has been reading the Bible and has fallen asleep with her head in her hand.' It was through the works of Ruisdael, of Daubigny, of Thorwaldsen, of Maris, and others still, that Vincent, who had mastered neither algebra nor the geography of Greece and Asia Minor, nor geometry, nor the history of ancient Rome, nor rhetoric, nor the declining of Greek verbs, and who beat and mortified himself and inflicted on himself all sorts of penances for his failure, came to perceive the roads, canals and faces before his eyes.

Old Breton woman, asleep in church

'It must be a good thing, to die conscious of having performed some real good, and to know that by this work one will live, at least in the memory of some, and will have left a good example to those that come after.' Vincent, expressing this conviction to Theo, was not yet twenty-five years old.

His nights of study, his fervour, his penances, the lessons of his tutors, Mendès da Costa and his nephew, Texiera de Mattos, none of these availed Vincent when it came to passing his exam. Failure. Back to Etten. In mid-July, in Brussels, Mr Jones, the Methodist clergyman, who had allowed Vincent to preach in Isleworth, introduced Pa and Vincent to Pastor Bokma who directed the Flemish evangelical school. A course of study there lasted only three years and it was possible to be posted to a mission during one's training. In the meantime there was no question of Vincent spending the following three months in Brussels. Pa could not meet the costs involved in such a stay. Back to Etten. Vincent continued to prepare for his studies. And the pretext for his meditations: a painting by Rembrandt, *The House of the Carpenter*, another by Groux, *The Bench of the Poor*, and a series of aquatint engravings, *The Life of a Horse*. At the end of August, Vincent was summoned to Brussels, to the noviciate of the school at Laeken. In November, the pastors Jonge and Pietersen re-

fused to grant him the title of gospel preacher. His intransigence, his rebuffs, were found unacceptable. There were objections to his going to the Borinage, a region he had decided to make his own as an evangelist following a sign he could not disregard: 'You know how one of the roots or foundations not only of the Gospel, but of the whole Bible is, "Light that rises in the darkness." *From darkness to light*. Well, who will need this most, who will have ears for it?' An immediate answer from Vincent: '. . . those who walk in the darkness, in the centre of the earth, like the miners'. From darkness to light . . . It was not painting that was the subject of Vincent's contemplations.

He left for the Borinage, having learnt from a handbook that it was 'a province of Hainaut, in the environs of Mons on the French frontier and beyond'. He stayed in Pâturages in the house of a door-to-door salesman, a certain van du Haegen at 39 rue de l'Eglise. In Brussels there was anxiety that the apostleship of this gospel preacher was subject to no authority. Resignedly, he was appointed lay evangelist in Wasmes for six months. Vincent moved into the house of the baker Jean-Baptiste Denis. Pa, who paid him a visit, advised him not to live alone in a little house he had rented and used as a workshop or studio. A studio . . . Vincent drew. (In July 1874 he had written to Theo from London saying that the urge to draw had left him. In 1877, from Amsterdam, he had told Theo that from time to time he was impelled to draw 'instinctively . . . I see it all so vividly before me.') Vincent drew . . . 'Around the mine are poor miners' huts with a few dead trees black from smoke, and thorn hedges, dunghills, and ash dumps, heaps of useless coal, etc. Maris could make a beautiful picture of it. I will try to make a little sketch of it presently to give you an idea of how it looks.' To draw . . .

Vincent wanted to associate himself with the ravaged miners, 'weather-beaten and aged before their time', with their 'faded and worn' wives haunted by death caused by the methylic air, fire-damp explosions, underground waters and the collapse of old galleries. Vincent left his room at the baker's for a straw mattress in a shack. He had to be the humblest of the humble, the poorest of the poor. He had to live according to the Gospels, stripped of everything, because it is harder for a rich man to enter the kingdom of heaven than a

camel to pass through the eye of a needle, because he had to gain the trust of those whom he sought to help, accompany, support. He prayed. He preached. He soothed. His zeal and self-denial disturbed the pastoral authorities. In July, Vincent was relieved of his duties. On foot, he made his way to Brussels to ask Pastor Pietersen what he should do. And what he showed the pastor was his drawings, in the manner of Schelfhout and of Hoppenbrouwers.

Since he was refused a mission, Vincent decided to dispense with authority and continue his apostleship on his own account. In August he left Wasmes for Cuesmes. He withdrew from the world and no longer wrote to anyone, not even to his brother. Extreme solitude, penury and dedication. In October, Theo, sent by his family, visited Cuesmes. For the first time, he intervened, tried to persuade Vincent to renounce an apostleship that no church would answer for. His determined obstinacy was an aberration and this aberration was a disgrace which did not concern only Vincent. Theo argued, in vain. Long hours which restored Vincent's peace of mind and at the same time exasperated him. A decisive conversation. 'If I really had to think that I were troublesome to you, or to the people at home, or were in your way, of no good to anyone, and if I should be obliged to feel like an intruder or an outcast, so that I had better be dead. . . . If it were indeed so, then I might wish that I had not to live much longer.' Vincent did not want to listen. Scoffing, arrogant, in the same letter Vincent said to Theo: '. . . you would also be mistaken if you thought that I would do well to follow your advice literally, of becoming an engraver of bill-headings and visiting cards, or a book-keeper or a carpenter's apprentice – or else to devote myself to the baker's trade – or many similar things (curiously difficult to combine). . . . May I observe that this "idleness" (of which Theo accused him) is rather a strange sort of idleness.' Theo's visit, Vincent's long emotional, angry letter of 15 November 1879, caused a break in their relationship. The one could not accept shame, the other's pride could not tolerate disparagement. Vincent was at Cuesmes. He remained at Cuesmes.

And Vincent, intractable, remained alone. Silence. Poverty. He regularly received a few francs from Pa. In July 1880, at Etten, he discovered

that this money had been provided by Theo. On his return to Cuesmes, Vincent wrote him a letter which was neither of thanks nor of repentance. It was an exercise in lucidity. 'I must tell you that it is with Evangelists as with artists. There is an old academic school, often detestable, tyrannical, the accumulation of horrors, men who wear a cuirass, a steel armour of prejudices and conventions; those people, when they are at the head of affairs, dispose of positions, and by a rotary system they try to keep their protégés in their places. . .' Vincent went on to specify: '. . . there is something of Rembrandt in the Gospel, or in the Gospel something of Rembrandt, as you like it, it comes to the same . . .' And he confessed one of his sadnesses: 'When I was in other surroundings, in the surroundings of pictures and things of art, you know how I then had a violent passion for them, that reached the highest pitch of enthusiasm. And I do not repent it, for even now, *far from that land, I am often homesick for the land of pictures.*' Vincent had said it all. He knew. There was no difference between a painter and an evangelist. If he were to be a painter, he would be one as he had been an evangelist. And he would again be rejected and scorned.

To be a painter? In September Vincent related that he had gone on foot, at the beginning of the year, to Courrières in the Pas-de-Calais. He had wanted to see the painter Jules Breton there. He had seen only the outside of his house. Without a sou, he had had to sleep in an abandoned cart in a field. And he wrote of having 'earned some crusts of bread along the road here and there, in exchange for some drawing . . .' A terrible and critical experience: '. . . it was even in that deep misery that I felt my energy revive and that I said to myself: in spite of everything I shall rise again, I will take up my pencil, which I have forsaken in my great discouragement, and I will go on with my drawing; and from that moment everything seems transformed for me; and now I have started and my pencil has become a little more manageable, and more so every day.' Vincent refused to go to Paris. '. . . it will take some time before I shall have arrived at a point of being able to think of such a thing . . .' On sheets of paper 'rather large in size', in the room cluttered with beds which he occupied in Charles Decrucq's house, 8 rue du Pavillon in Cuesmes, where he was not to stay much longer, he drew miners and weavers '. . . so that those types unknown or so little known, would be brought before the eyes of the people'. In October, he went to Brussels. Not having enough space to work, unable to get more at Decrucq's, had compelled him to leave Cuesmes, as had the poverty he had suffered for long and exhausting months and his need 'to have good things to look

Miners' women
carrying sacks

at and also to see artists at work'. He took a room at 72 boulevard du Midi. Resolved to do everything in his power not to be reckoned among mediocre artists. Few meals. A diet of dry bread, potatoes and chestnuts. Winter. Solitude.

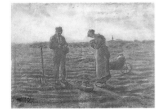

The Angelus,
after Millet

To Theo who did not reply to his letters: 'In thinking of you I unconsciously said to myself: Why does he not write? If he is afraid to compromise himself in the eyes of Messrs Goupil & Cie by keeping in touch with me, is his position towards those gentlemen so shaky and unsteady that he is obliged to be so careful? Or is it that he is afraid I will ask him for money?' A few days later: '. . . I wrote my last letter in a moment of spleen. My drawings went all wrong, and not knowing what to do I began to write.' Vincent did not know that some months earlier Theo had again started sending Pa regular sums of money for him – Pa was to tell him in April. On the other hand he did know that Theo could not bear embarrassment, as he also knew Theo was the only one to whom he could speak of his troubles, whom he could address despite his troubles.

And Theo was the only one to offer him support. The uncles were wary of a nephew who wanted to be an artist, who asked for 100 francs a month while learning the basic rules of his craft – anatomy, perspective – and who turned down the teaching of the Ecole des Beaux-Arts, believing that the professors, 'academicians', would be hypocrites and pharisees just like those at his evangelical school. Vincent asked only to be put in touch 'with persons from whom I could learn many things'. Anthon van Rappard, whom Theo met in Paris, numbered among them. He was five years younger than Vincent. The age difference was nothing. Everything set them apart. Rich, aristocratic, van Rappard had a high opinion of the Ecole des Beaux-Arts and continued to study there and to respect its principles in Brussels as he had done in Paris. Vincent was destitute and refused to accept that old plaster casts could serve as models. Despite this, van Rappard welcomed Vincent to his studio in rue Traversière. He showed him both what perspective was and his anatomical plates.

April 1881. Van Rappard warned Vincent that he was going to leave Brussels. Pa told him that Theo was coming to Etten. Why linger? Vincent, the prodigal son, returned to Etten. Thin, exhausted, in tatters, he was at the end of his tether. His threadbare black velvet suit, like that of a second-rate artist, disgusted his father. But this was not the latter's most serious reservation. Vincent had dared to bring into his father's house books by Michelet, Hugo and others, works attributed in Pa's eyes to 'thieves and murderers, or "immorality"' and which he refused to read. In the family history a great-uncle, contaminated by 'French ideas' had ended up a drunkard. Nonetheless, Vincent was allowed to stay for a while to recoup his forces and work. His drawing might mean that he would cease to be a financial burden to anyone. It was reassuring that the well-born van Rappard came to draw and paint at his side. Together they went out in the country choosing subjects. Heather and heath, fen and fields of potatoes, in Passievaart, Lierbosch, Seppe. Vincent drew. He studied with the help of Bargue's *Cours de dessin* and Cassagne's *Traité d'aquarelle*. He copied engravings after Millet, after Holbein.

August 1881. Theo, on a visit, persuaded Vincent to show his drawings to Tersteeg and Anton Mauve at The Hague – the family would not question the judgement of a painter who was a cousin by marriage on the maternal side. Neither Tersteeg nor Mauve denied that Vincent had made progress and would make more. And another painter, de Bock, convinced that Vincent had 'the touch', the temperament of a painter, encouraged him to draw figures. Back to Etten again. Kee Vos-Stricker – known as Kate – had just spent a few weeks there. This cousin – Pastor Stricker, her father, was Moe's brother – had recently been widowed. Vincent to Theo on 3 September 1881: 'There is something in my heart that I must tell you; perhaps you know about it already and it is not new for you. I want to tell you that this summer a deep love has grown in my heart for K., but when I told her this, she answered me that, to her, past and future remained one, so she never could return my feelings.' It mattered little to Vincent that Kate had immediately said 'never'. 'Then my melancholy left me, then all things became new for me, then also my energy increased.' And he

drew. In October he told van Rappard that he had done all kinds of studies of men and women digging the soil, sowing, that he worked in charcoal, distemper, sepia and conté crayon. All his studies, Vincent said, were of one and the same subject: Brabantine characters. Meanwhile Kate, back in Amsterdam, besieged with letters, remained silent. She did not retract her 'no, never, never'. Pa reproved a persistence he regarded as 'indelicate and untimely'. Vincent's analysis: 'If she would never, never return my love I would probably stay a bachelor always.'

December 1881. 'I always thought you a dullard, but now I see that it is not so.' It was in front of the first canvas painted by Vincent that Mauve uttered these words, which gave Vincent greater pleasure 'than a cartload full of Jesuitical compliments would have done'. Without warning, Vincent had arrived in The Hague to ask his cousin for a month of his attention and advice, enough to resolve the 'first petites misères of painting'. Mauve, in front of a still-life of a cabbage and some clogs, thrust into his hands a palette and some brushes and assured him that he would 'soon make something that is saleable'. Vincent decided to stay in The Hague. He found a modest lodging in Mauve's neighbourhood for thirty florins a month, including breakfast. He had to go back to Etten to fetch his clothes and materials. On the way, he passed through Amsterdam. He arrived at his Uncle Stricker's house on Keizersgracht. Kate lived there. He demanded to see her, refusing to accept that she had left as soon as she heard of his arrival. His uncle read aloud a letter she had just written to him which insisted that he give her up. And then? Vincent held his hand over an oil lamp to prove how much he wanted to see Kate. In vain. 'I have mistaken a picture by Brochart for one of Jules Goupil, a fashion-print for a figure of Boughton, Millais or Tissot.' It was of painting that Vincent spoke as he relinquished all hope and his departure from Etten was the occasion of further rupture. Everything was a cause of disagreement with Pa, even the Bible which Vincent did not read in the proper 'academical way'. Christmas. Vincent refused to attend the services of a religion he declared 'horrible'. Pa told him to leave the house.

The Hague. One hundred florins allotted him by Theo for his living and his painting. And he was already short of money. Mauve advanced the 100 florins Vincent needed to equip himself. '. . . there is no earthly reason to keep me from my work, or cause me to lose my spirits'. In this certainty, Vincent, who was nearly twenty-nine, decided to live with a woman. 'One cannot with impunity live too long without a woman.' Clasina Marla Hoornick – 'not young, not beautiful, nothing remarkable if you like . . . rather tall and strongly built' – bore a resemblance to 'some curious figure by Chardin or Frère, or perhaps Jan Steen'. It was painting that Vincent had in mind as he took up with this sick prostitute, mother of a child, alcoholic, pregnant, known as Sien, but to him as Christine.

Meanwhile Vincent continued to work at Mauve's side. Despite the help Mauve gave him, Vincent began to find his remarks intolerable. Mauve considered that he should show some propriety of dress, made fun of his 'green-soap or salt-water mood'. And Vincent feared that working with Mauve he would be obliged to 'confine myself within a system or theory'.

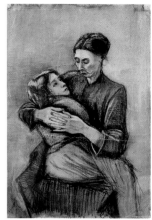

Sien with child in her lap

Vincent worked. 'I feel, Theo, that there is a power within me, and I do what I can to bring it out and free it . . . I feel that I am on a nearer road to success. I shall do what I can, I shall work hard, and as soon as I have more power over my brush, I will work still harder than I do now. . . . Well, boy, do what you can, and I shall also do what I can.' Crucial words written in the first months of 1882. For eight years neither brother broke this contract. It was on the respect of this contract that the life of Vincent depended, the life of Vincent the painter.

Vincent worked. He met painters, such as Maris, de Bock, Breiter, Weissenbruch. He drew models who came to sit for him in his studio with its south-facing window. For the figures he wished to draw, he needed more than academic poses. It was not easy to find models for men and women digging, for seamstresses, and he had to deprive himself of 'this and that' to pay them. Mended clothes, thread-

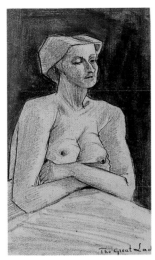

The Great Lady

bare shirts and hunger. Fever, migraine and hunger. Irritability, recurring toothaches and hunger. Tersteeg gave Vincent ten florins for a drawing? It was only because he had to pay a 'poor sick woman', one of his models, that he did not throw the florins at Tersteeg's head when the latter remarked: '. . . you are no artist . . . you started too late . . .'

Vincent worked. April 1882. '. . . every week I now make something which I could not make before . . .' What did it matter to him, his life of quarrels, rages and deprivation? Rupture with Mauve. The occasion was Vincent's refusal to work from plaster casts. 'It shall have to suffer much, especially from those peculiarities which I cannot change. In the first place my appearance and my way of speaking and dress . . . I shall always move in a different sphere from most painters, because my conception of things, the subjects I want to make, inexorably demand it.' To be an artist in the way Vincent intended entailed certain rules: 'an artist . . . would rather be in the dirtiest place where there is something to draw . . . the searching for subjects, the living among working people, the worry and troubles with models, the drawing from nature on the very spot, is rough work, even dirty work at times . . .' And acceptance of this strict discipline led to the artist's metamorphosis. 'Then my ugly face and shabby coat perfectly harmonise with the surroundings and I am myself and work with pleasure.'

Vincent worked. He drew. 'I draw, not to annoy people, but to make them see things worth observing and which not everybody knows.' It was possible for him to accomplish what this extreme definition of painting implies – to provoke people into seeing what without painting they would not know how to see – thanks only to the support provided by Theo, to whom he wrote of 'the worst – a death sentence from you – namely that you stop your help'. In the same letter Vincent announced that he wished to marry Sien and to move. Sien was his model – for *Sorrow*, for *The Great Lady* – as she was also his 'helper'. Reticence on Theo's part. Vincent argued and all his arguments reinforced his decision. 'It would not be right for me to give her up.'

7 June 1882. Vincent went into hospital: a public ward. For weeks, feeble and exhausted, he had suffered from insomnia, fever, and the painful effects of gonorrhoea. Five hundred florins payable in advance. A brief visit from Pa. Sien came to see him daily. Then Sien left for Leyden where she was due to give birth. Relapse. Long days, 'lonesome and melancholy'. Vincent was not allowed out until 1 July. The next day he was at Leyden. During the night, with chloroform and forceps, Sien was delivered of a boy. And nothing weakened Vincent's determination to marry her. (While he was trying to decide the best way to convince Pa, who knew nothing about Sien or his resolve, he remembered a few months previously 'having often thought of the manly words of father Millet: *"It has always seemed to me that suicide was the deed of a dishonest man."* The emptiness, the unutterable misery within me made me think: yes, I can understand that there are people who drown themselves.' He moved to a new studio for his life with Sien. Not long after her return, Tersteeg paid Vincent a visit. Scandal. Tersteeg felt obliged to inform the pastor that his son was compromising his reputation by living with a prostitute and her bastards. A few weeks later, Theo passed through The Hague. The day after he left, Vincent sent him a letter: 'I'm writing to you, still deeply affected by your visit, greatly pleased that I can go ahead vigorously with my painting.' He knew what to rest his case on. His proposed marriage was unacceptable. If his brother agreed to continue helping him, it would be only for the sake of his painting. So Vincent remained silent in his letters on every subject except his unremitting work. 'I feel in myself such a creative power that I'm conscious the time will arrive when, so to speak, I'll daily and regularly produce good work. But very rarely a day passes that I don't produce something, though it is not yet the kind of thing I'm aiming at.'

Meanwhile, though Vincent's drawings continued to be unsaleable yet he worked on, until he could take no more. 'A pain between the shoulders, and in the veins . . . it is not the question of losing courage or giving up things, but of having spent more strength than there was to spare, and of being more or less exhausted.' Vincent's artistic conscientiousness: 'If one wears out one's self too

much in those years, one does not pass forty . . . I don't intend to spare myself, not to avoid emotions or difficulties – I don't care much whether I shall live a longer or a shorter time.' And time was passing. 'Sometimes I can't believe that I'm only thirty years old, I feel so much older . . . I feel older only when I think that most people who know me consider me a failure.' It was to Theo, whom he was still trying to convince of the necessity of his marriage, that Vincent wrote resignedly: 'Society is full of that: people who strive to make a show instead of leading a true existence.' To Theo, before whom he knew he could not make a show . . . Writing again to Theo in the same period, 'Between you and me there is a bond, which by continuous work can be strengthened only by time,' and 'The only thing I want is to do some good work', was the prelude to a decision Vincent found hard to take, impossible to avoid.

\mathbf{A}t The Hague Vincent grew disillusioned with Sien's behaviour, and nature itself betrayed him. The dunes of Scheveningen were becoming more spoilt every year. 'Those very spots, where nothing is left of what one calls civilisation, where all that is decidedly left behind, those very spots are those one needs to be calmed down.' Time to go. Time was insistent. A terrible lucidity: 'I think I may presume without rashness that my body will keep going a certain number of years "quand bien même" – a certain number, say between six and ten for instance.' Time to go . . .

Vincent, heart-broken, did not rush matters. Slowly, patiently, calmly, he explained to Sien the reasons that drove him to depart. He was afraid that she would go back on to the streets – she took steps to join a brothel. Vincent advertised for work for her. But Sien simply considered this action ridiculous. Disillusion, disgust. '. . . she is unreliable.' Vincent left.

On 11 September 1883, he reached Hoogeveen, in Drenthe. In the surrounding countryside there were shepherds, kilns, thatched cottages to be seen. But for the first few weeks it was not these 'motifs' he had come in search of that haunted his imagination, but an overwhelming sadness and pity, 'discouragement and despair more than I can

tell'. It was small comfort that he could also write, 'There are moments when one finds rest only in the conviction that "misfortune will not spare me either".' Despite all that weighed him down, Vincent did not relinquish the essential. His resolution: '. . . to try to be luminous, and not to fall into dullness,' was unshakeable. And, lucid in mind, he left Drenthe to return to Nuenen.

\mathbf{V}incent had not been to Nuenen for two years. The 'cordial' welcome given him by Pa and Moe was one of resignation rather than warmth. Vincent felt oppressed by a reservation on their part he found intolerable. He did not expect his homecoming to be a mere respite, he expected eagerness, reconciliation. He was allowed to stay, but that was really all. And it was a boxroom that was put at his disposal as a studio. A boxroom . . . Vincent felt shunned. It did nothing to alter the choice of life he had made, in explanation of which he told a legend. In olden times, two men were given the free choice of what they wanted. One chose gold, the other a book. The first found riches, then died. The other, by dint of reading, working, struggling, gained a certain degree of power. Vincent chose the book. "The book", that does not mean all books or literature, it is, at the same time, conscience, reason, and it is art.'

And Vincent worked. Day by day, his relations with other people grew calmer. A few months passed. Moe fractured her right femur, and the care required by her condition brought the members of the family together. It was relations with Theo that grew tense. Vincent intended neither to be his protégé nor to live off him. 'Let me send you my work, and keep for yourself what you like, but the money which I shall receive from you after March, I insist on considering as money I earn.' An unequivocal deal which Vincent spelt out further: 'Of course I will send you my work every month. As you say, that work is your property then, and I perfectly agree with you, that you have the full right to do anything with it, I even couldn't make any objection, if you liked to tear it in pieces.' Theo did not destroy a single one of his brother's canvases, which began to accumulate in his Paris apartment. Did he show them? At Goupil & Cie,

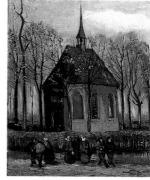

The little church at Nuenen

the oil paintings of Paul Delaroche, a member of the Institut, were sold – notwithstanding *Cromwell découvrant le cercueil de Charles I* exhibited at the Salon in 1831 and disparaged for being 'but a pair of boots in front of a violin case'. Misunderstanding. Theo talked to Vincent about the Impressionists. Vincent, who was ignorant of the nature of their painting, confused them with Delacroix, Millet and Corot. Theo specified: 'I have certainly realised that Impressionism is something quite different to what I had envisaged; but what one should understand by that word isn't yet entirely clear to me.' Further misunderstanding. On a wholly different matter: in August 1884(?), Margot Begemann, with whom Vincent had become involved, swallowed a dose of strychnine. A doctor in Utrecht suspected poisoning. Anguish for Vincent, accused of being the cause of this gesture of despair. Once again, he proved a source of scandal.

V incent worked. His models were weavers at work, again and again, diggers of the soil and sowers. He wanted nothing but to live among them and portray them. Vincent painted their portraits. 'You don't know how paralysing it is, that staring of a blank canvas, which says to the painter: *"You've not got what it takes."* Many painters are afraid of the blank canvas, but the blank canvas is afraid of the real passionate painter, who dares – and who has once and for all broken the spell of *"You're not up to it."'* It was such a painter that Vincent wanted to be.

On 26 March 1885, Pa was carried off by an apoplectic fit. For all the silences, the mutual suspicion that divided them, Vincent's grief was profound. In the studio he had set up in the house of the sacristan in Nuenen, he continued to work. It mattered little to him that his difficulties, his doubts and his remorse attracted scorn. '. . . my views are well considered and calculated, and in my opinion have their *raison d'être*.' And Vincent began to work on the composition of a canvas, *The Potato Eaters*. 'Apparently nothing is more simple than to paint peasants, rag-pickers and labourers of all kinds, but no subjects in painting are so difficult as these everyday figures.' Something that was not understood by van Rappard, to whom Vincent sent a proof of the lithograph cut after one of the first compositions of *The Potato Eaters*. Let van Rappard, who had taken umbrage when he received a printed card and not a letter on Theodorus van Gogh's death, continue to draw from plas-

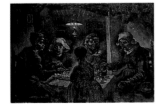
The Potato Eaters

ter casts! A brief trip to Amsterdam. Two hours in the museum in front of Rembrandt's *The Jewish Bride*. Return to Nuenen. October 1885 to Theo: 'In answer to your description of the study by Manet, I send you a still-life of an open – so a broken white – Bible bound in leather, against a black background, with yellow-brown foreground, with a touch of citron yellow. I painted that in a rush, in one day.' In front of the Bible which he had read and re-read, a novel in a yellow cover, *La Joie de Vivre*, by Zola. The Bible of his own past, the Bible to which he had wanted to devote himself, the Bible that had belonged to his father, the domine, the pastor. As for *joie de vivre* . . . Fresh scandal. A young woman who had posed for Vincent was pregnant. Suspicion of paternity fell on him, nicknamed in the village 'the little painter'. The priest forbade his parishioners to sit for him again. If the farmers, the de Groots, in whose house the 'accident' had occurred, continued to receive Vincent, he would have to relinquish his studio. 'In this studio just next to the priest and the sexton, that trouble would never end, that is clear, so I am going to change this.' What good reason was there to stay? Nothing remained to keep Vincent in Nuenen. Not even the family which, after the death of Pa, existed only in name. Vincent had nothing in common with his sisters who were in dispute with him over a wretched share of their inheritance. 'I am going to change this . . .' At the end of November 1885, Vincent left Nuenen.

A ntwerp. 'It will probably be the same here as everywhere else – I mean I shall be disillusioned.' (Did Vincent, later, in the room at Auvers understand that aspirations pitched unreasonably high, and incapable of realisation, always end in bitter disillusion?) At 194 rue des Images, he rented a room for 25 francs a month. He discovered Rubens; 'a strong impression'. '. . . heads and figures of women, these are his speciality. There he is deep and intimate too.' This discovery reinforced his resolution, declared a few days before, to 'paint the eyes of people rather than cathedrals, for there is something in the eyes that is not in the cathedral, however solemn and imposing the latter may be – a human soul, be it that of a poor beggar or a woman of the street, is in my eyes more interesting.' He affirmed his belief in strong terms: 'After all there is nothing in the world as interesting as people, and one can never study them enough. And that is why people like

Turgenev are such great masters, because *they teach us to observe*.' At the beginning of 1886, Vincent began to attend courses at the Ecole des Beaux-Arts. Painting classes with Verlat. Drawing from the antique with Vinck. Vincent's consciousness of his work: '. . . it is very useful to draw from the casts. But please not as it is usually done. In fact the drawings which I see there are in my opinion all equally bad and absolutely wrong, and I know for sure that mine are totally different. Time must show who is right.' And because Vincent saw his goal clearly before him, he drove himself at an exhausting rate. Painting classes. Drawing classes. And in the evening, in a club, further drawing from models, from 9.30 to 11.30. '. . . I want to get on at any price – and I want to be myself.' To be this very thing, Vincent paid a terrible price. A long period of hunger – in February 1886 Vincent admitted to Theo he had not been able to treat himself 'to a hot dinner more than perhaps six or seven times . . .' since 1 May 1885, some ten months previously – long coughing fits, vomiting of a 'greyish phlegm', a sour stomach, teeth that broke and fell out, dizzy spells. Vincent, who wrote: '. . . when I was younger, I looked like one who has been intellectually overwrought, and now I look like a skipper or an ironworker,' was marked as if by 'ten years in prison'. Yet despite everything he could affirm: '. . . it does not prevent my having all my energy and capacity when at work.' Nonetheless exhaustion could bring him to the limits of his endurance. February 1886, to Theo: 'My impression of the time I have spent here does not change either; relatively I am very much disappointed in what I have produced here, but my ideas have been modified and refreshed, and that has been the real object of my coming here. But as I have perceived as to my health, that I trusted too much on it, and that, though the core is all right still, yet I am but a ruin of what I might have been . . . I think we cannot join each other soon enough.' Impossible to delay any longer. '. . . if I neglected myself too much . . . I should catch my death, or worse still – become crazy or an idiot.' It was in order not to become crazy that Vincent went to Paris in February 1886.

Afew days before his arrival, which Theo had tried to postpone, Vincent had spelt out their line of conduct: '. . . we will be poor for it, and suffer want as long as it is necessary, as one does in a besieged city which one does not intend to surrender, but we will show that we are *something*.' It repelled Theo to have to be *something*. Director of one of the Boussod & Valadon galleries, in Paris, with the possibility that from one day to the next everything could go up in the air, it mattered to him to be someone. Vincent, who sent Theo a note to tell him he was waiting in the Salon Carré du Louvre, had not set foot in Paris since, ten years earlier, he had had to leave Boussod & Valadon. Theo had Vincent to stay at his address, 25 rue Laval (now Victor-Massé). At No 37, according to the electoral register, Renoir lived. At the foot of the hill of Montmartre, parallel to boulevard de Rochechouart, this street gives on to rue des Martyrs and adjoins place Pigalle, where the Nouvelle Athènes was one of the cafés frequented by artists. Who among those known as the Impressionists had not drunk a beer or an absinthe there? Further down rue des Martyrs, leading off it, was rue Clauzel. There, at No 14, was a shop selling paints run by Julien Tanguy, known as Père Tanguy, former communard, from whom Cayenne was spared thanks to the intervention of a painter member of the municipal council. Cézanne, Pissarro, Renoir, Monet, Guillaumin, Gauguin all frequented this shop. Painting was discussed in the back room. It was there that Choquet bought his first Cézanne for a few tens of francs. It could have been there, or in the gallery run by Theo (which was beginning to find buyers for Monet, Renoir, Pissarro and Sisley), or in rue Lepic at Alphonse Portier's, an agent with whom Theo had dealings and whom *Le Gaulois* in 1882 described as 'the intelligent and affable organiser of exhibitions of painters of the new school', that, for the first time, Vincent discovered what an Impressionist painting was. In the apartment in rue Laval and in the larger one, at 54 rue Lepic, to which they moved in June, he painted, alone. And the colour of the bouquets – 'simply flowers, red poppies, blue cornflowers and myosotis, white and rose roses, yellow chrysanthemums' – changed as, from canvas to canvas, gradually, the colours of his self-portraits also changed. In The Hague as in Drenthe, as in Nuenen, as in Antwerp, accentuations of light shaped his figures and landscapes composed of darkness, turf and low horizons. In the spring of 1886, his self-portraits still consisted of darkness picked out by light. It was a long struggle for him to learn colour. Vincent, 'in *colour* seeking life'. If he needed contact with other artists, Vincent needed above all to look at paintings repeatedly, all kinds of painting. He went to the Louvre as he went to the musée du Luxembourg, which opened, after renovations, in April 1886. The same month, he attended the second exhibition of the Société des Pastellistes Français; the exhibition of the Maîtres du Siècle,

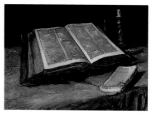

Still-life
with Bible

Père Tanguy

Agostina Segatori,
café du Tambourin

which brought together some two hundred works by Delacroix, Corot, Millet; and the eighth exhibition of the Impressionists at rue Lafitte. 'In Antwerp I did not even know what the Impressionists were, now I have seen them and though *not* being one of the club yet I have much admired certain pictures by them.'

That autumn, in Cormon's studio, Vincent associated with young painters. Among them, John Russell, Toulouse-Lautrec, Emile Bernard. This last, expelled from the studio by the master, came to work there only in his absence. The group frequented the same cafés, the same paint shops, and introduced Vincent to other artists such as Anquetin, who had been a student in charge at the Cormon studio where he now rarely set foot, and Charles Angrand. After three, four months at Cormon's Vincent left the studio, as he had left Antwerp. He had finished with academies, schools, their studios and what these could teach him. He went back to working alone. To Levens, who had drawn his portrait at Antwerp, he wrote: 'And fancy that after all that, I feel more myself.' Over the months, participating in the life of these painters in Paris, its tempo, its customs, he had assimilated in his own fashion the current motifs and techniques, what the painting of his century revealed and invented. In Paris Vincent, who had worked in isolation for some five years, put himself to the test painting 'in the manner of' those around him, a new discovery for him. 'What is to be gained is progress.' It was when his canvases began to 'resemble' the painting of his century in their freedom that the foundations of his achievement were laid, his ability to paint the incomparable. By the self-portraits he painted again and again in Paris, he measured his progress. When these ceased to be a mere copying, and the painting at last began to resemble him, he left. It was to achieve this metamorphosis that he stayed on in Paris; for no other reason. Everything was difficult, disappointing, hurtful. '. . . anyone who has a solid position elsewhere let him stay where he is. But for adventurers such as myself, I think they lose nothing in risking more. Especially as in my case I am not an adventurer by choice but by fate.' 'The faith in colour'

that was his became his destiny.

The rest is anecdote. In his portrait of Agostina Segatori, it is not the fact that the model had been Vincent's mistress, nor that she had allowed him to exhibit his paintings on the walls of the Tambourin, nor the break-up of their relationship that count; it is the Japanese prints bought at Bing's shop which he hung and reproduced behind her that are significant. In the portrait of Père Tanguy, the fact that Vincent hated his sitter's wife, a mean 'witch', changes nothing in the work. It is the Japanese prints with which he surrounds the model that are important. A rediscovery of their brilliance . . . That Portier did not manage to sell a single one of his pictures; that he himself was no more successful in the exhibition of the painters of the 'petit boulevard' – the 'grand' being that of Monet, Renoir, Picasso – which he organised in the Chalet restaurant, 43 avenue de Clichy, with Toulouse-Lautrec, Bernard, Anquetin, Koning; that these painters, their quarrels, their rivalries and their ambitions drove him to wish not to see 'so many painters that disgust me as men'; that he extricated himself from his 'not terribly respectable' love affairs 'only with shame and suffering'; that his presence became unbearable to Theo because he was vindictive, vehement and disorganised: all this did nothing to alter Vincent's determination to pursue his own destiny. Vincent was dirty and acerbic? 'What does it matter! My work is dirty and difficult: painting. If it was not as I am, I would not paint.' Exhausted, irritable, stupefied by talk, absinthe and tobacco, Vincent began to find it impossible to paint in Paris. It became imperative to leave.

On 20 February 1888, Vincent got out of a train at the Arles station. 'There's about two feet of snow everywhere and more is falling.' Vincent, who found a room in the restaurant Carrel, 30 rue Cavalerie, was overcome to see that 'The landscapes in the snow with the summits white against a sky as luminous as the snow were just like the winter landscapes that the Japanese have painted.' An aspect of Nature comparable to that revealed to him by Japanese prints brought Vincent comfort.

He wrote to Theo: 'I feel as though I were in Japan . . . and mind, I haven't seen anything in its usual splendour yet.' And to Emile Bernard: 'This country seems to me as beautiful as Japan in the limpidity of the atmosphere, the brightness of the colour effects.' And Vincent, soothed in spirit, painted from the moment of his arrival. His work in Arles became to him a mission not so very different from the one he had initially chosen. He gave of himself – 'it's my constant hope that I am not working for myself alone' – as he prayed – 'I believe in the absolute necessity of a new art of colour, of design – and of the artistic life. And if we work in that faith, it seems to me there is a chance that we do not hope in vain.' He had yet to appease the sadness that loneliness and exile evoked in him. To take 'all things tongue in cheek'. Loneliness was the passage of days and more days with no one to talk to, not even to ask for a cup of coffee, exile was nature itself. 'Ruisdaelesque', it made him think 'often of Holland and, across the gulf of distance and time, these memories tugged at the heart'. In April he declared: 'I am now entirely taken up with work, and I think this will be forever; and while this is not an unhappiness, I envisage happiness as being quite otherwise.' All that he knew of happiness was the counterfeit version of the zouaves' brothel in rue des Récollets.

The orchards in flower which he painted again and again in spite of the mistral, easel well secured, transformed his palette; this was of 'absolute colours, sky blue, orange, pink, vermilion, very vivid yellow, bright green, wine-red, violet'. And his manner of painting altered too: 'Impasto, here and there parts of the canvas left uncovered, unfinished corners, reworkings, crudenesses . . .' 'It is absolutely clear and done at a single sitting. A fury of impasto, scarcely tinted with yellow and lilac, on a base of white brush-strokes.' It was in one of these orchards that he was moved to write his 'Souvenir de Mauve' on learning that the man who had set him to paint his first canvas at The Hague had just died. At the time of the death of this painter without genius, Vincent was invited to exhibit in the Salon des Indépendants, which Mauve

never had been. He set his terms: 'My name must appear as it does on my canvases, Vincent and not van Gogh, for the excellent reason that no one here will know how to pronounce the latter.' The Salon at which Vincent exhibited was not Theo's uppermost concern. His position at Boussod & Valadon was under threat. And this threat affected Vincent's situation. To be as little a burden as possible, Vincent gave up painting for several weeks: 'In the belief that art can also be achieved at less expense than is required by painting, I have embarked on a series of pen-and-ink drawings.' And he left the restaurant Carrel, where he was cheated on the pretext that with his pictures he took up more space than a normal lodger. Neither this move nor his drawings amounted to renunciation. On the contrary: 'I believe that I am actually a worker, and not a soft and pleasure-seeking foreign tourist, and that it would be a lack of energy on my part to let myself be exploited like one. So I am taking steps to set up a studio which will at the same time be of use to my friends, if they come, or if there are painters here.' There was no question of his leaving Arles. 'I feel that nature here holds all one needs to do good work.' It was in a house with four rooms, two on the ground floor, two on the first floor, a house due to be re-painted in yellow, at 2 place Lamartine, that he made ready the studio in which he was to carry out the work that would make him into the painter of the future. He could not imagine himself as such: 'The painter who is to come – I can't imagine him living in little cafés, working away with a lot of false teeth, and going to the zouaves' brothels, as I do.' He was to be 'a colourist such as has never yet existed'. Like his paintings, Vincent's letters from Arles are charged with colour. He described: 'A plain full of very yellow buttercups, a ditch full of irises with green leaves and purple flowers, in the background the town, a few grey willows, a band of blue sky.'

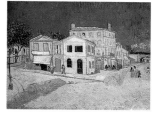

Vincent's house in Arles

Vincent's determination to paint what had to be painted, to accomplish what had to be accomplished, is imbued with tragedy: always a consciousness of sacrifice. 'And sometimes you lack

all desire to throw yourself heart and soul into art . . . you'd rather live in a meadow with the sun, a river and other horses for company, likewise free, and the act of procreation. And perhaps, to get to the bottom of it, the disease of the heart is caused by this . . . I do not know who it was who called this condition – being struck by death and immortality.' Vincent learnt from Theo that Gauguin, in Pont-Aven, was in financial difficulties. He suggested to Theo that he join them. It would be less expensive to help the two of them together than to send money to one in Brittany, to the other in the Midi.

While waiting for the yellow house to be got ready, for the installation of gas lighting and for the repainting, Vincent slept in another part of the same block, above the café de la gare run by the Ginoux family, and he went away for several days to Saintes-Maries-de-la-Mer. He drew in a way that was 'more spontaneous and more exaggerated'. He painted. And on his return he began to await the coming of Gauguin. 'One always loses out when one is alone.' Vincent did not want to lose out. With Gauguin he wanted 'to take a step forward', to paint the human figure. 'That is the subject I am always skirting, as if it was of no importance, but in reality it is my end.' Vincent decorated and furnished the house. Gauguin tarried. Vincent grew impatient.

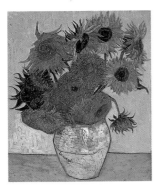
Sunflowers

Gauguin did not arrive. And Vincent, who was waiting, reflected: 'Painters – to take them alone – dead and buried speak to the next generation or to several succeeding generations through their work. Is that all, or is there more to come? Perhaps death is not the hardest thing in a painter's life.' And Vincent worked – on portraits: 'I always feel a confidence when I paint portraits, knowing that this work is much more serious – that is perhaps not the word, I mean to say that it allows me to cultivate what is best and most serious in me.' Portraits of a smoker, of a young girl, a one-eyed man, a peasant, Roulin the postman, Patience Escalier . . . 'I want to paint men and women with that something of the eternal which the halo used to symbolise, and which we seek to convey by the actual radiance and vibration of our colouring. Ah! portraiture, portraiture with the thoughts, the soul of the model in it, that is what I think must come.' Vincent worked. 'The only choice I have is between being a good painter and a bad one.' Relentless work. Cafés, café terraces at night. Sunflowers. 'I go on painting like a steam-engine.' It was on painting that Vincent spent the

money he received from Theo. He complained that for weeks he lacked the three francs to go out for a drink. In the yellow house, which he had occupied since 17 September, Vincent's only companions were the self-portraits of Bernard, Laval and Gauguin. He was still waiting for Gauguin.

On 28 October 1988, Gauguin arrived – at last. Cynically he had confided to a friend a few days earlier: 'Rest assured, however much Theo van Gogh may love me, he is not going to rush to feed me in the Midi for the sake of my blue eyes. He made his calculations in the Dutch cold.' The Dutch Vincent's anticipation was enormous, Gauguin looked forward to nothing. And it was not Japan that Gauguin found on arrival. 'I am in Arles, completely bewildered, so small, so mean, do I find the landscape and the people. Vincent and I do not, generally speaking, agree, above all about painting. He is romantic and I am rather drawn to the primitive.' This was something Vincent recognised. He felt himself 'in the presence of a being with untainted and primitive instincts'. When Gauguin revealed that he had been a sailor, seafarer, topman, the admiration Vincent felt for his fellow artist was unbounded: he expressed an 'extreme respect' and a 'total confidence'. And Vincent let Gauguin manage life in the yellow house. Gauguin cooked, as he arranged for the making of frames, and set money aside to pay for visits to the brothel. And everything, the painting at which they worked side by side, Vincent's untidiness, the canvases in the Bruyas collection which they were to see in Montpellier, afforded a pretext for irritated discussions, disagreements and confrontations. Gauguin wanted only to get away. He painted a portrait of Vincent. 'It is clearly myself, but myself gone mad.' On 23 December 1888, in place Lamartine, Vincent followed Gauguin who had left him alone. Gauguin turned round. In his fist, Vincent clutched a naked razor. He halted and returned to the yellow house. Later, towards 11.30, he handed a closed envelope to a certain Rachel, who lived in licensed brothel, No 1. And he went home.

In the envelope, Rachel and the madame of the brothel found Vincent's severed left ear lobe. The gendarmes who discovered him, unconscious, lying curled up in his room, amidst linens and napkins stained with blood, informed Gauguin, who returned in the morning, that Vincent was dead. Gauguin telegraphed to Theo and then disappeared. At the Hôtel-Dieu, to which Vincent was admitted, he was shaved and bandaged. The twenty-two-year-old house surgeon, Dr Rey, had

Vincent locked into a cell, where he shouted, complained and struggled. The young doctor could not give any reassurance to Theo, who feared the worst, but could only assure him of his own solicitude. This Theo also sought from the Revd Salles. Then, overwhelmed, he departed. On the 27th, following a visit from Mme Roulin whose husband and a cleaning woman had restored the yellow house to order, came a fresh crisis. Back to the cell. Refusal to eat. Dr Rey considered transferring Vincent to an asylum in Aix-en-Provence, but four days later, 31 December, the Revd Salles found Vincent calm.

1 January 1889, Vincent to Theo: 'I reckon to go back to work soon . . . in the end, no harm has befallen me and there is no need for you to worry.' To Gauguin, on the back of the same sheet and in pencil: 'In the end there is no harm in this best of worlds where everything always turns out for the best.' This best of worlds was that in which Theo was to marry Johanna Bonger: the 'real life' which for Vincent never ceased to be an affliction. His own life, which he resumed in its solitude on the 7th, returning to the yellow house, was that of a painter. In other words a mad way of living. Three months earlier he had written to say that he was undefeated: . . . so many painters die or go mad with despair or become unable to work because no one loves them for themselves.' Vincent had waited for Gauguin. He had prepared a room for him which he had wished to be 'like the boudoir of a truly artistic woman'. And Gauguin had not liked it. 17 January: 'How can Gauguin pretend he is afraid of disturbing me with his presence, when he could hardly deny knowing that I have continually asked for him and he has been told again and again that I want to see him straight away.' In vain.

A painter mad from despair at being loved by no one, all that was left to Vincent was not to become 'paralysed in his production'. For eighteen months, from January 1889 to July 1890, Vincent could do no more than be conscious of this: despite his despair, in defiance of his crises, for all that destroyed him, to work. And if it became impossible to work. For eighteen months, Vincent was wholly dominated by this necessity. On 28 January 1889, he beseeched: '. . . look here,

let me go quietly on with my work; if it is that of a madman, well, so much the worse. I can't help it . . . And once again, either shut me up in a madhouse right away – I shan't oppose it, for I may be deceiving myself – or else let me work with all my strength, while taking the precautions I speak of.' For if he accepted, endured and suffered everything, it was only for the sake of painting.

Fresh crisis on 9 February. Hôtel-Dieu. Telegram from Dr Rey on the 13th: 'Vincent is much better. Hoping to cure him we are keeping him here. Do not worry for the present.' And Dr Rey allowed Vincent to paint in the yellow house during the day. Into March. A petition went the rounds. 'It seems that the people here have a superstition which makes them afraid of painting.' Vincent, a possible public danger, was interned, the yellow house closed by the police. Dr Rey was away. Vincent could not paint. 'I miss my work more than it tires me.' Same letter to Theo: 'You will see that the paintings I have done in the intervals are calm and not inferior to others.' On his return, Dr Rey scolded Vincent for drinking too much coffee and alcohol. 'I admit all that, but all the same it is true that to attain the high yellow note that I attained last summer, I really had to be pretty well keyed up.' On his way through Arles, Signac accompanied Vincent to the yellow house and forced the door. Signac to Theo: 'He took me to see his pictures, a number of which are very good and all very curious.' A few days later, Dr Rey allowed Vincent to paint in hospital. April: 'If I had to stay in a hospice for good, I would settle to it and I think I would find subjects to paint there too.' Despite 'considerable inner despair', Vincent worked in the hospice itself and in its environs. But this was not enough and Vincent made a decision: 'At the end of the month I should like to go to the hospital in Saint-Rémy, or another institution of this kind. . . . I should be afraid of losing the power to work, which is coming back to me now, by forcing myself and by having all the other responsibilities of a studio on my shoulders besides.' On 8 May, Dr Peyron and Jean-François Poulet, an attendant, admitted Vincent to the hospice of Saint-Paul-de-Mausole by Saint-Rémy-de-Provence. And the day after his arrival he painted 'purple irises and a lilac bush, two motifs found in

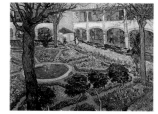

Courtyard of the
hospital at Arles

the garden'. At Theo's request, Vincent was allocated a room adjoining his own as a studio. Note by Dr Peyron, May 1890, on the subject of Vincent: 'Patient calm most of the time. During his stay in the home has had several attacks of fifteen days and one month's duration; during these attacks the patient is exposed to terrifying fears; he has tried on several occasions to poison himself; either by swallowing the colours he uses for his painting, or drinking petrol which he had taken from the boy while he was replenishing the lamps. In between these attacks the patient is perfectly tranquil and lucid and devotes himself with great keenness to his painting.' During his internment Vincent had painted over 140 canvases. And this was his salvation. 'Face to face with nature, it is the feeling for work that supports me.' 'Work is an infinitely greater distraction to me than anything else, it is possibly the best medicine.' Once, and once only, he gave a clue to what might drive him to leave the hospice: 'In the long run I shall lose the faculty for work, and that is where I begin to call a halt.' Vincent painted. 'I try to paint in a style that will look well in a kitchen, and sometimes I find that it will look well in a drawing room too, but I never worry about that.' Vincent painted. 'We must work and with as few pretensions as a peasant if we want to last.'

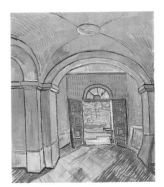

Hospital vestibule of
Saint-Paul-de-Mausole

January 1890. Brussels. Eighth exhibition of Les XX. Six of Vincent's paintings were exhibited. An article, 'Les isolés: Vincent van Gogh', by Albert Aurier was published in *Mercure de France*: 'It is difficult for someone who wishes to be impartial and who knows how to look at painting to deny or dispute the naive veracity of his art, the ingenuousness of his vision . . . What distinguishes his work as a whole is excess, excess in the force, excess in the nervous power, the violence in the expression.' And one of Vincent's pictures in the exhibition, *The Red Vineyard,* was bought by the painter, Anna Boch, for 400 francs. On 31 January, in Paris, Vincent van Gogh was born: his nephew. For two days Vincent had been laid low by a new attack. A long relapse at the end of February. Ten of

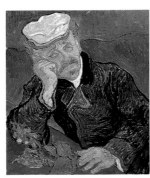

Dr Paul Gachet

his canvases were exhibited at the Salon des Indépendants. Vincent's painting was talked about. And Vincent himself had reached the end of his tether. 'This is how things nearly always go in a painter's life: success is about the worst thing that can happen.' The time to cry 'Stop!' had returned. He had to leave.

On 17 May, Vincent was in Paris. Theo took him at once to 8 cité Pigalle where he was living with Johanna, and now . . . Vincent. Tears of emotion over the cradle. Fraught days. He attended the Salon, and gave up a plan to see, in the Ecole des Beaux-Arts, an exhibition of Japanese crépons. It was imperative that he leave Paris and its noise; that he find Dr Gachet who, Pissarro had assured Theo, would be able to give Vincent all the help he needed to recover his faculties in Auvers-sur-Oise. He knew of what stuff a painter was made. He was close to all the Impressionists. Cézanne had worked at his side. Cézanne, the Midi. . . . And the doctor engraved and signed van Risle-Lille in Flemish, proofs he had himself struck off. Van Risle, van Gogh. Vincent arrived in Auvers on the 20th. When he chose to move in with the Ravoux, place de la Mairie, rather than at the St Aubin inn which he considered too expensive, he was thinking not of medical care but of painting: 'I can already tell that going to the Midi did me good and helped me to see the North better.' Vincent was not over-concerned as to how Dr Gachet might help him. He was sure that it was 'above all an illness of the Midi' he had caught and that 'the return here will manage to get rid of all that'. Vincent painted. On Sunday 8 June, Theo, Johanna and little Vincent spent the day in Auvers. They lunched in Dr Gachet's garden. The fields, the streets of Auvers, portraits. And Gachet sat for him. 'I wanted to produce portraits that in another century will seem like apparitions.' Vincent painted. And it was the health of another Vincent that stirred anxiety in Theo, whom Boussod & Valadon continued to pay as if he had just joined the firm. On Sunday 7 July Vincent was in Paris, at Theo and Johanna's. There he met Albert Aurier, and Toulouse-Lautrec lunched with them. That evening he was in Auvers, exhausted, shattered. What were the remarks or reproaches that Theo or Johanna had felt they must make to call forth such heart-broken words from Vincent, who wrote to them on his return. 'Can I do anything – perhaps I can't – if I do something wrong or can I actually do something that you want?' And Theo left for Holland. On his return, he got a letter from Vincent: 'As far as I am concerned, I am applying myself wholly to my paintings, I am trying to do as well by some of the painters I have greatly loved and admired . . .' It was in the past tense that Vincent cast his verbs. On 28 July in the morning, Hirschig,

a Dutch painter, who lived at the Ravoux' inn, arrived at boulevard Montmartre bringing Theo a letter from Dr Gachet written the previous day. 'I was summoned at nine o'clock at night today Sunday on behalf of your brother Vincent, who had asked for me urgently. Arriving at his side, I found him very ill. He has wounded himself . . .' On the afternoon of 27 July, Vincent had shot himself with a pistol. On 29 July 1890, at one o'clock in the morning, Vincent van Gogh died. Theo to Johanna: 'One of his last words had been: "I wanted to be able to die like this", and that is what happened; a few moments later, it was over, he found the peace he had been unable to find on earth.' On 30 July, Emile Bernard, Père Tanguy, Lucien Pissarro, Lauzet, Bonger, Dr Gachet and Theo attended the burial, at which the curé had refused to perform the Office of the Dead, and followed the coffin to the cemetery of Auvers-sur-Oise. Vincent's coffin was covered with yellow flowers; among them, sunflowers.

<div style="text-align: right">Pascal Bonafoux</div>

Death mask
of Vincent van Gogh
by Paul van Ryssel
(Dr Gachet)

> *'If I shall be any good later on,*
> *then I am some good now,*
> *for corn is corn,*
> *even if people from the city*
> *take it for grass at first '*

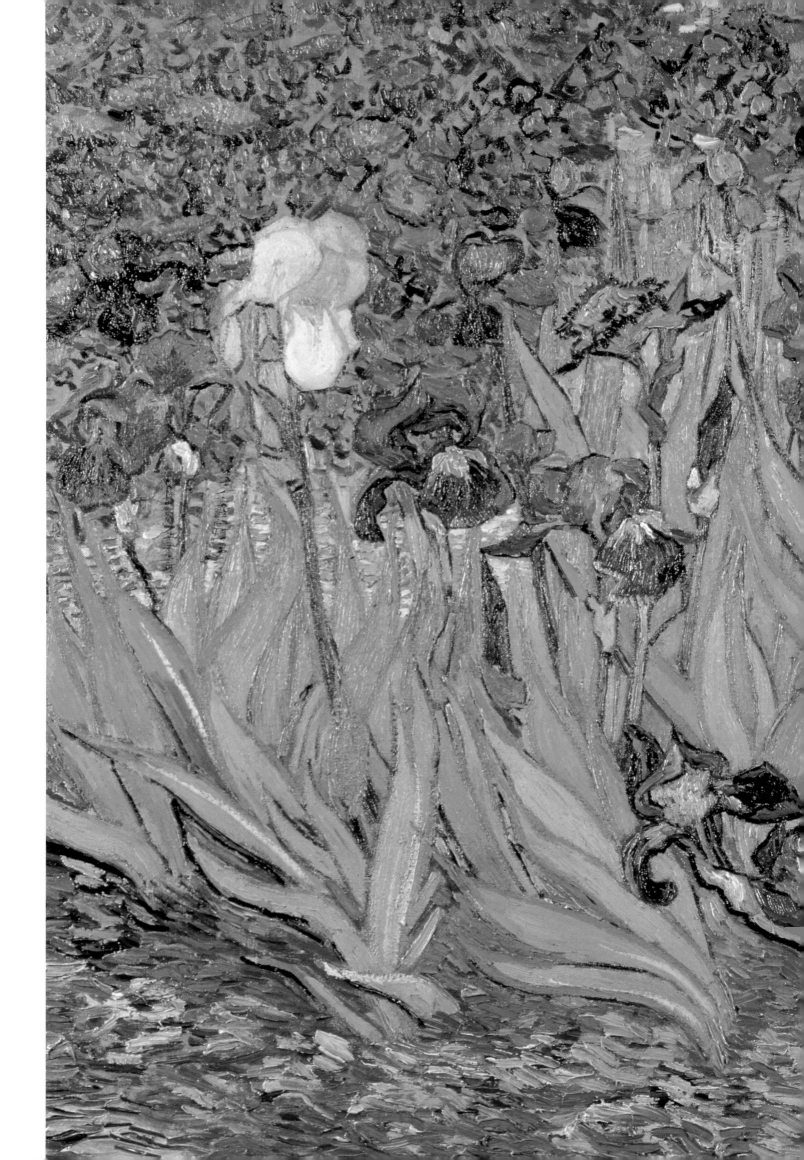

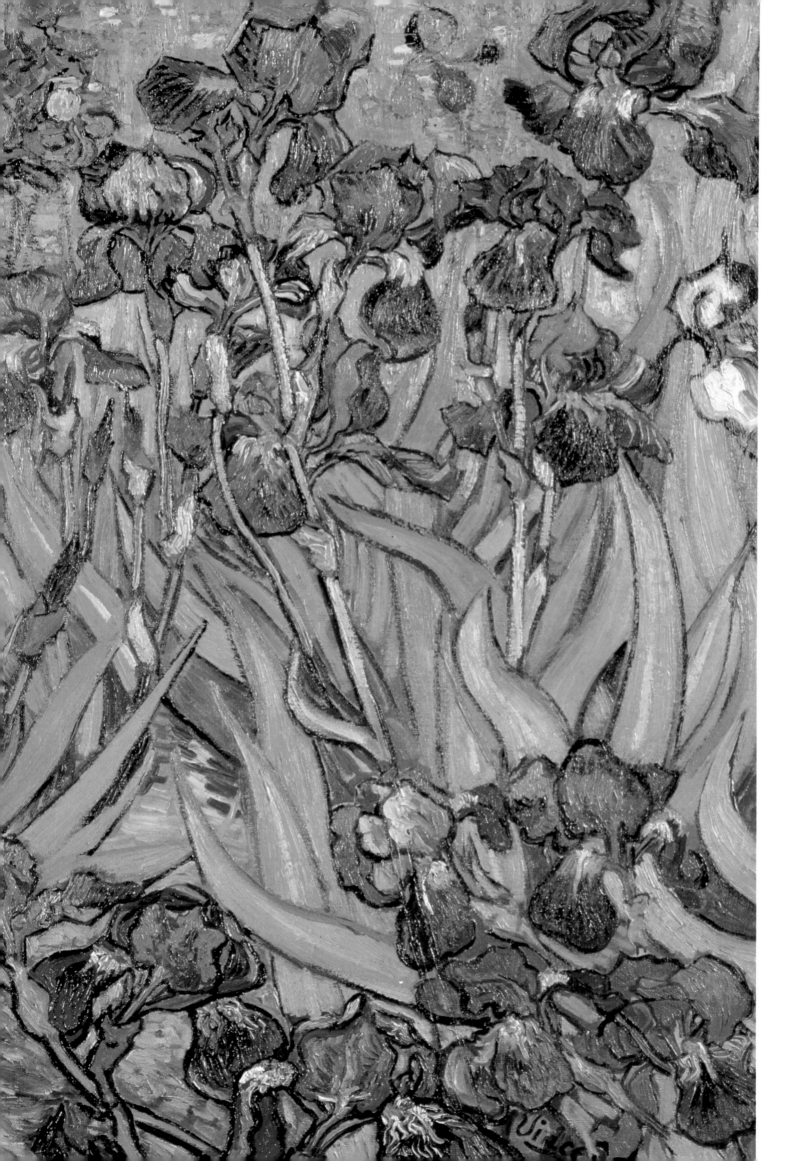

On 11 November 1987, Irises *fetched the unheard-of sum of $53,900,000, an absolute record for a painting at that time. Just as the repercussions of the New York stock exchange crash were making themselves felt throughout the world, this astonishing sale turned Vincent van Gogh into the most highly valued of modern artists, though it is true that the prices of Impressionists had already started to soar, as had those of contemporary artists. Yet in Vincent's coming to fortune and glory scarcely a hundred years after his death, there is something that tears at the heart. He had but thirty-seven years of life. Except in his childhood, he knew only poverty and anguish. Incapable of tolerating compromise, fanatical about genuineness, one after another he lost the friends he ceaselessly sought. Each time he loved a woman, love was refused him. Vincent lived on a monthly allowance sent by his brother Theo. This was scarcely enough to buy the canvases and paints he needed. He could not pay for models. Only two successes in his lifetime are definitely known: one when Albert Aurier published a leading article in* Mercure de France *in 1890 praising his painting; the other when* The Red Vineyard *fetched 400 francs. Today the latter is in the Pushkin Museum, Moscow. A few months before the sale of* Irises, Sunflowers *was bought by a Japanese insurance company. This canvas is painted in the emphatic yellow tones Vincent relentlessly strove for while awaiting his friend and master Gauguin in Arles with feverish impatience.* Irises, *at the time of its extraordinary sale, came from the collection of Joan Whitney Payson and belonged previously to the poet, Octave Mirbeau. The beauty of the blues and greens, the suffocating intensity of the flowers, imprisoned on a canvas from which the sky is excluded, close round the lone white bloom in the composition. Vincent painted them in May 1889. He was then voluntarily confined to the asylum of Saint-Paul de Mausole, near Saint-Rémy de Provence. Fourteen months later, Vincent killed himself with a single pistol shot under the torrid July sun. Theo had never ceased to be his confidant, his friend, his rational supporter. A year after Vincent, he too met his death, from sickness. Now ivy binds their two graves in the little cemetery of Auvers-sur-Oise. Vincent's vicarious wealth has not reached there.*

'I live not for myself,
but for the generations to come'

Theo

Vincent

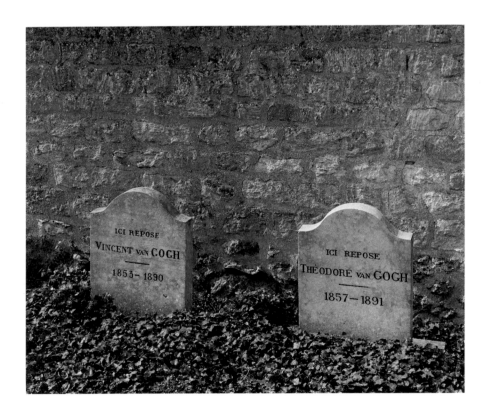

Preceding pages:
Irises, 1889
Oil on canvas, 71 x 83 cm
Private collection

1 *Sunflowers*
Oil on canvas, 91 x 72 cm
Pinakothek, Munich

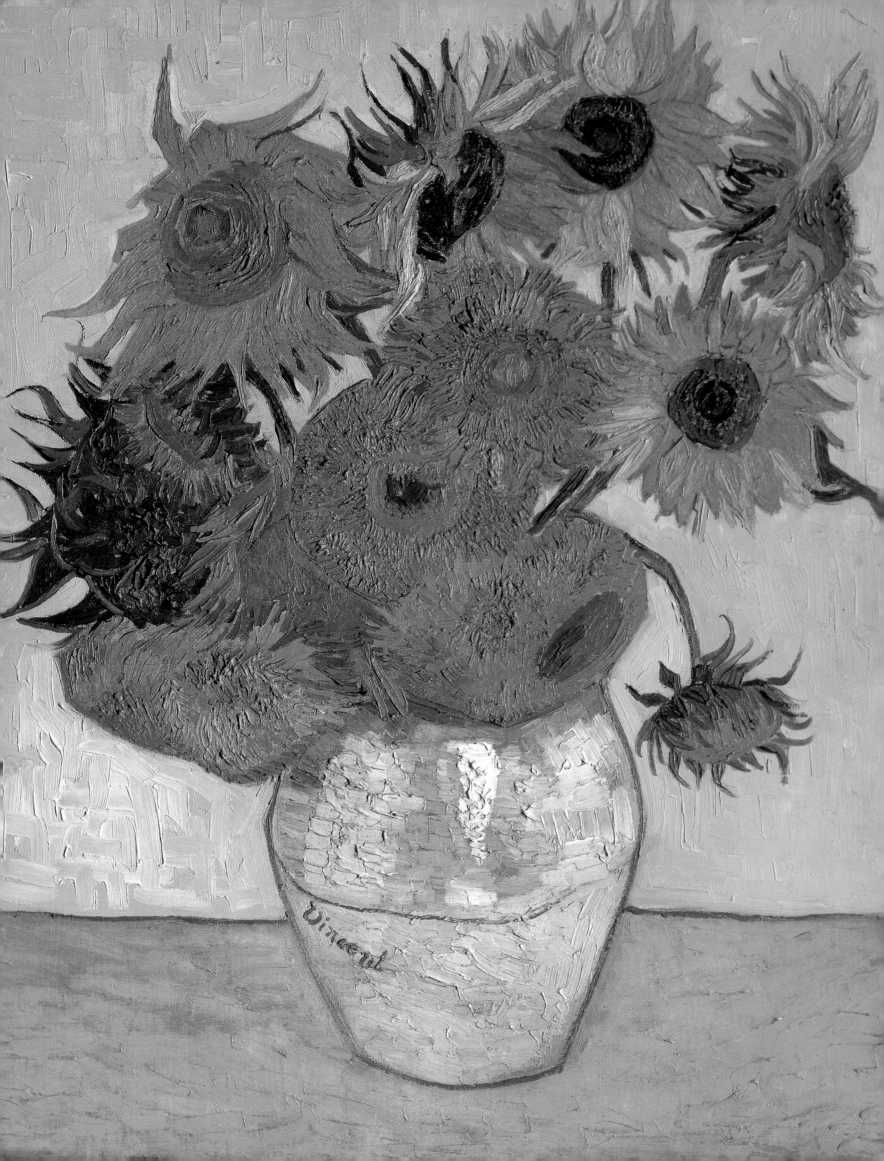

Groot Zundert was a little village in the cold and misty countryside of Brabant, 30 kilometres from Antwerp. Pastor Theodorus van Gogh moved there in May 1851. He married Anna Cornelia, a gentle woman of artistic temperament, who gave birth the following year to a boy: Vincent. Not our Vincent. This one was born and died on 30 March 1852. Vincent van Gogh, whose works now hang in the greatest museums of the world, was born a year later, to the day, on 30 March 1853. Each Sunday on his way to church, a small, sensitive and reserved little boy passed a headstone on which his name and date of birth had been carved. Death too figured on the stone. Was this Vincent another, or was it himself? To be oneself: this became his life's obsession, something that had to be established and proved. Three daughters were born to the van Gogh family and two sons, including Theo in 1857. This young brother was never to abandon Vincent in his sufferings. He never ceased to be his correspondent, his sounding board, his support, until those days in 1890 when Vincent, from more than one indication, felt that Theo was detaching himself to concentrate on his own newly established family. But in the beginning it was Vincent who had the role of elder brother. He took birds from their nests for little Theo, led him on expeditions into the surrounding countryside, exploring and observing the wonders of nature. Meanwhile, at the village school, Vincent was a noticeably poor pupil. His father and mother, Pa and Moe, decided to send him to boarding school in Zevenhagen. He was eleven when he started there in October 1864. Ten years later, Vincent still nursed sad and painful memories of this separation. 'It was an autumn day. I was standing on the steps of M. Provily's school, my eyes following the cart in which Pa and Moe were making their way home. One could see it from afar, the little yellow cart, on the long road wet with rain, lined with slender trees, running across the fields. The grey sky over it all, mirrored in pools of water.' Vincent's schoolwork continued to be mediocre: he was enrolled at the Hannick Institute in Tilburg. Three years of fruitless studies went by, before Pa faced the facts: Vincent, who spoke only of wanting to draw and be a painter, could not go on living at his expense. And, as it happened, Vincent – Uncle Cent – Pa's brother, after whom the first two boys – one dead and one alive – had been christened, was a partner at the French gallery Goupil & Cie. He was by then retired, spending the summer months

Pastor Theodorus van Gogh settled in Groot Zundert at the age of twenty-seven. He was a poor preacher, but was loved for his kindliness. Anna Cornelia Carbentus shared with the young Vincent her love of art and nature. Uncle Cent was the pastor's closest brother. They had married two sisters. It was he who found work for Vincent and his brother Theo at Goupil & Cie

1 *The Milk Jug,* 1862
Pencil on laid paper, 27.8 x 22 cm
Kröller-Müller Foundation, Otterlo

2 *Old Breton Woman,
asleep in church,* 1873 or 1874
Pencil and white chalk, 26.5 x 19.5 cm
van Gogh Foundation, Amsterdam

3 *The Bridge,* 1862
Pencil on laid paper, 12 x 36.5 cm
Kröller-Müller Foundation, Otterlo

Groot Zundert

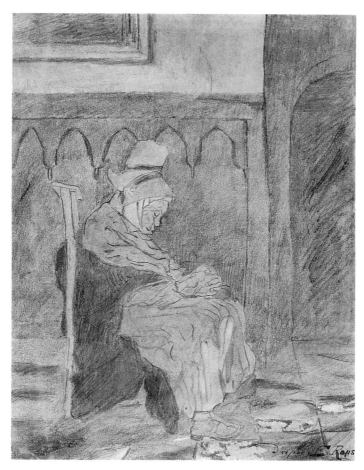

2
Vincent was twenty-one when he did this drawing of an old Breton woman asleep in church, copying an illustrated paper

'In what can
I be useful, what
purpose can I serve?'

From this house, in which he was born, Vincent set out every Sunday for the Groot Zundert church where he heard his father preach

1 (*left*)
One might feel doubts as to the dating of this drawing by Vincent; it is nonetheless maintained that he was nine years old

3 (*right*)
If the subject of this drawing, a bridge, is undoubtedly common in Vincent's work, the dating of it (1862) leaves one sceptical

in Princenhage, the winter in Menton, but his former employee, M. Tersteeg, the present director, could hardly refuse to comply with Uncle Cent's recommendation to engage the young van Gogh, and gave him a post in the firm's branch at The Hague. M. Tersteeg found his employee satisfactory. Vincent sold prints, lithographs, lodged with the Roos, a strict and worthy family, visited museums and exhibitions, went to the beach on Sundays. At Goupil, Vincent made a favourable impression and was offered a job in the London office. Vincent's first lodging there proved too expensive, the other lodgers, Germans, too rich. He moved his few possessions and rented a room from a clergyman's widow, Mrs Loyer, then fell in love with her daughter Eugénie. It took the taciturn and awkward Vincent a year finally to declare his love. He was rejected. In consternation, he took refuge for the holiday period with Pa and Moe, in Helvoirt where Pa now had his parish. Vincent's changed character and gloomy spirits worried his parents. He was an encumbrance to them. He returned to England, taking his sister Anna who wanted to find a job there. Quick-tempered, unpredictable, Vincent was no longer the satisfactory employee Goupil had grown accustomed to. He was moved to Paris, and returned to London in December. But he was just as intolerable to other people. He had lost the desire to draw, did nothing but read, finding in his reading pointers that were to lead him to his next calling, that of evangelical missionary. The terrible misery he had encountered in the poor districts of London and the 'virginity of the soul and purity of the body' were at this stage the two driving elements of his life. He was twenty-one years old. In May 1875, he was recalled to Paris. The little room beneath the rafters that he found in Montmartre pleased him. And his loneliness was assuaged by his friendship with a young Englishman, Harry Gladwell, who also worked at Goupil and who was as little liked as himself. 'Every evening we go home together, eat something in my room and the rest of the evening I read aloud, generally from the Bible. We intend to read it through.' In September 1876 Vincent wrote to Theo: 'Let us ask that our part in life should be to become the poor in the kingdom of God, God's servants.' And he added: 'It is the same with the feeling for Art.' In December, suddenly, right in the middle of the seasonal festivities, he abandoned his job to rejoin Pa, Moe and his sisters at Etten where Pa had been appointed pastor. This was too much for Messrs Boussod & Valadon, the sons-in-law of M. Goupil, who had taken over the running of the shop. As soon as he returned, they sacked him, with effect

First exile

1
Vincent admired Gustave Doré whose engraving of London seems to illustrate the evangelist's life that Vincent wished to lead among the poor, extending even to the doss-houses where the most destitute sought refuge for a night

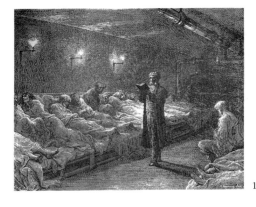

1

In this house in Ramsgate, a teacher called Mr Stokes ran a little school. The pupils were aged between ten and fourteen. Vincent taught them, among other things, a little French. Fired by his love of God, Vincent was soon to teach the Holy Scriptures at the Revd Mr Jones's establishment and, at last, to preach in church

1 *A preacher reading the Holy Scriptures in a doss-house*
Gustave Doré
Engraving

2 *Vicarage church at Etten*, 1881
Pen, 9 x 14 cm
van Gogh Foundation, Amsterdam

3 *Square at Ramsgate*, 1876
Pen, 5.5 x 5.5 cm
van Gogh Foundation, Amsterdam

2

3

*'My salary at Mr Stokes will be very small
probably, only board and lodging and
some free time to give lessons'*

Return to Holland

from 1 April. Vincent then went back to Etten, where he felt a stranger among his own. He had no choice but to accept the offer of a post in England. At Ramsgate, a certain teacher called Stokes ran a boarding school for twenty-four boys aged from ten to fourteen. Vincent was to teach them the rudiments of French. But what Vincent wanted was somehow to associate himself with the miseries of the poor, to bring them the help of God and the light. He wanted to preach – even if his imperfect English proved an obstacle. He studied the Bible determinedly. In July, the boarding school moved to Isleworth, in the London suburbs. Vincent saw 'a glimmer of light breaking on the horizon' and described it to Theo: 'It seems to me of late that there are no other situations in the world but those of schoolmaster and clergyman, with all that lies between these two; such as missionary, especially a London missionary, etc.'

Vincent left Stokes to join a boarding school run by the Revd Mr Jones, as an assistant master teaching the Holy Scriptures. At last, on 5 November 1876, he preached: 'Theo, your brother has preached for the first time, last Sunday, in God's dwelling.' He was convinced that from now on he would preach the Gospel wherever he might be. The Revd Mr Jones gave him leave to return to Etten for Christmas. Vincent's parents, horrified by his mysticism, again had recourse to Uncle Cent, who obtained a job for him in a bookshop in Dordrecht. But Pa was finally to surrender to Vincent's obstinate determination. In May, he was sent to Uncle Jan in Amsterdam, to prepare for the Faculty of Theology's entrance examinations. Neither the zeal with which he worked nor the dedication of the teachers who prepared him saved him from failure. He fell back on the Flemish evangelical school. It was possible to be assigned a mission before one's studies there were completed. In November, he was refused the title of evangelist – too extreme, too arrogant, a poor preacher, according to the pastors Jonge and Pietersen. They refused to let him work as a lay missionary in the Borinage, that mining country which Vincent knew to be the most terrible of all, the cruellest to man. He made his way there nonetheless.

'I spend some happy days here, yet I do not fully and entirely trust in this happiness, in this quietude'

3
This portrait was long thought to be that of Kee Vos-Stricker, whom Vincent so much loved. It is, in fact, that of his sister Wilhelmina, with whom he exchanged long letters when he was at Saint-Rémy. She figured in the feminist movement in the Netherlands. 'Will' ended her days in a psychiatric asylum, aged seventy-nine
1/2
When employed at Goupil & Cie, an art gallery at The Hague, Vincent drew these little sketches and sent them to his brother to amuse him. He loved The Hague. On the eve of his departure to London, he wrote to Theo: 'It is only now, when my departure is decided, that I realise how much I have grown attached to The Hague'

1 *The 'Lange Vijverberg'*, 1870-3
Indian ink & graphite, 22 x 17 cm
van Gogh Foundation, Amsterdam

2 *The Canal*, 1870-3
Indian ink & graphite, 25 x 25.5 cm
van Gogh Foundation, Amsterdam

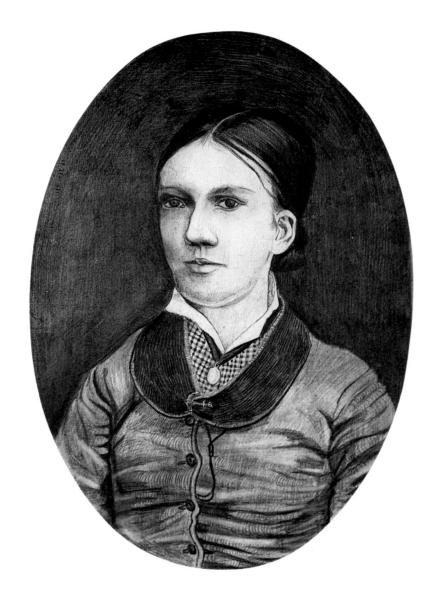

Admiral Johannes,
Uncle Jan, had
Vincent to stay when he started
his theological studies in
Amsterdam

4 Anton Mauve, painter of
animals, helped Vincent greatly
with advice and even a little
money. He wanted Vincent to
draw from plaster models.
Vincent initially followed his
advice, then rejected it. This,
added to van Gogh's tricky
character, caused a rift in their
relationship

3 *Portrait of Wilhelmina*, 1881
Pencil, 35 x 24.5 cm
van Gogh Foundation, Amsterdam

4 *Ane de plage,* nd, Anton Mauve
Oil on canvas, 37 x 48 cm
Mesdag Museum, The Hague

5 *Vue de la plage,* 1887, H. J. Weissenbruch
Oil on canvas, 73 x 103 cm
Gemeentemuseum, The Hague

5 Weissenbruch, who studied
at the school at The Hague, had
an influence on the work of
van Gogh

Wasmes, April 1879

'I was for six hours in a mine. It was one of the oldest and most dangerous mines in the neighbourhood, called Marcasse. That mine has a bad reputation, because many perish in it, either in descending or ascending, or by the poisoned air, or by gas explosion, or by the water in the ground, or by the collapse of old tunnels, etc. It is a gloomy spot, and at first sight everything around looks dreary and desolate. Most of the miners are thin and pale from fever and look tired and emaciated, weather-beaten and aged before their time, the women, as a whole, faded and worn. Around the mine are poor miners' huts with a few dead trees black from smoke, and thorn hedges, dung-hills and ash dumps, heaps of useless coal, etc. . . . So we went down together, 700 metres deep, and explored the most hidden corners of that underworld. . . . Imagine a row of cells in a rather narrow and low passage supported by rough timber. In each of those cells a miner, in a coarse linen suit, filthy and black like a chimney-sweep, is busy cutting coal by the pale light of a small lamp. In some of those cells the miner stands erect, in others he lies on the ground. . . . Some of the miners . . . load the cut coal in small carts, . . . this is done especially by children, boys as well as girls.'

In July 1879, Vincent was relieved of his duties. As far as the Brussels evangelical authorities were concerned, he had overdone it. His zeal was excessive. The straw mattress on which he slept, the old sack he had turned into a garment, were tantamount to scandal in the eyes of the good pastors. A visit from Theo, in October, gave him comfort: 'When one lives with others and is united by a feeling of affection, one is aware of a reason for living, and one perceives that one is not quite worthless and superfluous, but perhaps good for something . . . that feeling of proper self-esteem also depends very much on our relations to others.'

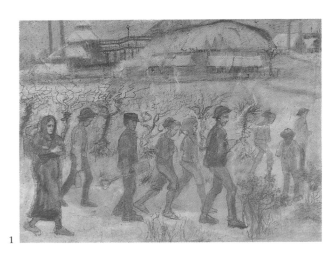

1

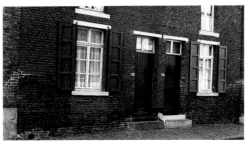

'To get on with miners you have to identify with them and not give yourself airs and graces, otherwise you won't establish a rapport with them and gain their confidence.' It was in this house in Wasmes, home of the Denis family, that Vincent lodged before he moved to a shack

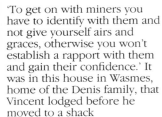

1 *Miners,* 1880
Pencil, lightly coloured, 44.5 x 54 cm
Kröller-Müller Foundation, Otterlo

2 *Coal Shoveller,* 1879
Black chalk, pencil, pen, brush, heightened & washed with white, 49.5 x 27.5 cm
Kröller-Müller Foundation, Otterlo

3 *Miners' wives carrying sacks of coal,* 1882
Watercolour, 32 x 50 cm
Kröller-Müller Foundation, Otterlo

The Borinage

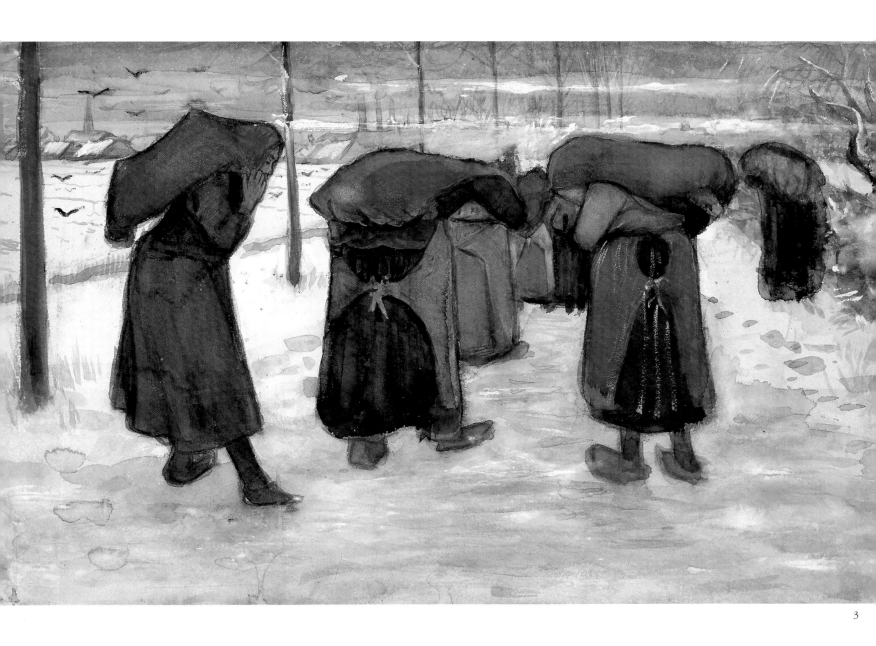

3

'Here, it is the sick
who tend the sick,
the poor who befriend the poor'

But between the two brothers there were also material problems: 'If I really had to think that I were troublesome to you, or to the people at home, or were in your way, of no good to anyone, and if I should be obliged to feel like an intruder or an outcast, so that I had better be dead, and if I should have to try to keep out of your way more and more – if I thought this really were the case, a feeling of anguish would overwhelm me, and I should have to struggle against despair.' In a later letter Vincent adds: '... far from that land, I am often homesick for the land of pictures.' Suddenly, in January 1880, Vincent set out on foot for Courrières where he wanted to see the painter Jules Breton. But all he saw was the outside of his house, not daring to venture in. The return journey was even more gruelling: 'I earned some crusts of bread along the road here and there, in exchange for some drawings which I had in my valise. But when the ten francs were all gone I had to spend the last nights in the open air, once

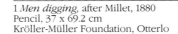

in an abandoned wagon, which was white with frost the next morning – rather a bad resting-place – once in a pile of fagots, and once, that was a little better, in a hay-stack, where I succeeded in making a rather more comfortable berth, but then a drizzling rain did not exactly further my well-being. Well, it was even in that deep misery that I felt my energy revive and that I said to myself: in spite of everything I shall rise again, I will take up my pencil, which I have forsaken in my great discouragement, and I will go on with my drawing; and from that moment everything seems transformed for me; and now I have started, and my pencil has become somewhat docile, becoming more so every day. My trouble had been that I had suffered so long and had been so wretched that I had become too discouraged to tackle anything.'

'So you would be wrong in persisting to believe that, for instance, I should now be less enthusiastic about Rembrandt, Millet, Delacroix, or whoever it may be, for the contrary is true'

'I would have some drawings to show you, types from here, it wouldn't be worth while for you to leave the train for those alone, but you would easily find something to attract you in the scenery here,' wrote Vincent. But behind this lightness of tone, *The Return of the Miners* was an expression of compassion and revolt. Vincent decided to be a painter. He copied engravings after the French masters, such as Millet

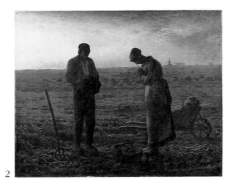

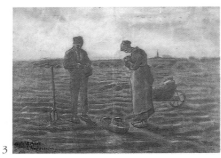

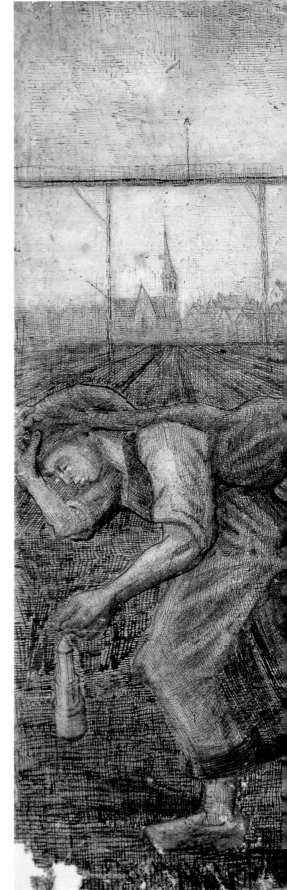

1 *Men digging,* after Millet, 1880
Pencil, 37 x 69.2 cm
Kröller-Müller Foundation, Otterlo

2 *The Angelus,* Millet, 1857
Oil on canvas, 55 x 66 cm
Musée du Louvre, Paris

3 *The Angelus,* after Millet, 1880
Pencil, red chalk, 47 x 62 cm
Kröller-Müller Foundation, Otterlo

4 *The Return of the Miners,* 1881
Pen, pencil & brush, 43 x 60 cm
Kröller-Müller Foundation, Otterlo

At twenty-seven Vincent reached a decision – he was determined to be a painter. He found lodgings in Brussels, asked Theo to procure prints for him to copy, searched out other artists, envisaged entering the Academy of drawing (its classes were free), made friends with van Rappard who, for his part, was rich. But, for Vincent, life in Brussels proved too expensive. He went to Etten, where he came into conflict with his father who was exasperated by Vincent's decision to be a painter. In the course of the summer a young widow arrived with her four-year-old little boy. It was his cousin Kee and she bowled Vincent over. He declared his love and wanted to marry her. She rejected him. Vincent persisted, utterly obstinate. Pa could not tolerate his behaviour. Vincent could no longer live under his roof. Anton Mauve, a cousin and an artist himself, invited Vincent to join him in The Hague. Mauve, who had a good reputation as a painter, liked Vincent's first oil paintings. But, outside Mauve's studio, to Vincent The Hague meant nothing but loneliness. One winter evening, on a pavement or in some café, he met a prostitute: Clasina Marla Hoornick, Sien for short, but whom he called Christine. 'This winter I met a pregnant woman, deserted by the man whose child she bore. A pregnant woman who in winter had to walk the streets, had to earn her bread, you understand how. I took that woman for a model, and have worked with her all the winter. I could not pay her the full wages of a model, but that did not prevent my paying her rent, and, thank God, I have been able thus far to protect her and her child from hunger and cold, by sharing my own bread with her. When I met that woman she attracted my notice because she looked ill. . . . Posing was very difficult for her, but she has learned it. I have made progress in my drawing because I had a good model. . . . She has no money, but she helps me to earn money in my profession. I am full of ambition and love for my work . . .' Mauve broke off with Vincent. Sien was alcoholic. Vincent had to go into hospital to be treated for gonorrhoea which he had caught from Sien. From all sides he was urged to leave her. He found a new lodging for her and her two children, left her at The Hague and set off for Drenthe. Sien tried to join a brothel. One night, years later, she threw herself into the docks of a port.

Sien

*'When I met Christine,
as you know she was
pregnant, ill, in the cold;
I was alone'*

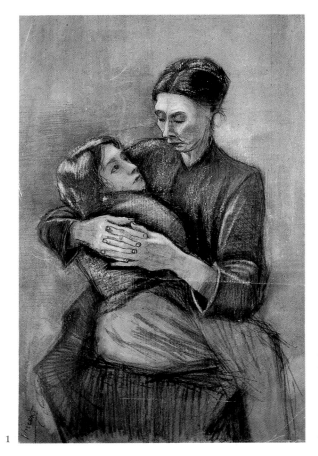

1

'Christine is not a hindrance or a trouble to me, but a help. If she were alone she would perhaps succumb; a woman must not be alone in society at a time like the one in which we live, which does not spare the weak but treads them under foot, and drives over a weak woman when she has fallen down'

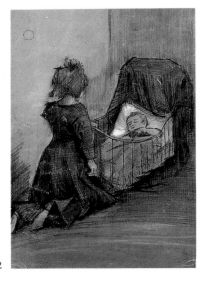

2

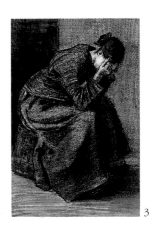

3

1 *Sien with child in her lap,* 1883
Charcoal & pencil, heightened with white & brown, 53.5 x 35 cm
van Gogh Foundation, Amsterdam

2 *Child kneeling in front of the cradle,* 1883
Charcoal, heightened with white, 48 x 32 cm
van Gogh Foundation, Amsterdam

3 *Woman with head in her hands,* 1883
Black chalk, heightened with white,
47.5 x 29.5 cm
Kröller-Müller Foundation, Otterlo

4 *The Great Lady,,* 1882
Graphite & ink, 19 x 10.5 cm
van Gogh Foundation, Amsterdam

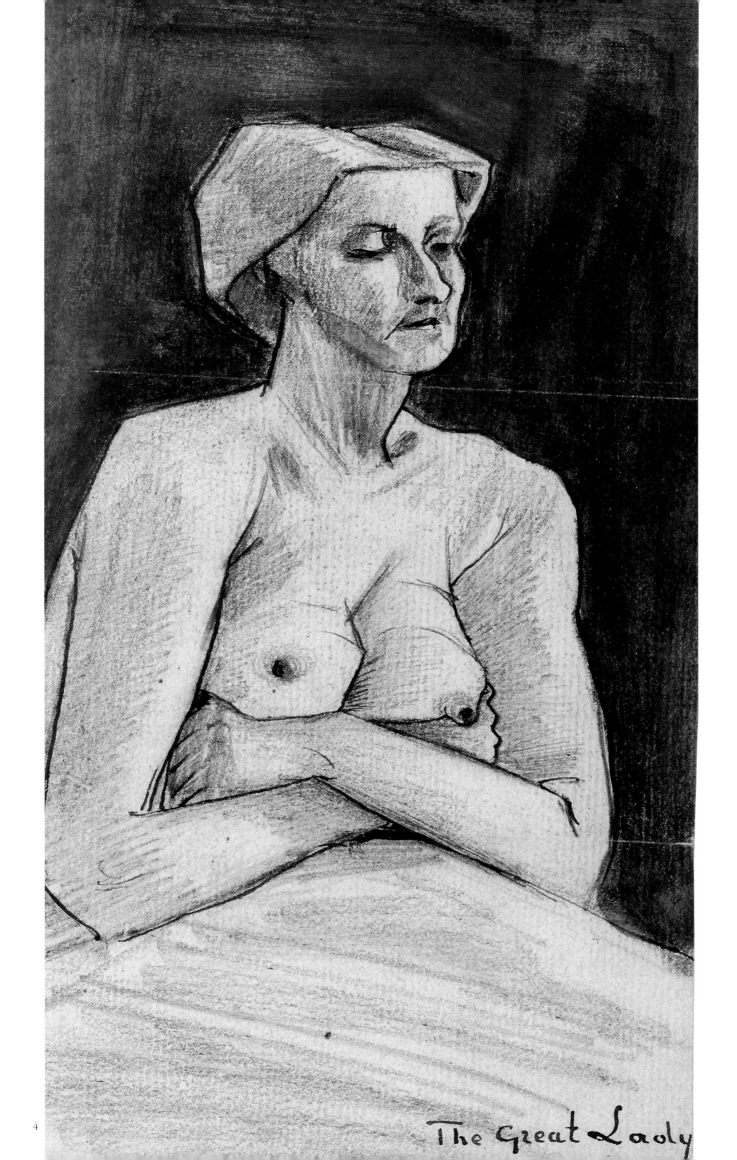

The Great Lady

Nuenen

T he hardships of peasant life in the Drenthe did not rouse Vincent's indignation as they had done in the Borinage. Only a handful of girls of seventeen and under showed the face of youth in the village of Hoogevenn where women 'are very soon faded'. But this did not stop him finding 'Everything is beautiful here.' Vincent sent Theo his drawings, sometimes incorporated into his letters, drawing and text reinforcing each other's power of conviction. 'As I feel a need to speak out frankly, I cannot hide from you that I am overcome by a feeling of great care, depression, a "je ne sais quoi" of discouragement and despair more than I can tell.' Thoughts of Sien haunted him. 'Besides, the fate of the woman and the fate of my poor little chap and the other child, cut me to the heart. I should like to help them still, and I cannot.' Vincent's melancholy disturbed Theo: Vincent could join him in Paris and escape his loneliness. But Vincent did not feel ready: '. . . here on these beautiful moors I have not the least longing for Paris.' Theo, alternatively, could come to Holland; Theo, too, could become a painter: '. . . in order to grow, one must be rooted in the earth. So I tell you, take root in the soil of the Drenthe – you will germinate there. . . . Neither of us would be alone, our work would merge . . .' Letter followed letter, each brother confessing his loneliness to the other, the ties between them strengthening. Trying to persuade Theo to join him, Vincent described the wonders of the world around him. But Theo did not come. Vincent was seized afresh by the need to be with his family. And Christmas was approaching. He went home, to the house in Nuenen where Pa had been living for the past sixteen months. He explained to Theo: 'So for several reasons I made up my mind to go home for a while. . . . Drenthe is splendid, but one's being able to stay there depends upon many things, depends upon whether one is able to stand the loneliness . . . But, lad, it is so difficult for me, it becomes so much a matter of conscience that I should be too great a burden to you, that I should perhaps abuse your friendship when I accept money for an enterprise which perhaps will not pay.' Vincent's welcome at Nuenen was not warm. A tense mutual incomprehension set in between father and son.

'I am sick at heart about the fact that, coming back after two years' absence, the welcome home was in every respect kind and cordial, but at bottom, there is not the least change whatever, in what I must call their blindness to and their total lack of understanding of, the relations between us.'

'The strange effects of
perspective
intrigue me much more
than human intrigues'

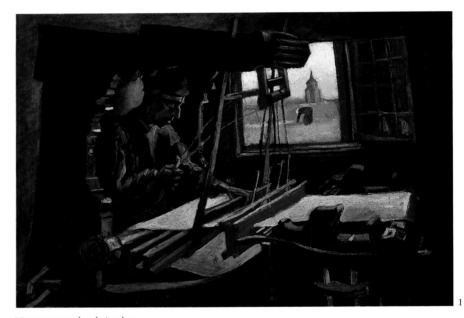

1

Vincent was back in the house in Nuenen. Returning to the land, men, women, objects were the motifs of his drawings: peasants cutting and binding corn in sheaves, weavers at home at their wooden machines. The peasant's harrow replaced the miner's sack

2

1 *Weaver with a view of the Nuenen tower through the window,* 1884
Oil on canvas, 68.5 x 93 cm
van Gogh Foundation, Amsterdam

2 *Peasant woman binding sheaves,* 1885
Black pencil, 43.5 x 54 cm
van Gogh Foundation, Amsterdam

3 *The Harrower,* 1883
Letter, in pen
van Gogh Foundation, Amsterdam

om een half jaar moedeloosheid te veroorzaken
waarna men toch eindelijk ziet dat men niet zich
had moeten laten desorienteeren –
Van twee personen ken ik den zielstrijd tusschen
het ik ben schilder en ik ben geen schilder.
Van Rappard en van mij zelf – een strijd soms bang
een strijd die juist is dat wat het onderscheid is tusschen
ons en zekere anderen die minder serieus het opnemen
voor ons zelf hebben wij het soms beroerd aan 't eind
eener melankolie een beetje licht een beetje vooruitgang
zekere anderen hebben minder strijd ~~och ten~~ werken
misschien makkelijker doch het ~~niet~~ persoonlijk
karakter ontwikkelt zich ook minder. Gij ~~zoudt~~ ook
dien strijd hebben en ik zeg weet van uw zelf dat gij
het gevaar om door lui die zonder twijfel magere beste
intenties hebben van streek te worden gebragt –
Als als en u zelf zegt u gij zijt geen schilder – schilder
dan juist Kerel en die stem bedoart ook maar
slechts daardoor – want als hy dat voelt gaat naar
vrienden en zijn nood klaagt verliest iets van
zijn mannelijkheid iets van het beste wat in hem is –
Uw vrienden kunnen slechts zijn dezulken die
zelf daartegen vechten door eigen voorbeeld van
actie ~~het~~ hy actie in u opwekken –

Resolved to leave Nuenen, Vincent had a final conversation with Pa. He would remain at the presbytery and be given a hut for a studio. He went to The Hague to fetch his canvases and drawings and returned full of remorse: he had seen Sien and her children. She had been ill when he had taken her in, she had almost regained her strength by the time he left her. But after he had abandoned her, she had relapsed. The child, whom he considered his own, was failing in health by the day. He felt crushed and reproached Theo for having urged him to abandon Sien, while recognising that Theo had wished to act only in his best interests. Family tensions were at breaking-point, when an accident occurred. Moe, getting off a train, fell and broke her femur. Vincent watched by her bedside. To distract his mother, he did little paintings of the presbytery. A young neighbour, Margot Begemann, came to relieve his vigil. Vincent went to paint in the weavers' houses, in the fields. Sometimes Margot accompanied him on his long walks and visited his studio in the evenings to see his paintings. Neither beautiful nor plain, she was appealing. Their friendship developed into something deeper. But their families

'To draw a peasant's figure in action, I repeat that's an essentially modern figure, the very heart of modern art, what neither the Greeks nor the Renaissance nor the old Dutch school have done'

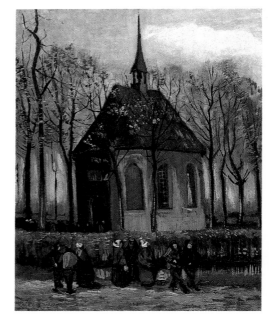

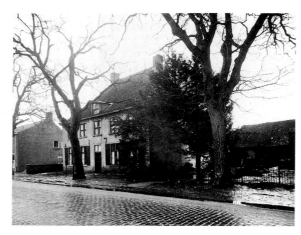

1/2
The little church in Nuenen and the presbytery where Pa preached were the subjects Vincent used to distract his mother who was immobilised by a fracture

immediately opposed any idea of marriage. Vincent wrote to Theo: 'Both she and I have sorrow enough, and worries enough, but neither of us feels regret. Look here, I certainly believe, or know for sure, that she loves me. I certainly believe, or know for sure, that I love her, that feeling has been sincere.' Margot tried to poison herself, but the doctor saved her. On 26 March 1885, on the threshold of his house, Pastor Theodorus van Gogh died suddenly of apoplexy. Gossip was rife. The people of Nuenen accused Vincent of killing his father by the constant anxiety his presence in the presbytery had caused him. Vincent, throwing himself into his work more feverishly than ever, conceived the idea of a painting of several figures lit only by the pale glow of a little lamp: 'I am working again at those peasants around the dish of potatoes.'

A young neighbour, Margot Begemann, followed Vincent's work with sympathetic interest. Their idyll was opposed by their families; Margot tried to commit suicide

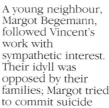

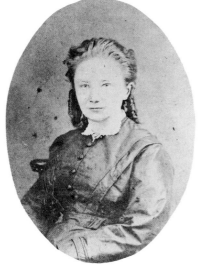

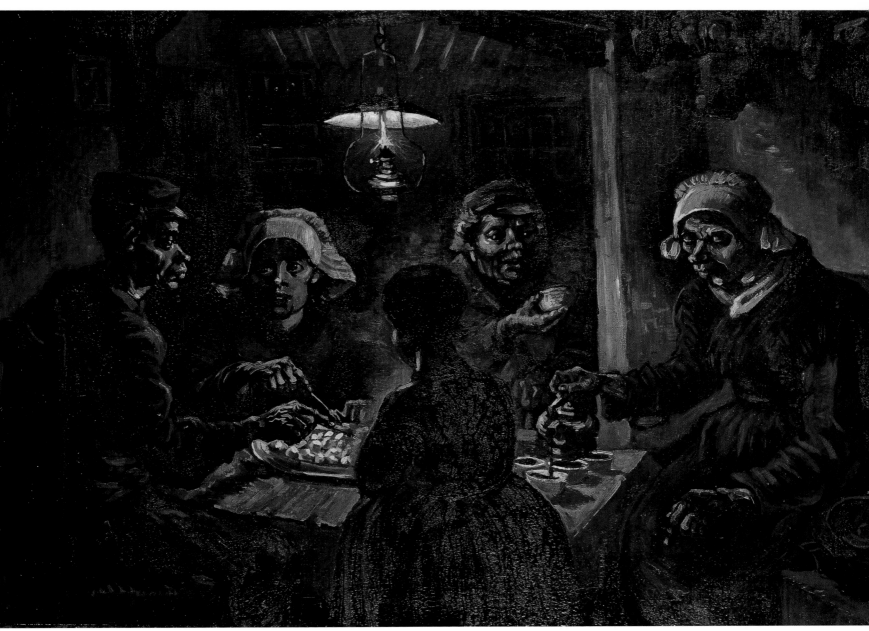

3
Vincent had a great project:
The Potato Eaters. The little
lamp in the hut he used as a
studio provided the inspiration
for a composition in which the
figures were illuminated by a
pale glow. His friend, the
painter van Rappard, did not
care for this canvas, which he
thought badly composed; this
marked the end of a long
friendship

'A picture I have felt and lived'

1 *The Little Church at Nuenen*, 1884
Oil on canvas, 41 x 32 cm
van Gogh Foundation, Amsterdam

2 *The Presbytery at Nuenen*, 1885
Oil on canvas, 33 x 43 cm
van Gogh Foundation, Amsterdam

3 *The Potato Eaters*, 1885
Oil on canvas, 82 x 114 cm
van Gogh Foundation, Amsterdam

Shortly after Pa's death, he produced a strange picture: on the canvas, his father's Bible and, in front of it, a modern book, *La Joie de Vivre* by Zola. The works of Zola, like those of Maupassant, had occasioned dispute between Pa and Vincent. In this composition, Vincent was asserting his independence, his own personality, but linking them to the memory of his father, hence the Bible, which he had himself so extensively read, as a symbol of the everlasting. He wrote to Theo: 'I send you a still-life of an open – so a broken white – Bible bound in leather, against a black background, with yellow-brown foreground, with a touch of citron yellow. I painted that in one rush, in one day. This is to show you that when I say that I have perhaps not plodded quite in vain, I dare say this, because at present it comes quite easily to me to paint a given subject unhesitatingly, whatever its form or colour may be.' Meanwhile Vincent could not remain unaware that nobody in Nuenen felt any respect for him. Margot's failed suicide, Pa's death, tittle-tattle about a girl who gave birth to a bastard alleged to be his, drove him to leave: 'I am simply longing for it . . . it seems to me like a return from exile.' It was for some time that he had entertained the idea of going to Antwerp. He arrived there in November 1885, found a room with a house painter in rue des Images. 'My studio is not bad, especially as I have pinned on the wall a lot of delightful little Japanese pictures. . . . I feel safe now that I have a little den, where I can sit and work when the weather is bad.' He visited museums and discovered Rubens. The frenzy with which he worked wore him out. 'I am literally worn out and overworked, . . . not having money for a dinner, because the work costs me too much, and I have trusted too much on my being strong enough to hold out.' Falling ill, he consulted a doctor, and reported to Theo: '. . . if I neglected myself too much, it would be the same with me as with so many painters . . . I should catch my death, or worse still – become crazy or an idiot.' Nonetheless he enrolled at the Ecole des Beaux-Arts, rejected the criticisms of the director, fell ill again with exhaustion. In March 1886, at the age of thirty-three, he left his country for ever. Theo awaited him in Paris.

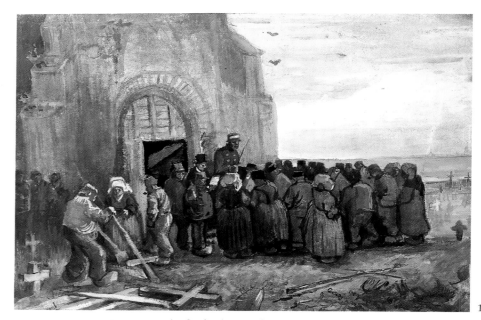

Vincent paid a final tribute to his native land in this painting of the demolition of the little church. His friend Kerssemakers one day noticed some ten studies of churches in Vincent's studio. Van Rappard must have remembered this incident after Vincent's death: 'What a fine study he has made of this old tower in the cemetery'

1 *Demolition of a church*, 1885
Watercolour, 35.5 x 55 cm
van Gogh Foundation, Amsterdam

2 *Rear view of old houses*, 1885
Oil on canvas, 44 x 33.5 cm
van Gogh Foundation, Amsterdam

*'I have read too many books
not to continue the habit:
I want to keep abreast
of modern literature'*

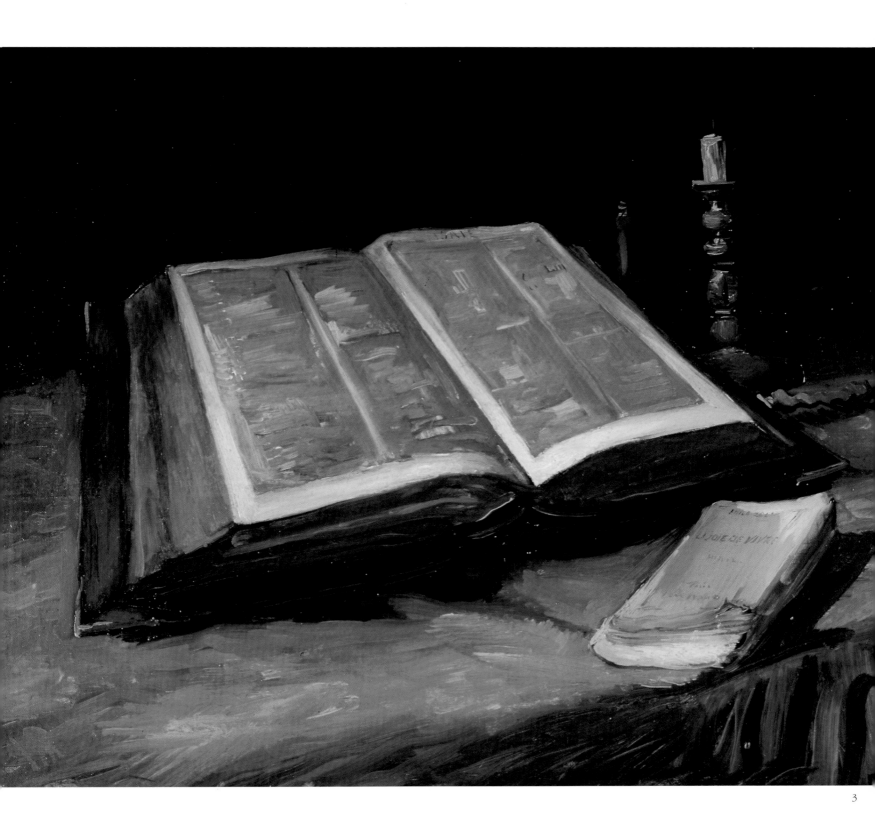

3

3 *Still life with Bible,* 1885
Oil on canvas, 65 x 85 cm
van Gogh Foundation, Amsterdam

Following pages:
The Quay, 1885
Oil on panel, 20.5 x 27 cm
van Gogh Foundation, Amsterdam

Vincent came to Paris from Antwerp in 1886. He moved into his brother's little apartment in rue Laval. Theo, who was working at Goupil, acted as his guide in the capital. He introduced him to all his painter friends: they were in a state of upheaval. While Puvis de Chavannes triumphed at the official Salon, the Impressionists assembled their eighth and final exhibition. In the maturity of their movement, differences were emerging. New movements were stirring passions and breaking away: Divisionism, Pointillism, which was practised by Seurat and Signac and entailed covering the canvas with numberless tiny strokes of primary colours, which the eyes of the viewer would recompose in all their luminosity. The prominent dealer, Durand-Ruel, indirectly hit by a financial crash, returned from the United States where he had begun to find a market for the Impressionists. He saw Monet and Renoir exhibited in the galerie Georges Petit. Le Douanier Rousseau featured, for the first time, in the Salon des Indépendants.

This artistic, effervescent Paris was not at all what Vincent had expected to find after his ten-year absence. For him, French painting, viewed from Antwerp, stopped at the masters of the Barbizon school: Delacroix and Millet. He had considered himself of sufficient stature to take on Paris, only to find he had everything to learn. He signed up for classes in Cormon's studio, where Emile Bernard, who became his friend, found him working in a frenzy 'wearing holes in his paper, so harshly did he rub it with his eraser'. Vincent was in the grip of a passion for work. In the two years spent with his brother, he experimented with all the techniques of the Impressionists, the Pointillists, alternately agreeing with and objecting to them; he exchanged ideas, he rejected them. When he first arrived from Antwerp, his paintings were dark: he discovered colour, lightness. He knew Toulouse-Lautrec, Anquetin, and the Australian painter John Russell. Theo found a larger apartment for himself and his brother at 54 rue Lepic, where Vincent had a little studio. From there, he explored the hill of Montmartre, beloved of painters. The dealer, Portier, a neighbour, accepted a few paintings on deposit and these were seen and admired by Guillaumin. The two men met and Vincent's new friend took him to his studio on the quai d'Anjou, which had been Daubigny's.

'Don't be cross with me for having come directly, I have thought so much about it and I think this way we will save time. I'll be at the Louvre from noon or earlier if you wish. RSVP to let me know what time you can come to the Salle Carrée'

1/2
As soon as he arrived in Paris, Vincent went to the Louvre. He wanted to see Delacroix's works, particularly *Pietà*, an engraving of which he later copied in his cell in the asylum near Saint-Rémy

1

2

3

1 *Pietà*, Eugène Delacroix
Oil on canvas, 29.5 x 42.5 cm
Musée du Louvre, Paris

2 *Pietà*, after Delacroix, 1889
Oil on canvas, 73 x 60.5 cm
van Gogh Foundation, Amsterdam

Paris

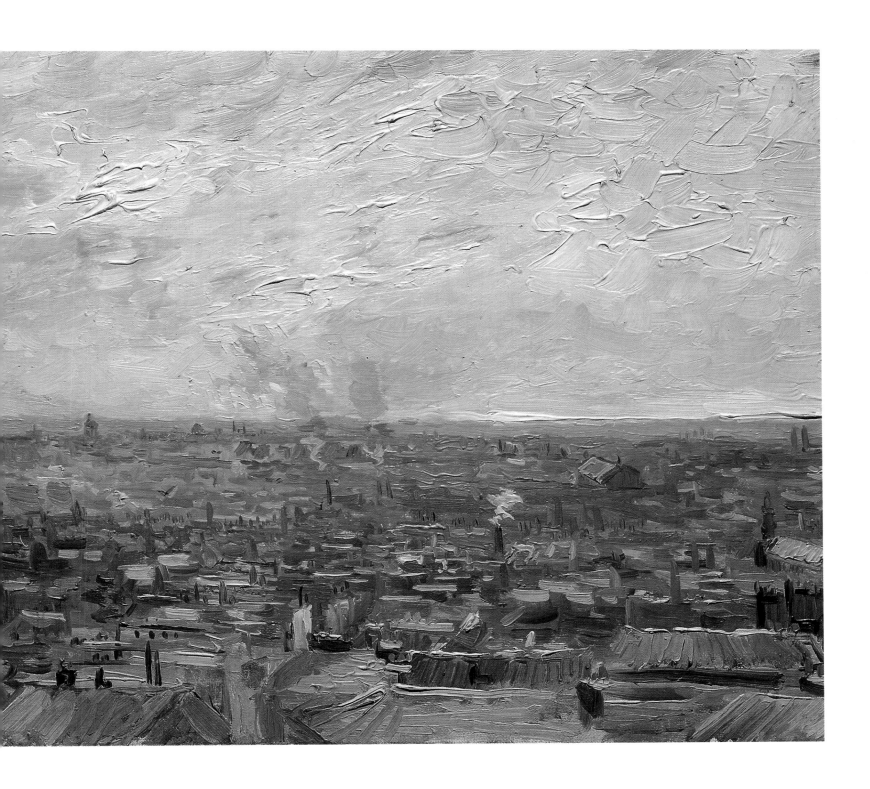

3
From the heights of Montmartre,
Vincent painted this panoramic
view of Paris. The Moulin de la
Galette belongs already to the
past; factory chimneys spew
smoke over an industrial city. For
all its apparent simplicity, this
work is one of the most
accomplished of van Gogh's
Parisian period

3 *View of Paris seen from Montmartre*,
1886
Oil on canvas, 38.5 x 61.5 cm
Kunstmuseum, Basle

The mills of Montmartre could not fail to remind Vincent of those of his native Holland. There, the infinite plains, low-lying clouds for a horizon, here three mills still in use, perched on the hill and surrounded by wretched shacks. Vincent favoured the 'Blute-fin', the moulin Le Radet, better known under the name Moulin de la Galette, on account of its speciality. The famous 'galette' was indeed sold here, and also good wine. Van Gogh portrayed it from the outside, like a sight seen by a foreign traveller. A little distance away was the café painted ten years earlier, in 1876, by Renoir, luminous in its flashes of colour and the *joie de vivre* of the workers and apprentices in their Sunday best. Vincent's café was a

Signac in about 1886

'I don't know what impression Paris will make on you. The first time I saw it, I was conscious above all of its sadnesses. . . . And this stayed with me a long time'

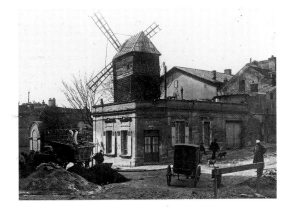

popular drinking spot in a district of Paris. On the wooden benches ordinary people tried to cheer themselves up and drown their sorrows in love and wine.

V an Gogh knew what poverty meant. His portrayal of the café is sad, in the sombre tones of his Antwerp period. Yet, in the background, one catches sight of the dancing-room where Toulouse-Lautrec set his louche figures dancing; and, of particular note, in the foreground, a couple are portrayed in complementary colours: green and red. The study of the colour scale which Vincent had pursued in Antwerp is in evidence. Van Gogh's transformation was just beginning. The shrewd discernment of Pissarro, the eldest and the master of the Impressionists, was being proved. He had given support to Gauguin and Seurat, and had encouraged Cézanne. Now that the Impressionist group was breaking up and he had seen *The Potato Eaters,* he was the first to recognise that van Gogh would surpass them all; van Gogh, whose work Cézanne described as 'the painting of a madman'.

1/2/3
Van Gogh set up his easel in the everyday spots of Paris, the Moulin de la Galette (2) and the neighbouring cafés (3). The artistic currents that were whirling round the city had not yet influenced his work: his palette was dull, as his vision was sad. Two years earlier Signac had painted the mill (1) in a similar range of colour, mingling Naturalism and Impressionism. The careful composition of the painting, the use of complementary colours, suggest that he had already met Seurat who was to lead him to Pointillism

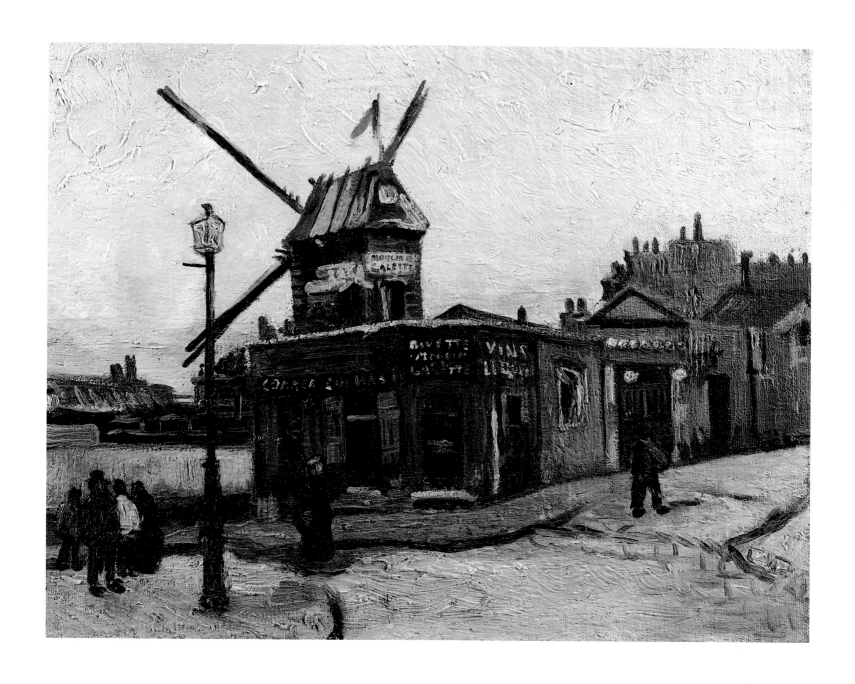

1 *Rue Caulaincourt, moulins
à Montmartre,* 1884, Signac
Oil on canvas, 55 x 27 cm
Musée Carnavalet, Paris

2 *Le Moulin de la Galette,* 1886
Oil on canvas, 38.5 x 46 cm
Kröller-Müller Foundation, Otterlo

3 *La Guinguette,* 1886
Oil on canvas, 49.8 x 64 cm
Musée d'Orsay, Paris

51

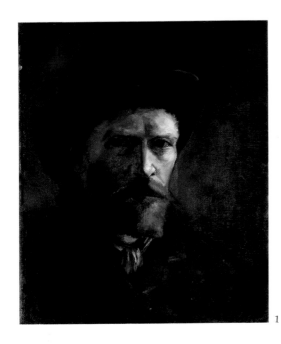

'I have to unlearn some things picked up in the days when I served my apprenticeship alone'

'I am thirty, my forehead is marked with wrinkles, the lines on my face are those of a forty-year-old, my hands are furrowed'

The first self-portrait painted by van Gogh on his arrival in Paris, in the manner of the Dutch masters, observed the conventions and the fashion.... Van Gogh, serious, a hat on his head, is portrayed here in the role of modern painter. In the space of four years, he painted nearly forty self-portraits. His face was a freely available model and readily lent itself to his pictorial researches: the Impressionist manner, too kindly for his impassioned temperament, and the Pointillism which tried his patience, were things he assimilated while developing his own technique. He painted with the sharpness of a naturalist observing his own emergence as a painter. Turned towards himself, he interrogated the mirror in front of him, portrayed his face but searched out the soul in the eyes. One of his last self-portraits in Saint-Rémy concentrated entirely on the face, the blue jacket merging into the blue background of the picture. He gave importance only to the eyes, which interrogated him as he interrogated himself, like an echo, in a letter to Emile Bernard: 'I would like too to have an approximate idea of what I am myself the larva.'

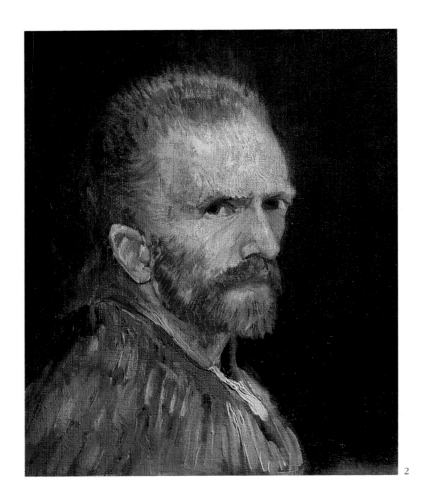

1 *Self-portrait*, 1886
Oil on canvas, 41 x 32.5 cm
van Gogh Foundation, Amsterdam

2 *Self-portrait*, 1886
Oil on canvas, 41 x 33.5 cm
Wadsworth Atheneum, Hartford

3 *Self-portrait*, 1886
Oil on canvas, 42 x 33.7 cm
Art Institute, Chicago

4 *Self-portrait*, 1886
Oil on canvas, 47 x 35 cm
Musée du Louvre, Paris

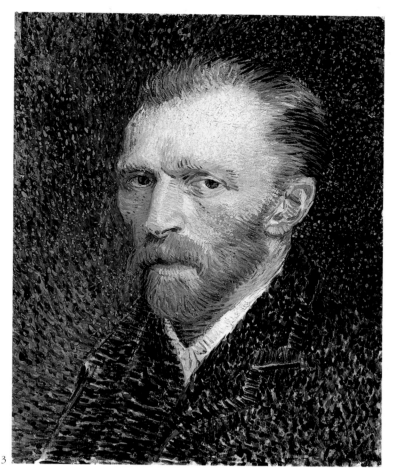

'I will always use my eyes to see, and I will always work by my own methods'

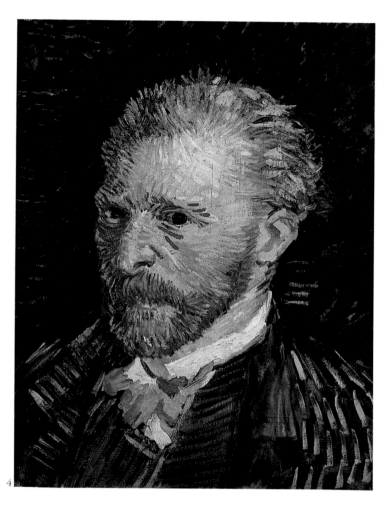

'I know for sure that I have a sense of colour and that this develops more and more, just as I have painting in the blood'

5 *Self-portrait*, 1889
Oil on canvas, 65 x 54 cm
Musée d'Orsay, Paris

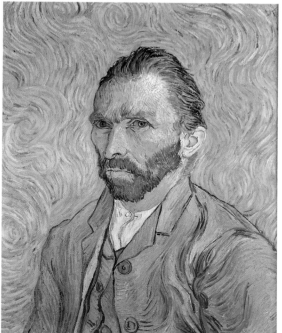

'Let me go quietly on with my work; if it is that of a madman, well, so much the worse – I can't help it'

Julien-François Tanguy, known as Père Tanguy, was an historic figure in the artistic circles of late-nineteenth-century Paris. Having married a 'charcutière' (a female pork butcher), he settled in Paris and in 1865 became colour grinder for Edouard, who sold paints in rue Clauzel. In 1867, he left Edouard's successor and set up independently in the same street. He was a travelling salesman and took himself to Barbizon and Argenteuil, seeking business in the artistic community. Not unnaturally, he ended up by exhibiting his customers' paintings in his front shop. A communard, who had been imprisoned in the camp at Satory and deported to Brest, he returned to Paris and his friends: Dr Gachet, Pissarro, Guillaumin, Cézanne, Gauguin, Monet and Renoir. 'A man who lives on more than fifty centimes a day is a rogue,' he declared; but he did not meet many rogues among the artists to whom he often gave credit, when he did not invite them to his own table. His reputation as an honest man and the quality of the works to be seen in his shop drew the young generation of artists to rue Clauzel.

In two of his three portraits of Père Tanguy, van Gogh could not resist paying tribute to the Japanese art that so fascinated the artistic circles of Paris. Vincent and Theo collected Japanese prints. Toyokuni, Sharaku, Kiyonaga Shunshô and the two most famous, Hiroshige and Hokusaï, became artistic beacons. Vincent meanwhile developed a personalised image of Japan which permeated his pictures. Behind the luminosity of the colours, the calm, the harmony, he sensed in the crépons an inner turmoil that corresponded to his own.

Vincent used colour without conforming to the rules of optical mixture propounded by Chevreuil and Blanc. He applied his own interpretation of Japanese art. Turning his back on the French theoreticians, he developed his own techniques as a colourist. Thus, by the use of colours that were almost pure and the fragmentation of the canvas, van Gogh touched on the Cloisonnism that became so dear to Gauguin. In this personal image of Japan, Père Tanguy becomes a form of Buddha, or perhaps a sage, whose perspicacity and kindness towards artists made him one of the most singular personalities on the hill of Montmartre.

3
Van Gogh painted Père Tanguy against a background of Japanese prints. One of them features the courtesan Kunisada who appeared on the May 1886 cover of the paper *Paris-Illustré*

'I envy the Japanese the extreme clearness which everything has in their work. It is never tedious, and never seems to be done too hurriedly. Their work is as simple as breathing, and they do a figure in a few sure strokes with the same ease as if it were as simple as buttoning your coat'

1 *Kunichika,* Oiran
Explorer Archives

2 *Geisha,* Toyokuni, 1850
Explorer Archives

3 *Portrait of Père Tanguy,* 1887
Oil on canvas, 92 x 73 cm
Musée Rodin, Paris

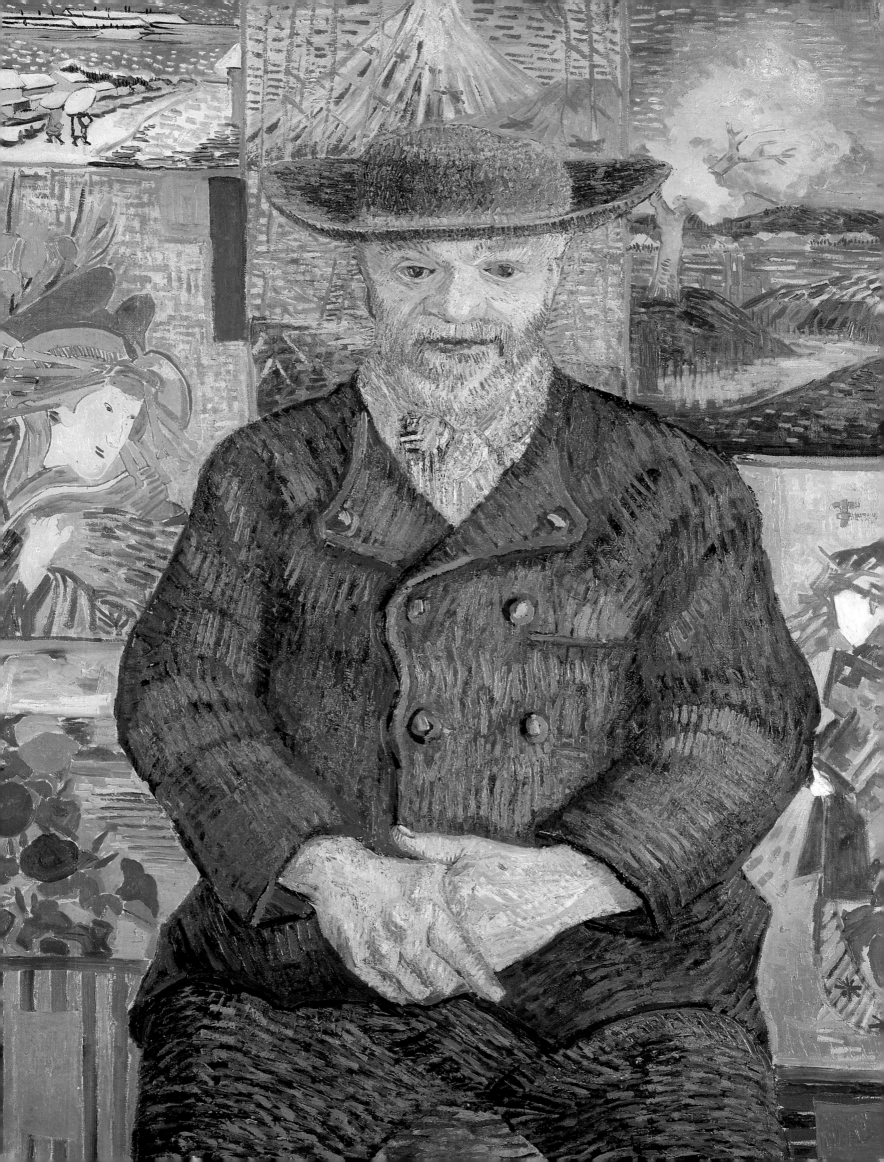

It was at Père Tanguy's that Vincent met
the young Emile Bernard, at the time some
twenty years old. He had complimented
him on his work and, as a pledge of their
newfound friendship, they had exchanged
canvases in the Japanese tradition. A large
blank canvas on his back, his box of paints
under his arm, Vincent went to join his
friend in Asnières, where the latter had built
a studio in the garden of his parents' house,
a short distance from the Ile de la Grande

Jatte where Seurat had painted one of the
most beautiful pictures in the history of art.
At Bernard's side, he painted as an Impres-
sionist. Having tried Pointillism, Bernard
now worked by laying on to the canvas even
portions of almost pure colour. He divided
his canvas up according to the colours
applied, thus anticipating the Cloisonnism
Gauguin came to favour; Gauguin, the
master of Pont-Aven, whom he was to join
after a final quarrel with his parents. Mean-
while Vincent had to give up his visits to his
friend in Asnières: as the rows between
Bernard and his father became more vio-
lent. Emile Bernard nonetheless cherished
a precise recollection of the time he had
spent with Vincent: 'Van Gogh, dressed in a
bright blue overall, had little dots of colour
painted on his sleeves. Sticking close by my
side, he cried, gesticulated, brandished his
large clean canvas and spattered himself
and passers-by with colour. In the evening,
when he set off back to Paris, he crossed the
bridge of Asnières, his canvas covered in
colour, resembling a little peripatetic
museum.'

A battered pair of shoes seemed a strange subject to the other painters in the Cormon studio. They cannot be explained, unless one sees them as a form of self-portrait, or rather an uncompromising representation of the painter's state of mind. These shoes mirror their owner's image. They reflect the two-sided temperament of van Gogh. One is prematurely aged, the other stands proud in its weary desolation. In his essay 'L'Origine de l'art', Heidegger attempted to show that 'in the dark intimacy of the creases of the shoe is inscribed the weariness of the steps of labour'. According to François Gauzi, a friend of Toulouse-Lautrec, who also frequented the Cormon studio, Vincent had bought this pair of shoes new and polished in the flea market. But Vincent looked at men, women or objects in a context of hardship: he painted his shoes only after they had suffered much tramping across Montmartre, down the streets of the suburbs, in all weathers. In this way the objects of daily life became for Vincent subjects of interest. To paint hobnailed boots was for him a communion with the toil of the labourer or peasant: weavers, underground mineworkers, sowers. In this period, he painted no portraits of his new

'I have been in Cormon's studio for three or four months but I did not find it as useful as I had expected it to be'

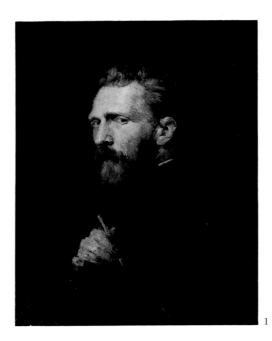

1
John Russell painted his friend in a manner that recalls the great Dutch masters. Vincent's face emerges from the darkness, his sharp gaze fixed on the viewer, his hand gripping the paintbrush. Toulouse-Lautrec, in contrast, chose pastel (3), a modern technique allowing him rapidly to execute his drawing by means of hatchings of vivid colours. Lucien Pissarro, quicker still, almost furtively, did a pencil sketch of Vincent in conversation with an unknown man (2)

2

friends. He never did Theo's. Instead, reversing roles, he posed for others, in the first place for John Russell. This young Australian had travelled to Europe to study engineering. He came to Paris to learn painting, and met Vincent at Cormon's studio. They shared an admiration for Millet and Puvis de Chavannes. Vincent spent hours in John Russell's studio or in his house. He introduced him to Japanese prints. These prints led to the meeting of Vincent and Lucien Pissarro, the son of Camille, to their friendship and exchange of pictures in the tradition of Japanese artists.

3

Preceding pages:
1 *Bridge at Asnières,* photograph
Collection Roger-Viollet, Paris

2 *Les Chiffoniers: Ponts de fer d'Asnières,*
1887, Emile Bernard
Oil on canvas, 45.9 x 54.2 cm
Museum of Modern Art, New York

3 *Bridges at Asnières,* 1887
Oil on canvas, 52 x 65 cm
Bührle Foundation, Zurich

1 *Portrait of Vincent van Gogh,* 1886,
John Russell
Oil on canvas, 60 x 45 cm
van Gogh Foundation, Amsterdam

2 *Vincent in conversation,* 1887,
Lucien Pissarro
Black chalk on paper, 19.6 x 29.2 cm
Ashmolean Museum, Oxford

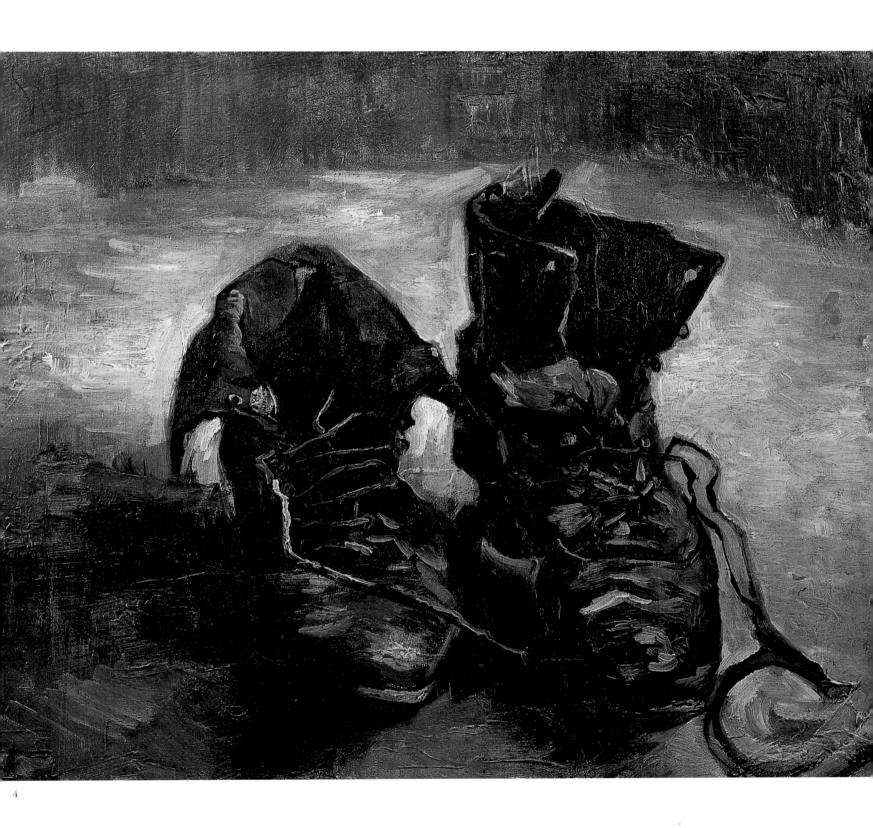

4

3 *Portrait of Vincent van Gogh,* 1887,
Toulouse-Lautrec
Pastel on pasteboard, 57 x 46.5 cm
van Gogh Foundation, Amsterdam

4 *A Pair of Shoes,* 1886
Oil on canvas, 38 x 46 cm
van Gogh Foundation, Amsterdam

From his window in rue Lepic, Vincent looked out over the rooftops of Paris. He portrayed for us what he saw; but from henceforward he was alone in front of his canvas. Haunted by his presentiment of the brevity of life, he felt driven to realise his object: to be Vincent. 'I have been in Cormon's studio for three or four months but I did not find it as useful as I had expected it to be.... I left there, too, as I left Antwerp and since then I have worked alone, and fancy that since then I feel more my own self,' he wrote to his friend, the painter Levens, who had remained at Antwerp. Renoir said that if he painted roses, it was to capture the perfect tone and texture of feminine skin. Vincent received flowers from his friends nearly every day and worked from them. 'I have made a series of colour studies in painting, simply flowers, red poppies, blue cornflowers and myosotis, white and rose roses, yellow chrysanthemums – seeking oppositions of blue with orange, red and green, yellow and violet seeking les tons rompus et neutres to harmonise brutal extremes. Trying to render intense colour and not a grey harmony.... So as we said at the time: *in colour seeking life* the true drawing is modelling with colour.'

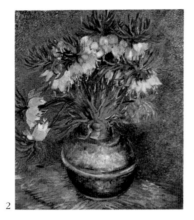

The same year, 1887, as Maximilien Luce (1) Vincent painted the rooftops of Paris from his window (4). He made use of complementary colours, blue and orange, red and green, as also in his still lifes: his fritillaries (2), for example, or *Still life: plaster statuette and books* (3), which shows his enthusiasm for Maupassant's *Bel Ami*

By the end of 1887, Vincent had mastered the use of colour. One of his last Paris canvases, *Still life: plaster statuette and books,* was a tribute to the city which he already knew he was to abandon for the Midi. All techniques are used in this canvas, which bring together the academicism studied at the Cormon studio, flowers given by his friends, and books representing his beloved French literature, which he had not neglected during his Paris sojourn. Michelet he had already come to know in his youth. This time, he had read the new naturalists: 'When one wants to see the truth, to see life as it is, one finds in *Germinie Lacerteux,* in *La Fille Elisa,* in Zola's *La Joie de Vivre* and *L'Assommoir,* in other masterpieces that portray life as we ourselves experience it, one finds, I say, that they satisfy our need to be told the truth. The work of the French naturalists, Zola, Flaubert, Guy de Maupassant, Goncourt, Richepin, Daudet, Huysmans, is magnificent.'

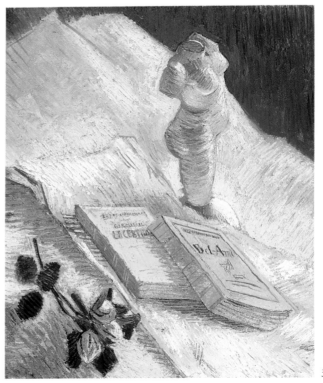

1 *Landscape seen from Montmartre,* 1887, Maximilien Luce
Oil on canvas, 54 x 65 cm
Musée du Petit Palais, Geneva

2 *Fritillaries in a copper vase,* 1887
Oil on canvas, 73.5 x 60.5 cm
Musée d'Orsay, Paris

3 *Still life: plaster statuette and books,* 1887
Oil on canvas, 55 x 46.5 cm
Kröller-Müller Foundation, Otterlo

4 *View from Vincent's window in rue Lepic,* 1887
Oil on canvas, 46 x 58 cm
van Gogh Foundation, Amsterdam

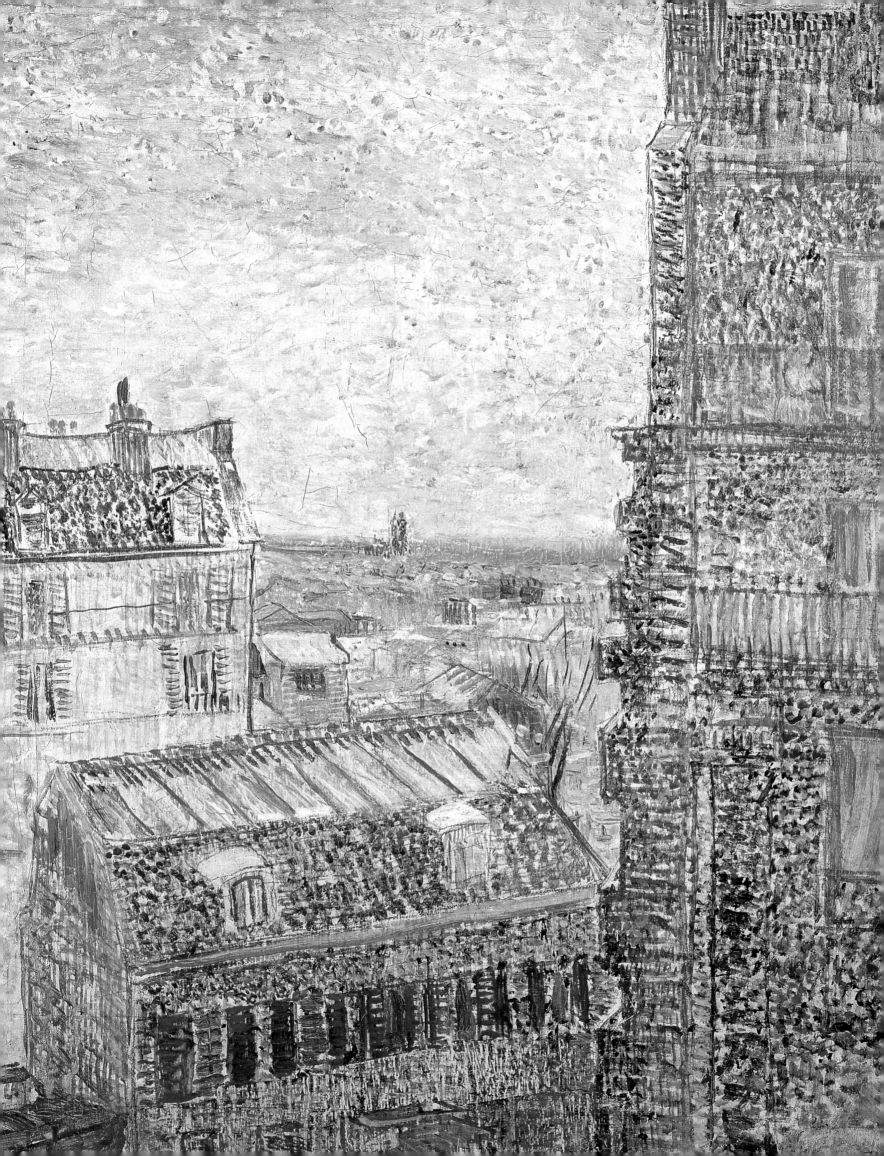

Henri de Toulouse-Lautrec, descendant of one of the oldest and most illustrious families of France, met Vincent at the Cormon studio in 1886. He already formed part of a group gathered around Anquetin, Emile Bernard and Gauzi. Always on the look-out for novelty, frequenting the Louvre as much as the cabarets of Montmartre, notably Aristide Bruant's Le Mirliton, Toulouse-Lautrec could not but succumb to the strange charm of this uncouth Dutchman. Like him, he consorted with the ordinary people of Paris. Toulouse-Lautrec must have fascinated Vincent in return. He was lively, affectionate, arrogant, and surveyed his entourage with an eye that was curious, critical and without illusions. Vincent, passionate in his ideals, was gloomy, tending to self-effacement and reflection. He had faith in human nature. Toulouse-Lautrec presented to the world an egoistic façade.

Nonetheless, recognising each other's sincerity, they became friends. Both had left the Cormon studio, but they met with pleasure in the studios of their friends. Vincent took Toulouse-Lautrec to the café du Tambourin where the latter painted his portrait, a portrait true to Vincent's own spirit, in pastel, executed with quick, colourful, emphatic strokes. Suzanne Valadon, with whom Toulouse-Lautrec had an affair, probably posed for Vincent. She later recalled the visits that Vincent had paid to Toulouse-Lautrec in his studio on the corner of rue Tourlaque and rue Caulaincourt: 'He came to our weekly meetings at Toulouse-Lautrec's. He arrived carrying a heavy canvas under his arm, set it down in a corner, but right in the light, and waited for someone to pay it some attention. Nobody remarked on it. He sat himself opposite, watching people's gaze, joining little in the conversation , then, growing tired, he left, taking his canvas. But the following week he returned and repeated the same performance.' Vincent admired Toulouse-Lautrec's talent in rendering the degradation and poverty of the good-time girls of Paris. *Poudre-de-Riz,* which he doubtless admired in Toulouse-Lautrec's studio, impressed him and inspired his own painting, *La Femme au tambourin.* Toulouse-Lautrec's picture had been bought by Theo as early as 1888 and Vincent, then living in Arles, sent him a painting of a gardener, with the suggestion that it hang beside his brother's painting by Toulouse-Lautrec.

'I am now trying to do portraits'

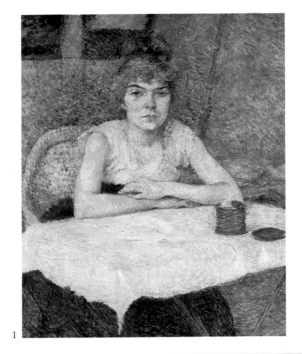

1/2
Toulouse-Lautrec loved to frequent cafés and music-halls, to paint the tired beauty of the women he found there. Suzanne Valadon posed for this portrait, close to Pointillism in its technique. Bought by Theo, the picture (1) appeared in the exhibition of Les XX at Brussels in 1888. Vincent had admired it in Toulouse-Lautrec's studio and it inspired his own portrait of Agostina Segatori in her cabaret, elbows on one of the tables that gave her establishment the name Tambourin (2)

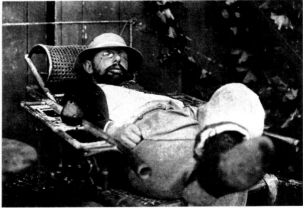

Toulouse-Lautrec in about 1887

1 *Poudre-de-Riz,* 1887, Toulouse-Lautrec
Oil on pasteboard, 65 x 58 cm
van Gogh Foundation, Amsterdam

2 *Agostina Segatori in the café du Tambourin,* 1887
Oil on canvas, 55.4 x 46.5 cm
van Gogh Foundation, Amsterdam

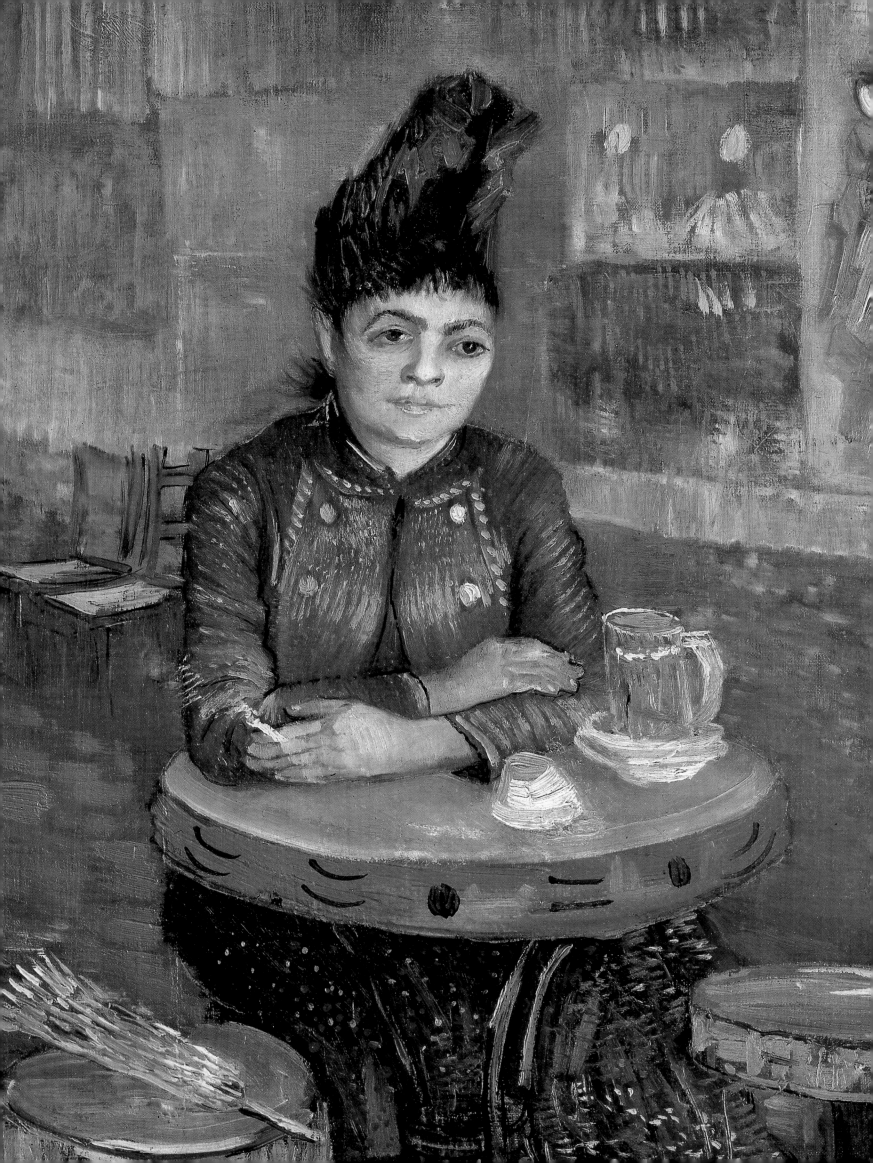

Confined to the apartment in rue Lepic in the winter months, Vincent made life difficult for his brother. Theo complained to his sister Wilhelmina: 'Life at home is almost unbearable, no one wants to come to see me any more because it always ends up in arguments. On top of that, he is so untidy that our apartment is far from attractive. I wish he would leave and live alone.... One would say that there are two men in him, one admirably gifted, charming and gentle, the other egoistic and ruthless. They appear turn by turn, so one hears him reasoning now like the one, now like the other, with arguments equally for and against. It is a pity that he is his own worst enemy ...' Vincent could not remain unaware of the tension between the two of them. As soon as spring arrived, he went elsewhere to paint, often going to Asnières to join Emile Bernard, and also Signac whose mother lived there. An admirer first of Monet, Signac painted the banks of the Seine in a wholly Impressionist manner. But his meeting in 1884 with Seurat was decisive. Signac's Neo-Impressionism became apparent in 1887. He associated at this point with Vincent and sought to make him an adherent of the new movement. At midday the young artists gathered round the lunch table and discussed theory, perhaps at the restaurant La Sirène, the former Hôtel de la Marine, where oarsmen and passers-by had sought relaxation from 1860 onwards.

Emile Bernard in about 1887

1/2/3
Signac, like a musician, classified his canvases under the generic title *Opus*. Vincent used to meet him on the banks of the Seine: here, *Quai de Clichy* (1). In Asnières, not far away, and close to his friends Signac and Emile Bernard, Vincent won fame for his mastery of the Impressionist manner as seen in *Interior of a Restaurant* (2) and *Restaurant de la Sirène at Asnières* (3). But his use of white, predominantly to emphasise the blue hatchings, shows that he is already striving to find his own personal style

'... painting never pays back what it costs'

Vincent, initially subject to every influence, was now working in the manner of Signac and experimenting with Pointillism. But his passionate temperament found it hard to master this stroke. It was not unusual to find him combining two techniques on the same canvas. He applied his dots of complementary colours only to render the atmosphere of a place, to give substance to open space. Objects were painted in a realistic manner. Vincent went through a period of concentrated research and this combination of several techniques on a simple canvas gives his Parisian work an indisputable charm, displaying considerable mastery.

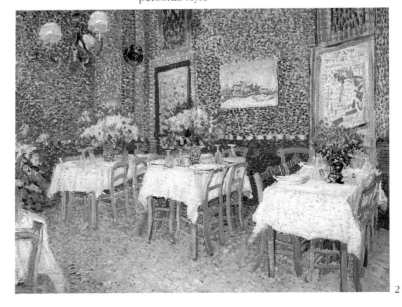

1 *Quai de Clichy,* opus 157, 1887, Paul Signac
Oil on canvas, 46 x 65 cm
Baltimore Museum of Art, gift of F. H. Gottlieb

2 *Interior of a restaurant,* 1887
Oil on canvas, 45.5 x 56.5 cm
Kröller-Müller Foundation, Otterlo

3 *Restaurant de la Sirène at Asnières,* 1887
Oil on canvas, 54 x 65 cm
Musée d'Orsay, Paris

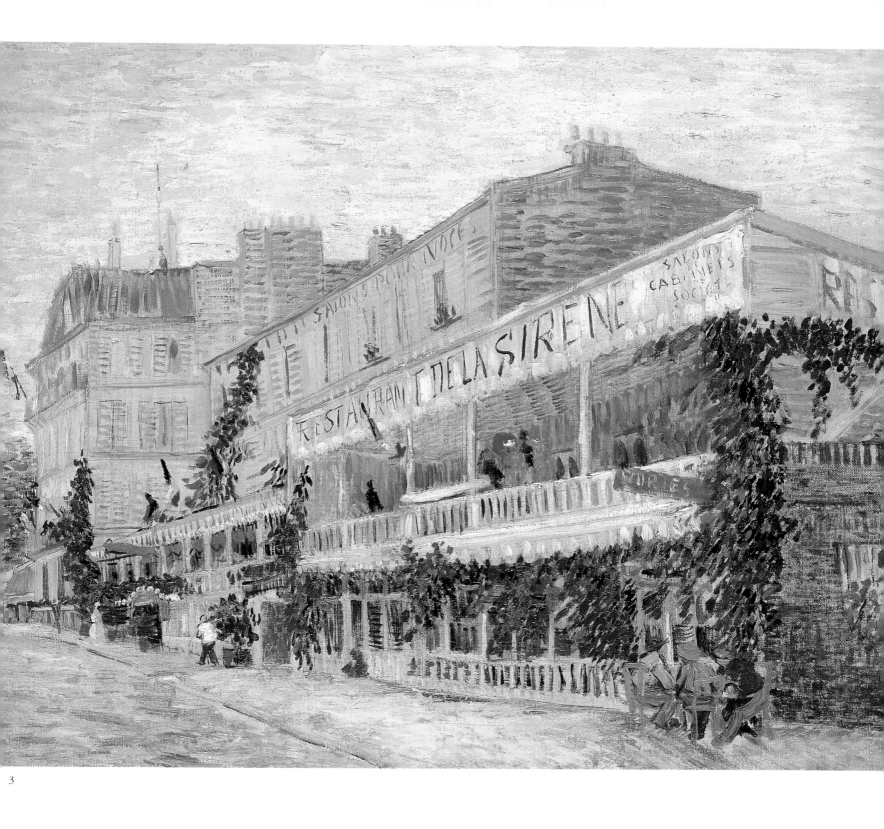

3

'This summer while I was painting
landscapes at Asnières, I saw
more colours there than before'

It was van Gogh's idea to organise an exhibition in the entrance hall of a restaurant situated at the junction of avenue de Clichy and avenue Saint-Ouen. Gauguin was about to leave Paris, but agreed to participate. Emile Bernard reported afterwards: 'Vincent van Gogh embarked on a new form of impressionist exhibition. The hall was vast and provided a surface on which over a thousand paintings could be hung.' Vincent obtained the help of Anquetin, Koning and Emile Bernard. Always fired by his ideal that the man in the street should be taught about art and enabled to apprehend the Beautiful, Vincent deliberately chose a popular restaurant; it is possible, also, that the owner was the only one willing to accommodate an invasion of canvases by little-known painters. The exhibition neither particularly shocked nor interested the diners. Pissarro and Guillaumin paid a visit, as did a number of dealers such as Georges Thomas who was apparently interested in this revolutionary art. Emile Bernard later recalled that 'Vincent's vigorous temperament expanded to its full extent. Already one could discern the style, the determination, the boldness of his later works. . . . The intensity of life was the striking aspect of his paintings and if, at times, a certain precociousness of touch betrayed the processes of the brain, one nonetheless felt the powerful trace of logic and of knowledge. With some hundred of Vincent's paintings hanging on the walls, the general impression in the hall derived directly from him, and it was a gay, vibrant, harmonious impression. Seurat, who came to view this exhibition, met Vincent there for the first time.

After the exhibition, which caused no lasting stir in the newspapers of the time, Antoine, director of the Théâtre Libre, rue Pigalle, volunteered to exhibit the young artists on his walls. 'I have sixty or eighty square metres of wall to decorate in the rehearsal room. They can hang their finished works here, and as I am going to have smart people coming and going, it will be a modest exhibition but perhaps useful. A painting need only catch a corner of their eye for them to buy it.' It appears that, nonetheless, Vincent sold nothing at this permanent exhibition.

'Later, I realised that Paris is a hothouse of ideas, and that people are trying to extract from life all that can be extracted from it. Compared with that city, all other cities are small. Paris seems as great as the sea. But one always leaves there a great chunk of one's life'

1

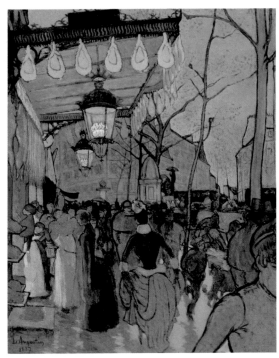

2

1/2/3
Signac, Anquetin, friends of van Gogh, like most of the painters living on boulevard and avenue Clichy, painted the street, its passers-by, its atmosphere. Vincent later called them the 'impressionists of the petit boulevard'

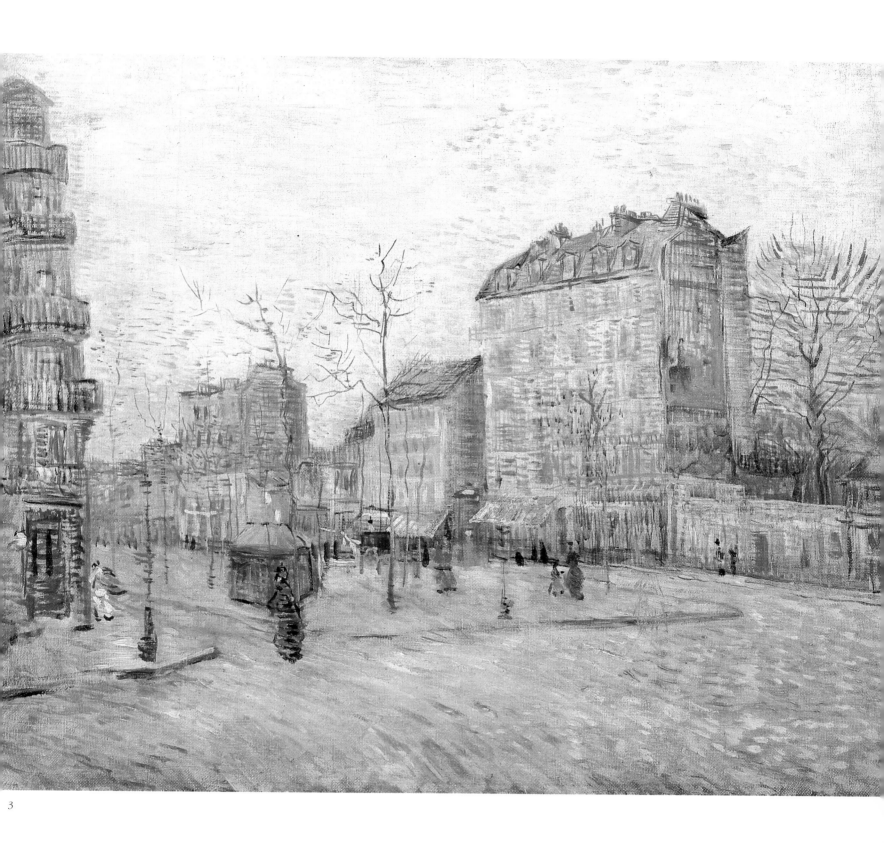

3

1 *Boulevard de Clichy, la neige,*
1886, Paul Signac
Oil on canvas, 46.5 x 65.5 cm
Minneapolis Institute of Arts,
Puthnam Diana McMillan bequest

2 *Avenue de Clichy à 5 heures de
l'après-midi,* 1887, L. Anquetin
Oil on canvas, 69 x 53 cm
Wadsworth Atheneum, Hartford

3 *Boulevard de Clichy,* 1887
Oil on canvas, 46.5 x 55 cm
van Gogh Foundation, Amsterdam

La Segatori was Vincent's only known love affair during his Parisian period. Early in 1887, he tried to organise an exhibition in the little cabaret, the Tambourin, whose proprietress, a former model of Corot's and Gérôme's in particular, was known by this name. Vincent invited his new friend Toulouse-Lautrec to this cabaret in boulevard de Clichy, and it was there that the latter painted his portrait. The place was popular with painters of the 'petit boulevard' and also with writers and journalists, such as Ernest Hoschedé (a friend and supporter of Monet), who collected Impressionist works between two bankruptcies. Vincent wanted to exhibit in places open to the man in the street and he had managed to persuade his friends Bernard, Toulouse-Lautrec and Anquetin to support him. Gauguin, whom he admired, and who, like him, had embarked very late on his artistic career, had already returned to Martinique with Charles Laval and could not join the group.

Vincent exhibited his canvases and also his collection of Japanese prints, on the walls of the Tambourin. Meanwhile, for reasons which remain unclear, La Segatori and Vincent had a quarrel which put an end to their artistic and romantic relationship. Vincent returned to the cabaret to remove his canvases and his prints, which he carried away in a pushcart.

Shortly before he left for Arles, Vincent painted a final portrait of an Italian woman who could well have been La Segatori. The pose of the woman brings to mind that of Père Tanguy. In the Paris of the time, Italian models were common. It is possible that in choosing this model to sit for him, he was evoking memories of a woman who had done him good. Theo being in Holland, Vincent kept him up to date. No money, not a single painting sold. 'It depressed me to think that even when it's a success, painting never pays back what it costs. . . . I should like to be less of a burden to you. . . . And then I will take myself off somewhere down south, to get away from the sight of so many painters that as men disgust me.' He paid a visit to Georges Seurat who was then working on *Les Poseuses,* which he admired. The next day, 21 February 1888, he was in Arles.

'As for La Segatori, that's very different. I still have some affection for her, and I hope she still has some for me. But just now she is in a bad way; she is neither a free agent nor mistress in her own house, and worst of all she is ill and in pain. . . . In two months' time she will be better, I hope, and then perhaps she will be grateful that I did not bother her'

Georges Seurat around 1887

1/2/3
A few hours before leaving Paris for Arles, Vincent paid Seurat a visit. He admired his preliminary studies for *Les Poseuses* (1). Vincent had studied, then abandoned, the Pointillism of which Seurat was chief practitioner. He turned towards Cloisonnism, as seen here in the portrait of *The Italian Woman,* clearly inspired by his friend Guillaumin (2), for which one does not know if La Segatori posed. However that may be, the memory of her suffuses the painting (3)

1

2

1 *Les Poseuses,* 1888, Georges Seurat
Oil on canvas, 25 x 16 cm
Musée d'Orsay, Paris

2 *The Italian Woman,* 1885, A. Guillaumin
Oil on canvas, 60.5 x 40.5 cm
Private collection, Paris

3 *The Italian Woman, Le Segatori (?),* 1887
Oil on canvas, 81 x 60 cm
Musée d'Orsay, Paris

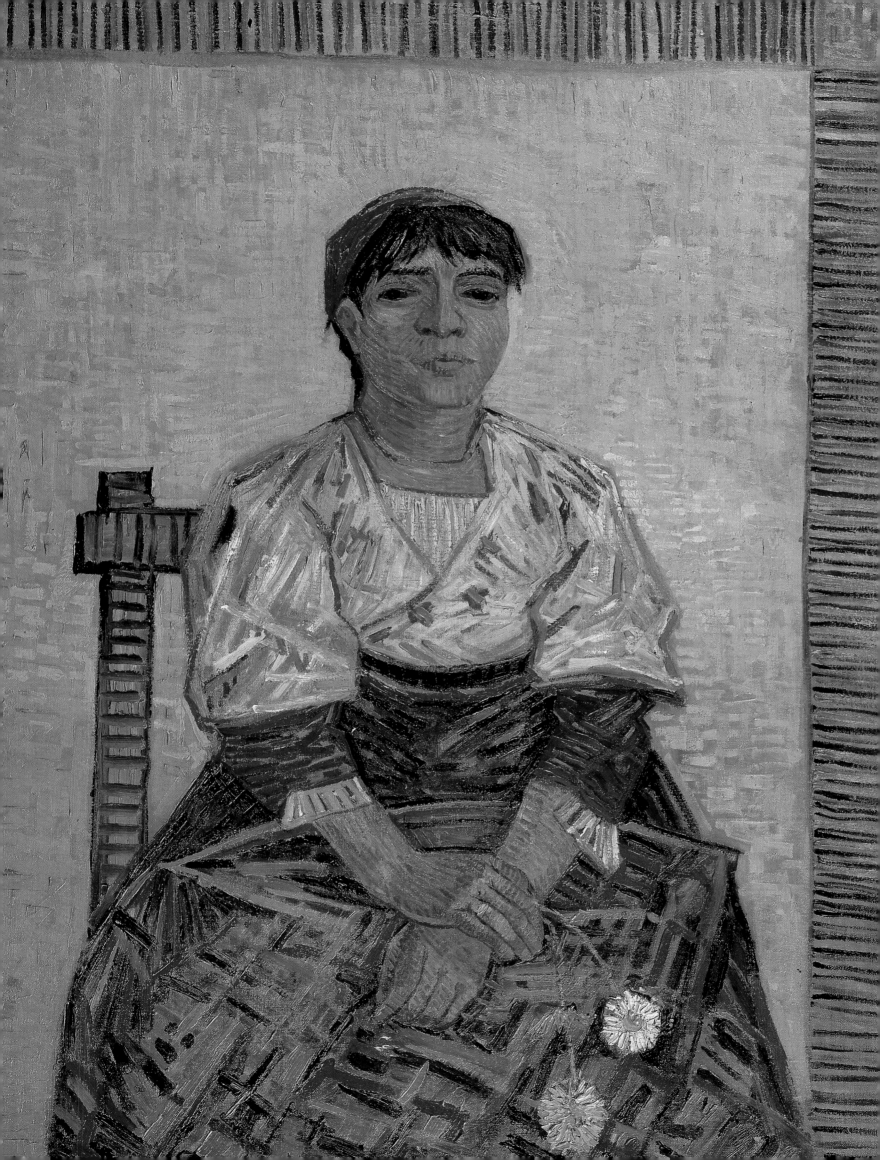

Letters from Arles

*A*fter a sixteen-hour journey, Vincent arrived to find Arles covered in snow.

'My dear Theo, during the journey I thought of you at least as much as I did of the new country I was seeing. Only I said to myself that perhaps later on you will often be coming here yourself. It seems to me almost impossible to work in Paris unless one has some place of retreat where one can recuperate and get one's tranquillity and poise back. Without that, one would become hopelessly stultified. And now I'll begin by telling you that there's about two feet of snow everywhere, and more is falling.

Arles doesn't seem to me any bigger than Breda or Mons. Before reaching Tarascon I noticed a magnificent landscape of huge yellow rocks, piled up in the strangest and most imposing forms. In the little village between these rocks were rows of small round trees with olive-green or grey-green leaves, which I think were lemon trees. [In fact they were olive trees.] But here in Arles the country seems flat. I have seen some splendid red stretches of soil planted with vines, with a background of mountains of the most delicate lilac. And the landscapes in the snow, with the summits white against a sky as luminous as the snow, were just like the winter landscapes that the Japanese have painted . . .'

To Bernard: 'Water forms patches of a beautiful emerald or a rich blue in the landscape, just as we see it in the crépons. The sunsets have a pale orange colour which makes the fields appear blue. The sun a splendid yellow. And all this though I have not yet seen the country in its usual summer splendour. The way the women dress is pretty, and especially on Sundays one sees some very simple and well-chosen combinations of colours on the boulevard. . . . It might be a real advantage to quite a number of artists who love the sun and colours to settle in the South. If the Japanese are not making any progress in their own country, still it cannot be doubted that their art is being continued in France.'

View of Arles, 1888
Oil on canvas, 72 x 92 cm
New Art Gallery, Munich

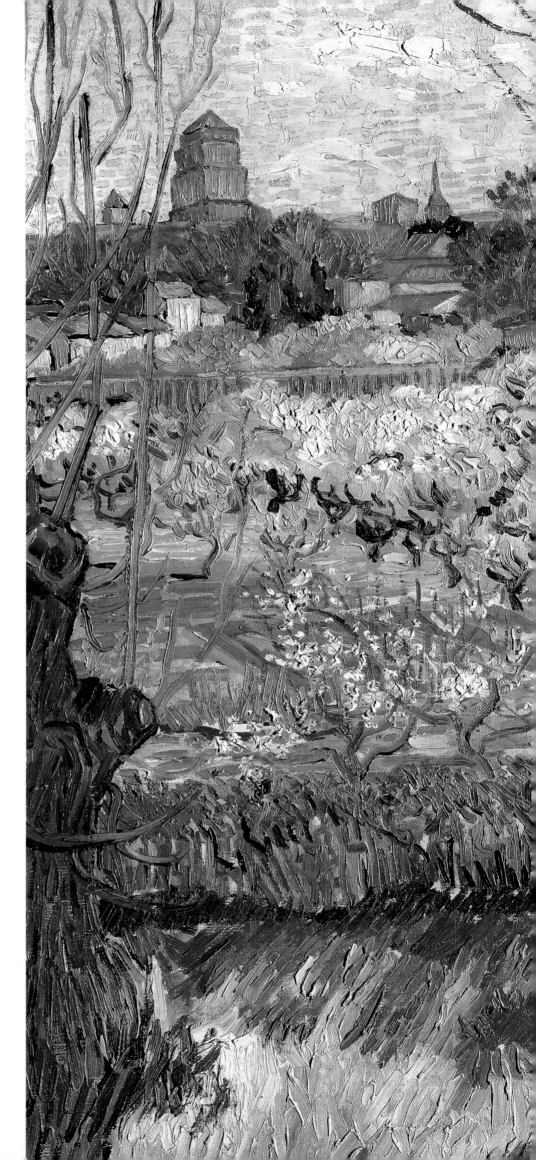

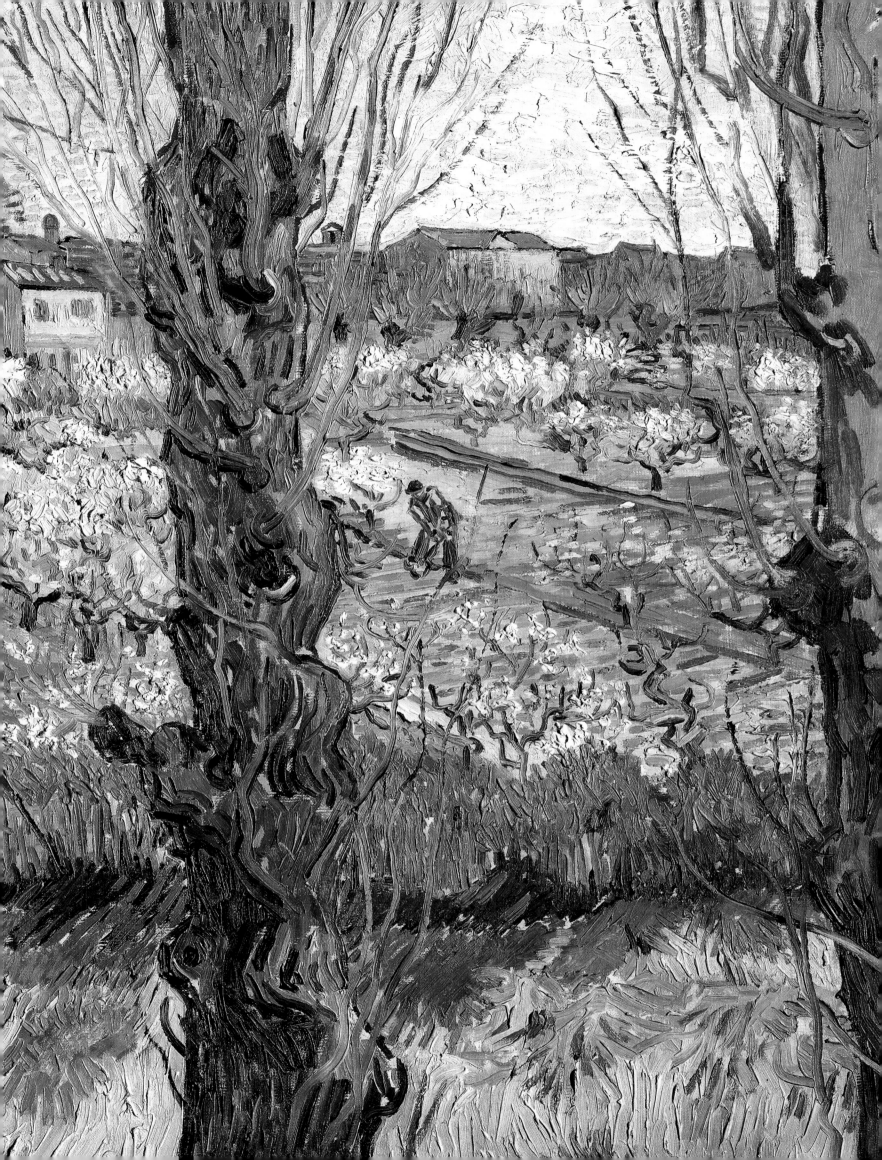

Vincent found lodgings at the restaurant Carrel, 30 rue Cavalerie, and set out to look for paintings by Monticelli whom he had discovered in Paris.

'I have seen only a little of the town so far, as I was pretty beat last night. I'll write soon. Yesterday in an antique shop on the same street, the man told me that he knew of a Monticelli.'

As soon as he arrived he embarked on several studies. As was his habit, he drew what he saw out of the window, or turned his attention to still lifes. His lodgings proved too expensive and he decided to find cheaper ones.

'I am sorry that life here is not as cheap as I had hoped, and so far I have not been able to manage as economically as one could at Pont-Aven. I began by paying 5 francs a day, and now I have come down to 4 francs. One must know the local patois, and learn to eat bouillabaisse and garlic, then I feel sure one could find an inexpensive middle-class boarding-house. Then, if there were several of us, I am inclined to think one could get more advantageous terms.'

The situation deteriorated. The restaurateur, thinking he could take advantage of a foreigner, obliged Vincent to pay for the storage of his canvases which cluttered up the inn.

'Meanwhile I have some vexations, and I don't think I can get rid of them as long as I stay where I am. I would rather take a room or, if need be, two rooms, one for sleeping, one for work. For the people here are trying to take advantage of me so as to make me pay through the nose for everything, on the pretext that I take up a little more room with my pictures than their other clients, who are not painters. For my part, I shall make the most of the fact that I stay longer, and spend more in the inn than the workmen who come and go. And they won't find it easy to get so much as a cent out of me. But it's a perpetual nuisance to have to drag all one's apparatus and one's pictures after one, and it makes it harder both to go out and to come in. As I must make a move in any case, would you like it, or would it suit you better, if I went to Marseilles now?'

The dispute was settled by a Justice of the Peace: he ruled in favour of Vincent, who was reimbursed the excess he had paid.

The restaurant Carrel where Vincent first lived on arriving in Arles. It was destroyed by bombing during the Second World War

'For many reasons I should like to get some sort of little retreat, where the poor cab horses of Paris – that is, you and several of our friends, the poor Impressionists – could go out to pasture when they are worn out.'

The 'charcuterie' Vincent painted from his window as it was in the 1930s

The public gardens in Arles

La Charcuterie, 1888
Oil on canvas, 39.5 x 32.5 cm
van Gogh Foundation, Amsterdam

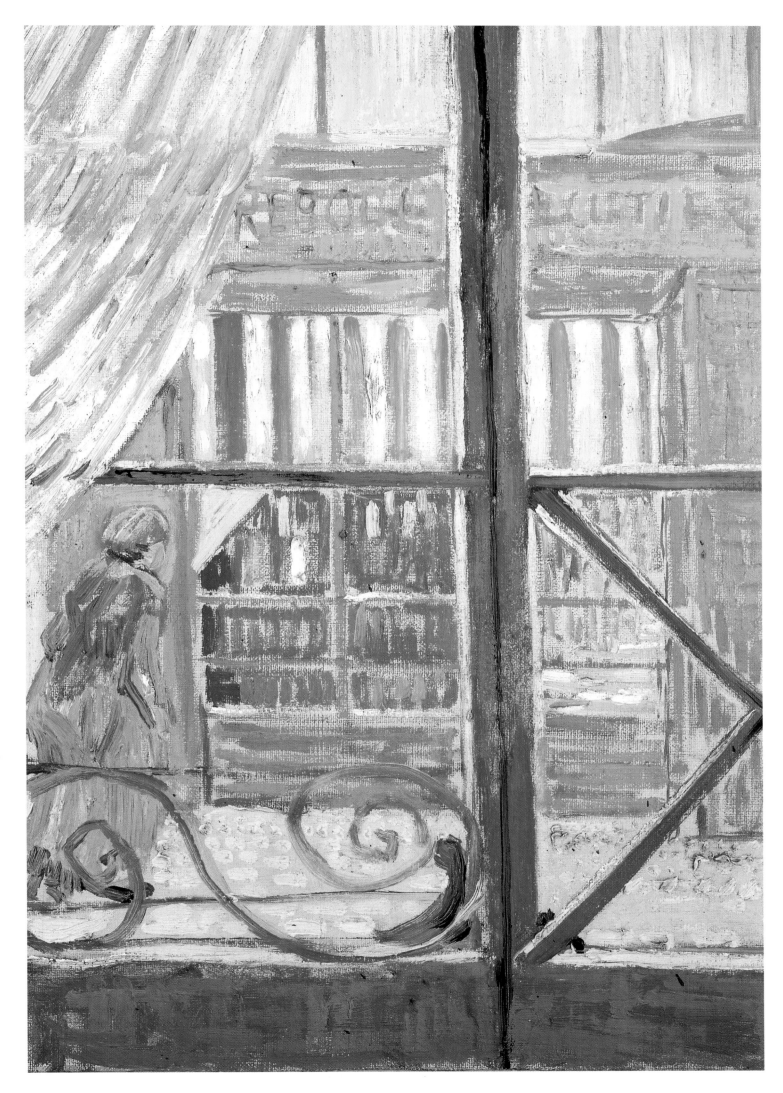

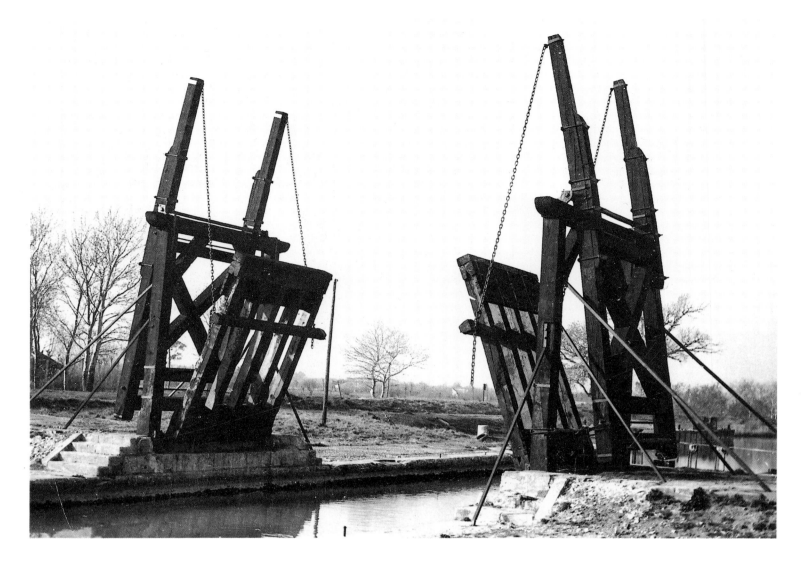

'The countryside seems to me as beautiful as Japan in the limpidity of the atmosphere, the brightness of the colour effects'

Now that the weather permitted, Vincent explored the Arles surroundings and began to paint them. Everything enchanted him in this country where he thought he could see something of Japan.

'My dear Theo, Thank you very much for your letter, which I had not dared to expect so soon, as far as the 50 franc note which you added was concerned. . . . As for my work, I brought back a size 15 canvas today. It is a drawbridge with a little cart going over it, outlined against a blue sky – the river blue as well, the banks orange coloured with green grass and a group of women washing linen in smocks and multi-coloured caps. . . . But, old boy, you know, I feel as though I were in Japan – I say no more than that, and mind, I haven't seen anything in its usual splendour yet. . . . Here I am seeing new things, I am learning, and if

I take it easy, my body doesn't refuse to function . . . I made my last three studies with the perspective frame I told you about. I attach some importance to the use of the frame because it seems not unlikely to me that in the near future many artists will make use of it, just as the old German and Italian painters certainly did, and, as I am inclined to think, the Flemish too. The modern use of it may differ from the ancient practice, but in the same way isn't it true that in the process of painting in oils one gets very different effects today from those of the men who invented the process . . . ? And the moral of this is that it's my constant hope that I am not working for myself alone. I believe in the absolute necessity of a new art of colour, of design – and of the artistic life. And if we work in that faith, it seems to me there is a chance that we do not hope in vain.'

1/2
Vincent did several paintings of the Langlois bridge and numerous pen drawings. The wooden bridge was destroyed during the Second World War. The municipality of Arles bought another at Fosses-sur-Mer and took it to pieces, in order to reconstruct it in the spot where Vincent had painted his masterpiece under the influence of Japanese prints

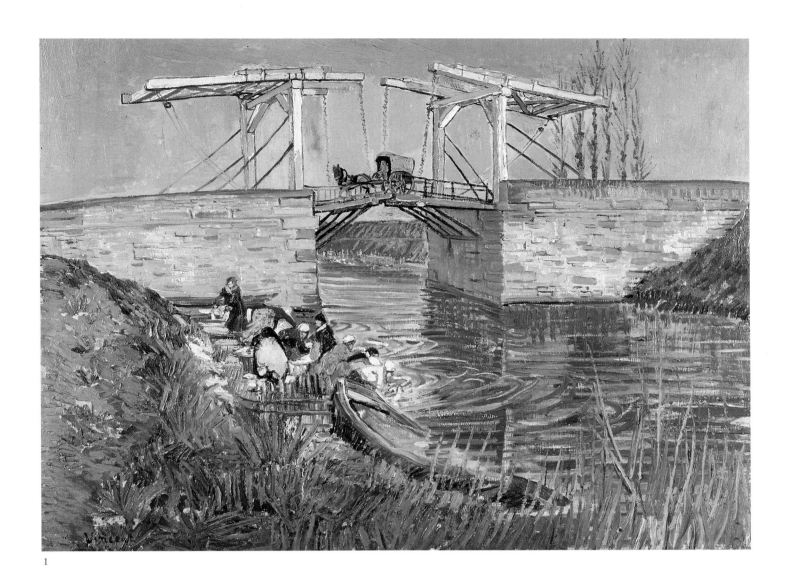

1

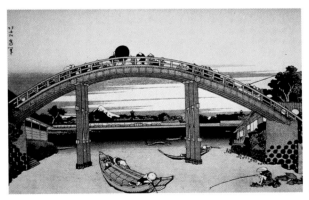

2

1 *The Langlois bridge,* 1888
Oil on canvas, 54 x 65 cm
Kröller-Müller Foundation, Otterlo

2 *Japanese bridge,* 1840, Hokusai
Print
Explorer Archives

'My dear Theo, Ideas for my work are coming to me in swarms, so that though I'm alone, I have no time to think or to feel, I go on painting like a steam engine . . . I have a study of an old mill painted in broken tones like the oak tree on the rock, that study you were saying you had had framed along with *The Sower*.'

While remaining receptive to everything that reminded him of Holland, Vincent was also extremely interested by life in Arles. One day he came upon a corrida in the town bull-ring. And in a letter in which he reassured Theo as to his health, he described this new experience:

'I'm hard at it again, still orchards in bloom. The air here certainly does me good. I wish you could fill your lungs with it; one effect it has on me is comical enough – one small glass of brandy makes me tipsy here, so that as I don't have to fall back on stimulants to make by blood circulate, there is less strain on my constitution. The only thing is that my stomach has been terribly weak since I came here, but after all that's probably only a matter of time. I hope to make great progress this year, and indeed I need to. . . . Yesterday I saw another bullfight, where five men played the bull with banderillas and rosettes. One toreador crushed one of his balls jumping the barricade. He was a fair man with grey eyes, plenty of sang-froid; people said he'll be ill long enough. He was dressed in sky blue and gold, just like the little horseman in our Monticelli, the three figures in a wood. The arenas are a fine sight when there's sunshine and a crowd.'

Vincent also wrote to tell Emile Bernard of his new discovery:

'By the way, I have seen bullfights in the arena, or rather sham fights, seeing that the bulls were numerous but there was nobody to fight them. However, the crowd was magnificent, those great colourful multitudes piled up one above the other on two or three galleries, with the effect of sun and shade and the shadow cast by the enormous ring.'

107 *ARLES. — Les Arènes. — Combat de Taureaux. — Le Matador. — LL.*

In *Lust for Life,* the film about van Gogh's life that Vincent Minelli directed with Kirk Douglas in the role of the artist, a number of shots suggest that the old mill and the restaurant Carrel are one and the same place. This is a minor stretching of the truth, which does not stop Roulin the postman from examining a canvas of Vincent's

The Old Mill, 1888
Oil on canvas, 65 x 54 cm
Albright-Knox Art Gallery, Buffalo

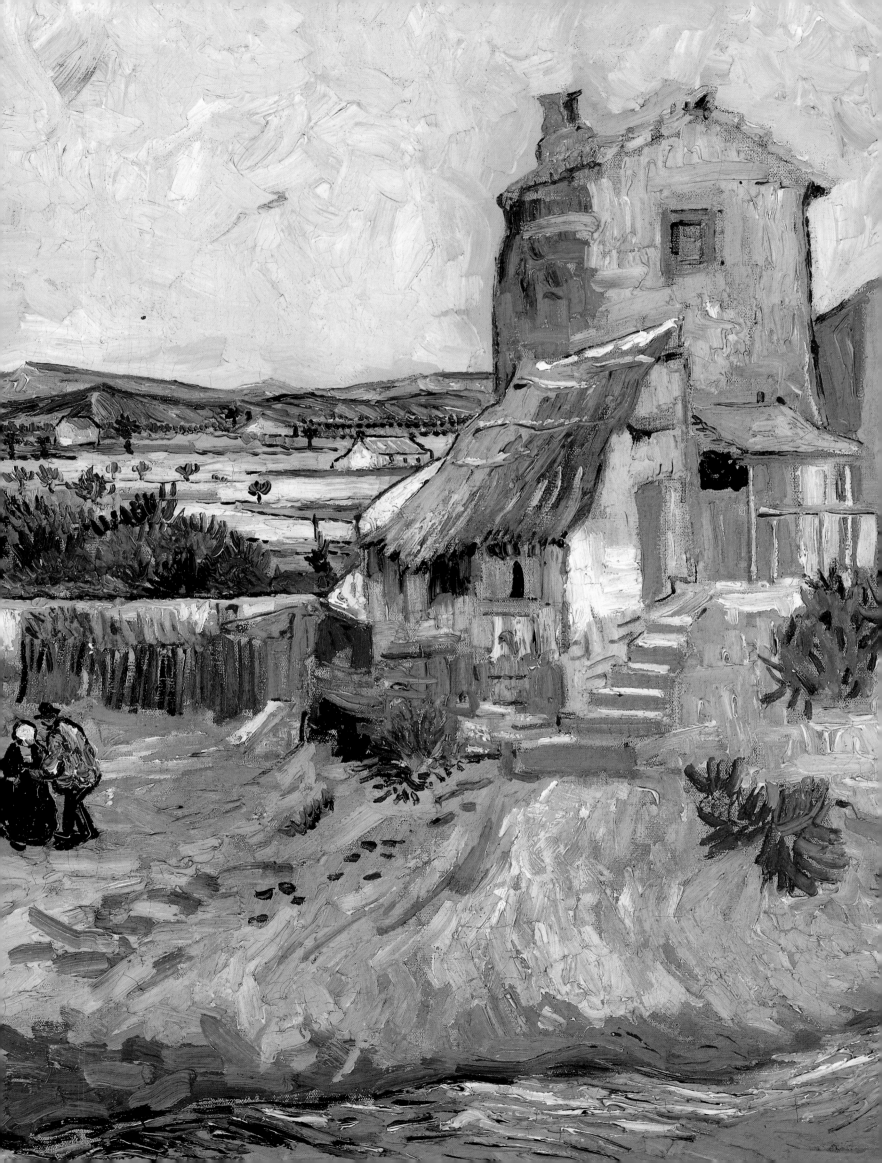

'Well, today I've taken the right wing of this complex, which contains four rooms, or rather two with two box-rooms. It is painted yellow outside, whitewashed inside, on the sunny side. I have taken it for 15 francs a month.

'Now my idea would be to furnish one room, the one on the first floor, so as to be able to sleep there. This [house] will remain the studio and the storehouse for the whole campaign, as long as it lasts in the South, and now I am free of all the innkeepers' tricks: they're ruinous and they make me wretched . . . And after this I can own up and let you know that I plan to invite Bernard and others to send me pictures, to show them here if there is an opportunity, which there certainly will be in Marseilles. I hope I have landed on my feet this time, you know – yellow outside, white inside, with all the sun, so that I shall see my canvases in a bright interior – the floor is red brick; outside, the garden of the square. . . . Meanwhile, if you approve, I shall furnish the bedroom, either hiring or buying it for cash down; I shall see about that today or tomorrow morning . . . I am still convinced that nature down here is just what one wants to give one colour. So that it's more than likely I shall hardly ever budge from here . . . I have one less big worry now that I have found the little white studio. I looked in vain at heaps of rooms. It will sound funny to you that the lavatory is next door, in a fairly big hotel which belongs to the same proprietor. In a southern town I feel I have no right to complain of it, since these closets are few and dirty, and one cannot help thinking of them as nests of microbes. For another thing, I have water laid on. I shall put some Japanese things up on the wall.'

Vincent wanted to make his yellow house into a 'studio of the Midi' where artists would come to work on a communal oeuvre. He was never able to realise this project.

'I wanted to arrange the house from the start not for myself only, but so as to be able to put someone else up too. . . . For a visitor there will be the prettier room upstairs, which I shall try to make as much as possible like the boudoir of a truly artistic woman. . . . The room you will have then, or Gauguin if he comes, will have white walls with a decoration of great yellow sunflowers.'

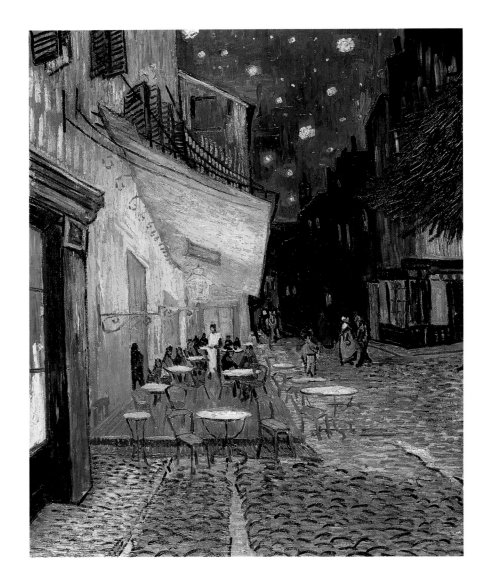

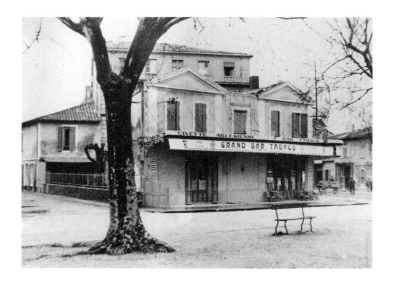

1 *Night Café*, 1888
Oil on canvas, 81 x 65.5 cm
Kröller-Müller Foundation, Otterlo

1/2
Vincent's house is the yellow
house. On the right is the road
leading to the station and the
railway bridge. On the left, the
café – the terrace of which Vincent
painted in *Night Café*

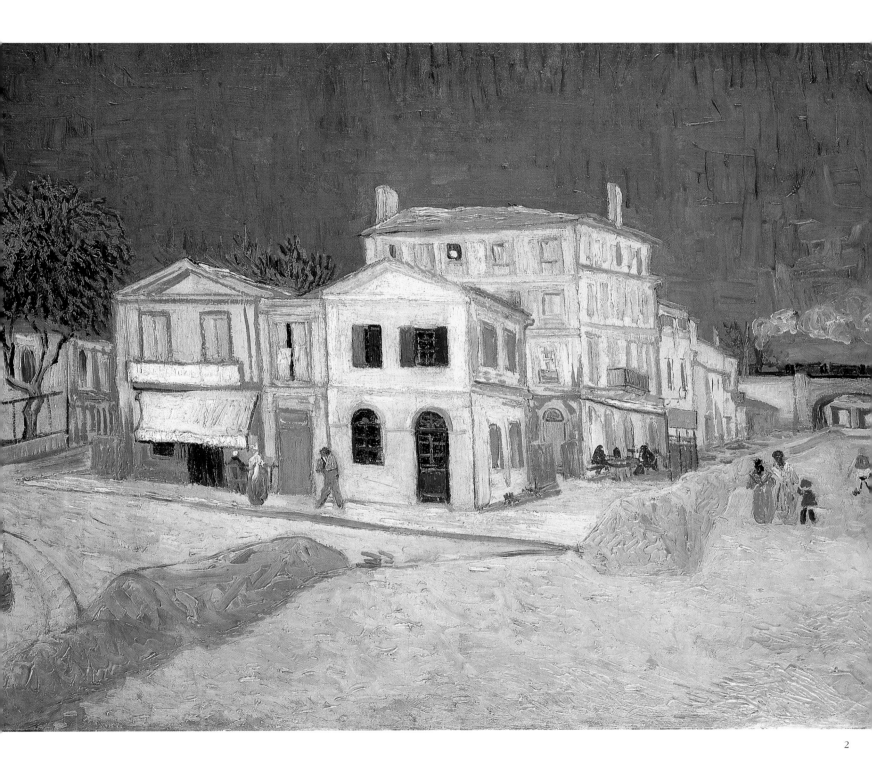

2

2 *Vincent's house in Arles*, 1888
Oil on canvas, 76 x 94 cm
van Gogh Foundation, Amsterdam

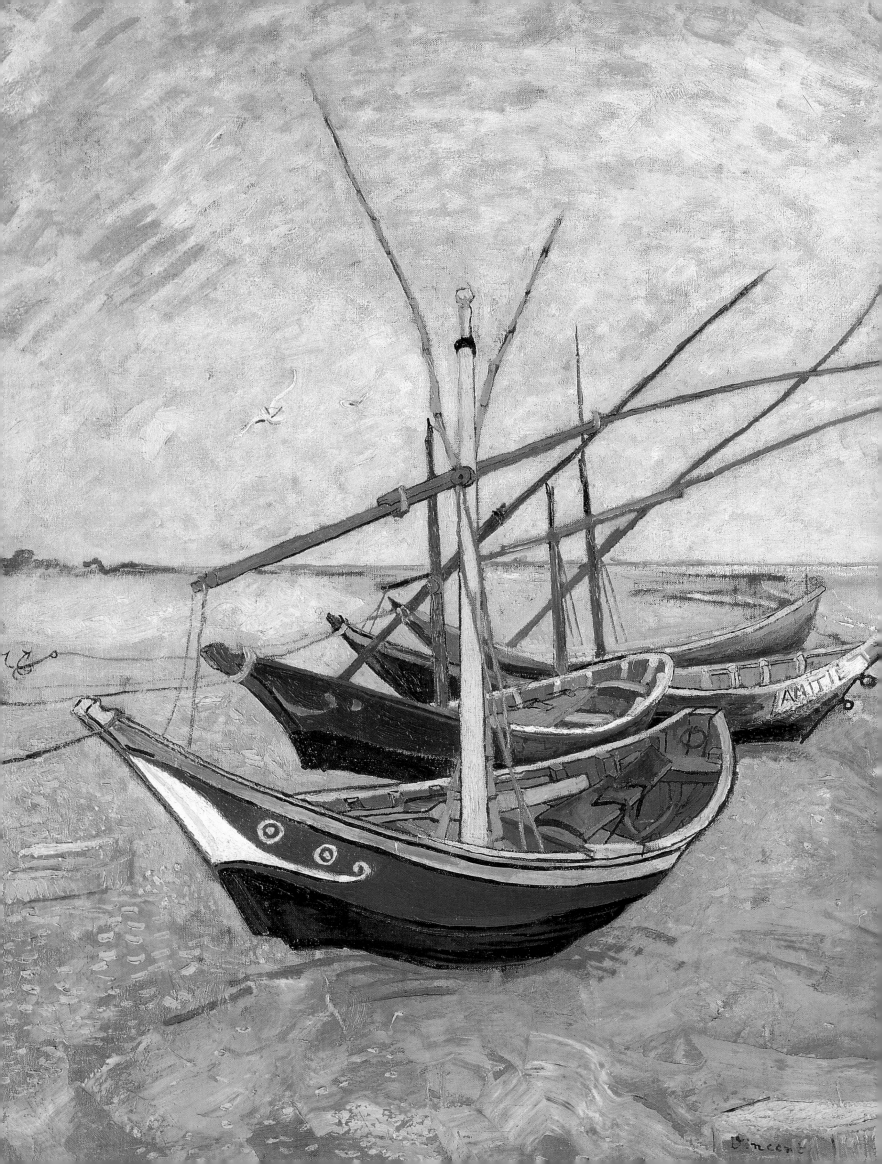

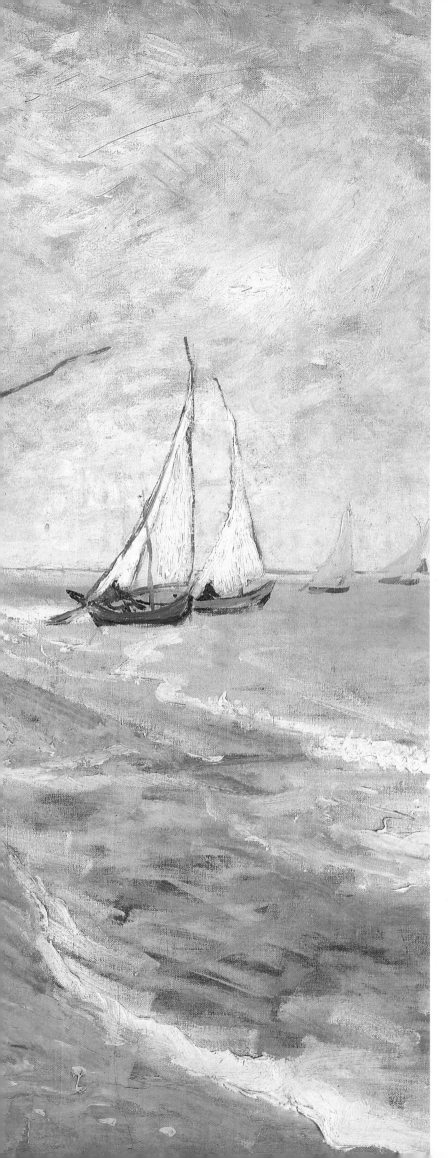

My dear Theo, I am at last writing to you from Saintes-Maries on the shore of the Mediterranean. The Mediterranean has the colours of mackerel, changeable I mean. You don't always know if it is green or violet, you can't even say it's blue, because the next moment the changing light has taken on a tinge of pink or grey.... I brought three canvases and have covered them – two marines, a view of the village, and then some drawings which I will send you by post when I return to Arles tomorrow.... The shore here is sandy, neither cliffs nor rocks – like Holland without the dunes, and bluer. You get better fried fish here than on

the Seine. Only fish is not available every day, as the fishermen go off and sell it in Marseilles. But when there is some, it's extremely good. ... One night I went for a walk by the sea along the empty shore. It was not gay, but neither was it sad, it was beautiful. The deep blue sky was flecked with clouds of a blue deeper than the fundamental blue of intense cobalt, and others of a clearer blue, like the blue whiteness of the Milky Way. In the blue depth the stars were sparkling, greenish, yellow, white, pink, more brilliant, more sparklingly gemlike, than at home – even in Paris: opals you might call them, emeralds, lapis lazuli, rubies, sapphires. The sea was very deep ultramarine – the shore a sort of violet and faint russet as I saw it, and on the dunes ... some bushes Prussian blue. Besides half-page drawings I have a big drawing, the pendant of the last one. Goodbye for the present only, I hope, with a handshake.'

Boats at Saintes-Maries, 1888
Oil on canvas, 64.5 x 81 cm
van Gogh Foundation, Amsterdam

Vincent, who so longed to return to Saintes-Maries-de-la-Mer, unfortunately had to relinquish his plan. The workmen who had repainted his house were demanding payment.

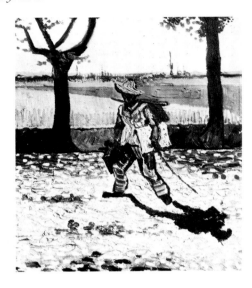

Throughout his time in Arles, Vincent lived in hope of making the yellow house a studio where Gauguin, Emile Bernard and others would come to paint. This fine dream died with him. The van Gogh Foundation of Arles has brought together works by the greatest contemporary artists, poets, writers, in response to its appeal in homage to van Gogh. Francis Bacon took his inspiration from a painting of Vincent's

'I have not gone to Saintes-Maries; they have finished painting the house, and I have had to pay for that, and then I had to get in a fairly big stock of canvases; so out of 50 francs I have one louis left, and it is only Tuesday morning, so it was hardly possible for me to go, and I am afraid next week will be just as bad. . . . One day I went to Tarascon, but unfortunately there was such a blazing sun and so much dust that day that I came back with an empty bag.'

But he managed nonetheless to paint a picture of himself on his way, loaded with box and canvases:

'If you saw the Camargue and many other places, you would be surprised, just as I was, to find that they are exactly in Ruysdael's style.'

It was on one of his excursions that he painted a gypsy camp which he described to Theo as follows:

'A small study of a gypsy camp, red and green caravans.'

Meanwhile in all his letters Vincent spoke of the arrival of Gauguin, whom he awaited with feverish impatience, but who delayed in coming. Gauguin, resident in Pont-Aven, was crippled with debt and ailing. He constantly put off his journey, which held little attraction for him.

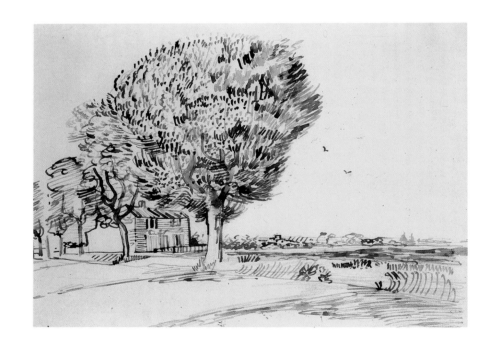

1 *The artist on the road to Tarascon,* 1888
Oil on canvas, 48 x 44 cm
Kaiser Friedrich Museum, Magdebourg
Burnt during the Second World War

2 *Homage to Vincent,* 1988, Francis Bacon
van Gogh Foundation, Arles

3 *A road near Arles,* 1888
Pencil, reed pen – sepia, 24.6 x 23.9 cm
Albertina, Vienna

4 *Encampment of gypsies in caravans,* 1888
Oil on canvas, 45 x 51 cm
Musée du Louvre, Paris

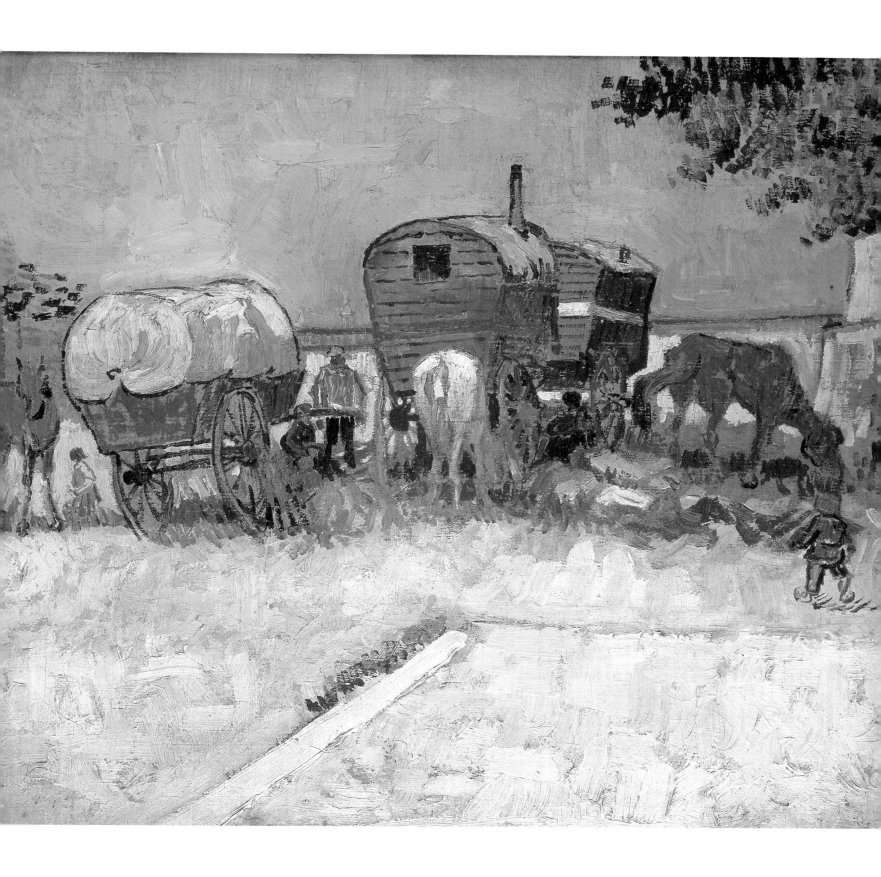

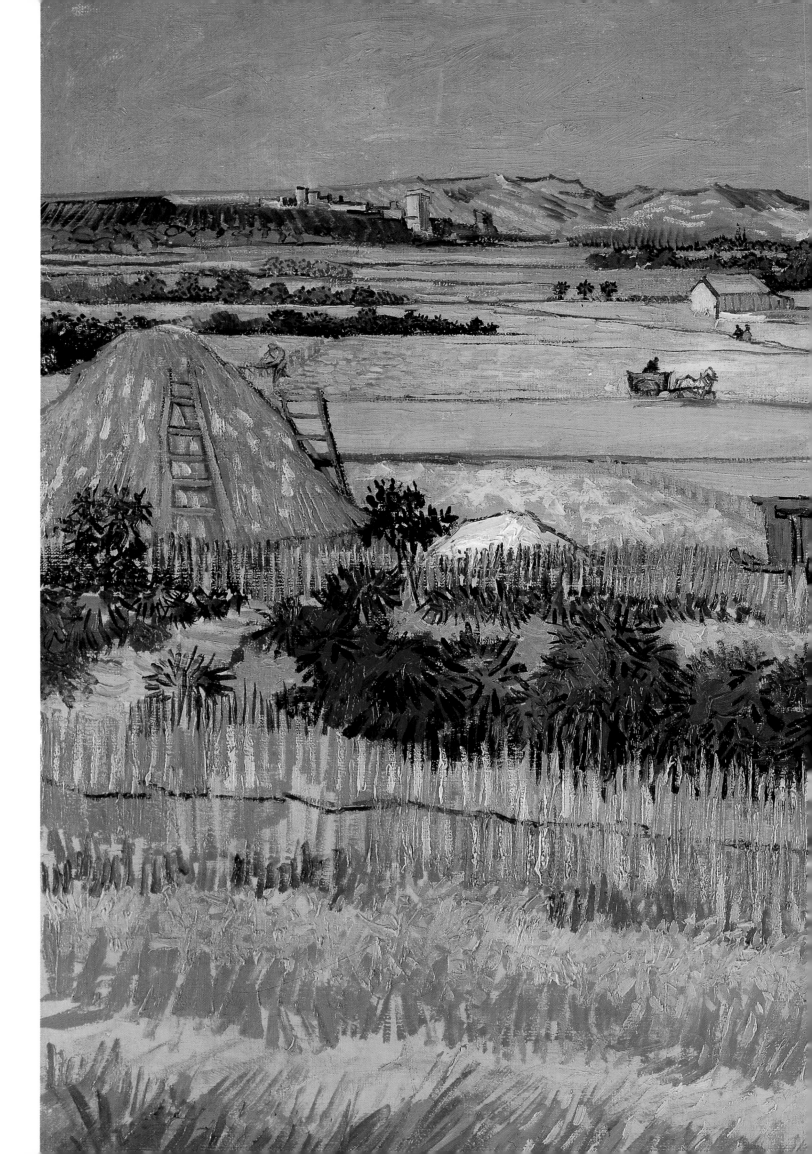

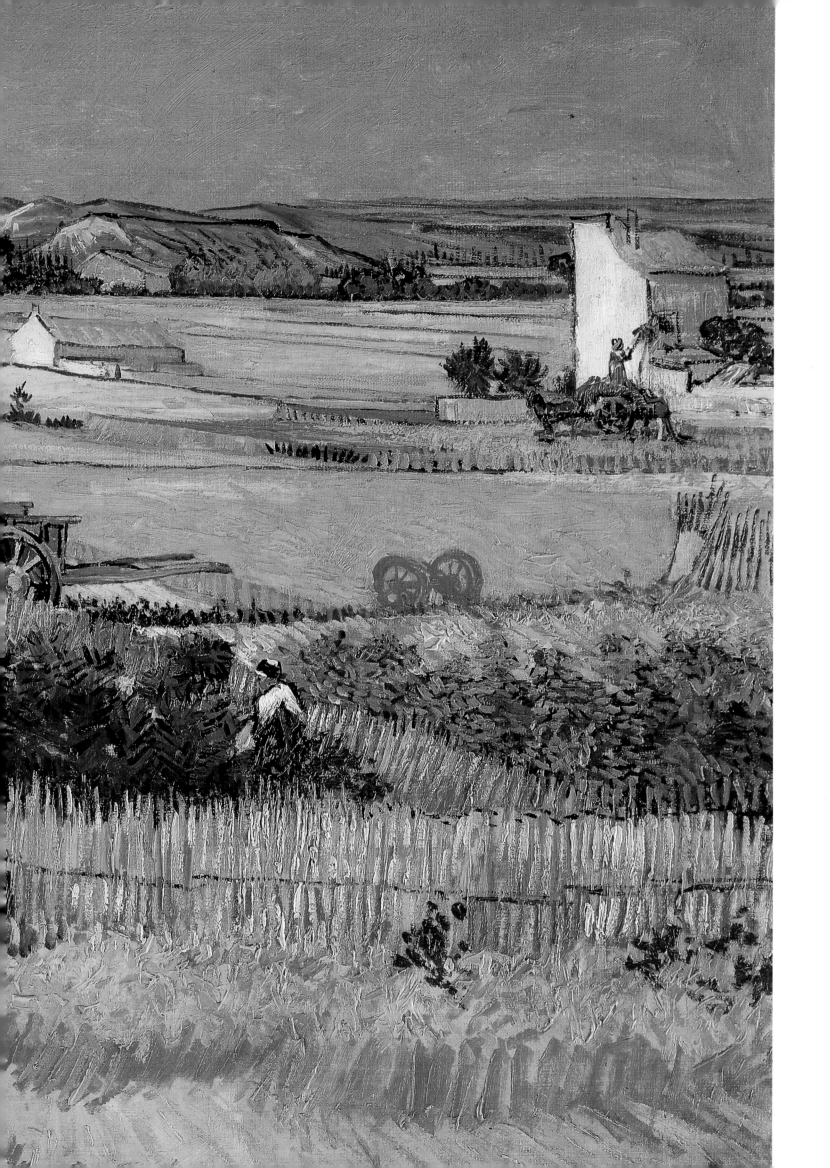

The young zouave officer Milliet enjoyed keeping Vincent company. Together they walked in the countryside and chose subjects for painting. For Milliet, quite ignorant of the quality of Vincent's painting, had taken it into his head to learn to draw:

'Milliet today was pleased with what I had done . . . generally he does not like what I do, but because the colour of the lumps of earth is as soft as a pair of sabots, it did not offend him.'

Vincent, giving up the idea of having Milliet as a pupil, used him instead as a model:
'If he posed better, he would give me great pleasure, and he would have a more distinctive portrait than I can manage now, though the subject is good – the matt pale tints of his face, the red képi against an emerald background.'

Vincent to his sister:
'I am working very hard now, and I think the summer here extremely beautiful, more beautiful than I ever saw it in the North, but people here are complaining loudly that it is not the same as usual. Now and then some rain in the morning or the afternoon, but infinitely less than in our country. The harvest was gathered long ago. There is much wind here, however, a very ill-natured, whining wind – le mistral – very troublesome for the most part, when I have to paint in it, in which case I put my canvas down flat on the ground, and work on my knees. For the easel does not stand firm. I have a study of a garden one metre wide, poppies and other red flowers surrounded by green in the foreground, and a square of bluebells. Then a bed of orange and yellow Africans, then white and yellow flowers, and at last, in the background, pink and lilac, and also dark violet scabiosas, and red geraniums, and sunflowers, and a fig tree and an oleander and a vine. And in the far distance black cypresses against low white houses with orange roofs – and a delicate green-blue streak of sky. Oh, I know very well that not a single flower is drawn completely, that they are mere dabs of colour, red, yellow, orange, green, blue, violet, but the impression of all these colours in their juxtaposition is there all right, in the painting as in nature. But I suppose you would be disappointed, and think it unbeautiful, if you saw it. But you see that the subject is rather summery.'

'This brave officer has abandoned the art of drawing to the mysteries of which I was trying hard to initiate him . . .'

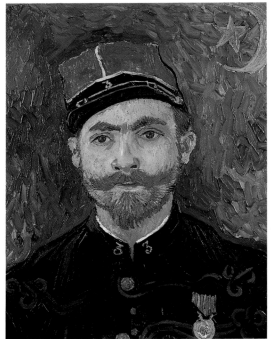

Preceding pages:
Harvest at La Crau, 1888
Oil on canvas, 72.5 x 92 cm
van Gogh Foundation, Amsterdam

1 and detail on right:
Flowering garden, 1888
Oil on canvas, 72 x 91 cm
Gemeentemuseum, The Hague

2 *Portrait of Milliet,* 1888
Oil on canvas, 60 x 49 cm
Kröller-Müller Foundation, Otterlo

'I am now engaged on a portrait of a postman in his dark-blue uniform with yellow. A head somewhat like Socrates, hardly any nose at all, a high forehead, bald crown, little grey eyes, bright chubby cheeks, a big pepper-and-salt beard, large ears. This man is an ardent republican and socialist, reasons quite well, and knows a lot of things. His wife was delivered of a child today, and he is consequently feeling as proud as a peacock and is all aglow with satisfaction . . . I am always looking for the same thing – a portrait, a landscape, a landscape and a portrait. I shall also get to paint the baby today, at least I hope so . . .

Vincent also painted the postman's entire family:

'I've done portraits of an entire family, that of the postman whose head I had already painted before – the man, the woman, the baby, the young boy and the son of fifteen – there you will feel how much I feel in my element and how this consoles me somewhat for not being a doctor. I hope to persevere with this and that I'll be able to get more serious poses, payable in portraits. If I manage to paint this whole family even better, I'll have done at least one thing of my own, to my own taste.'

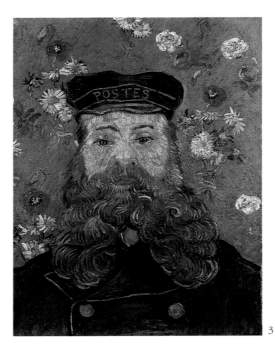

1 *The baby Marcelle Roulin,* 1888
Oil on canvas, 35.5 x 24.5 cm
van Gogh Foundation, Amsterdam

2 *Portrait of Camille Roulin,* 1888
Oil on canvas, 37.5 x 32.5 cm
van Gogh Foundation, Amsterdam

3 *Head of Roulin the postman,*
1889
Oil on canvas, 65 x 54 cm
Kröller-Müller Foundation, Otterlo

4 *Portrait of Armand Roulin,* 1888
Oil on canvas, 66 x 55 cm
Folkwang Museum, Essen

'I do not know if I will be able to paint the postman as I perceive him. . . . But I saw him one day singing "La Marseillaise," and I thought I was seeing '89, not next year, but ninety-nine years past. It was Delacroix, Daumier, old Holland pure and simple'

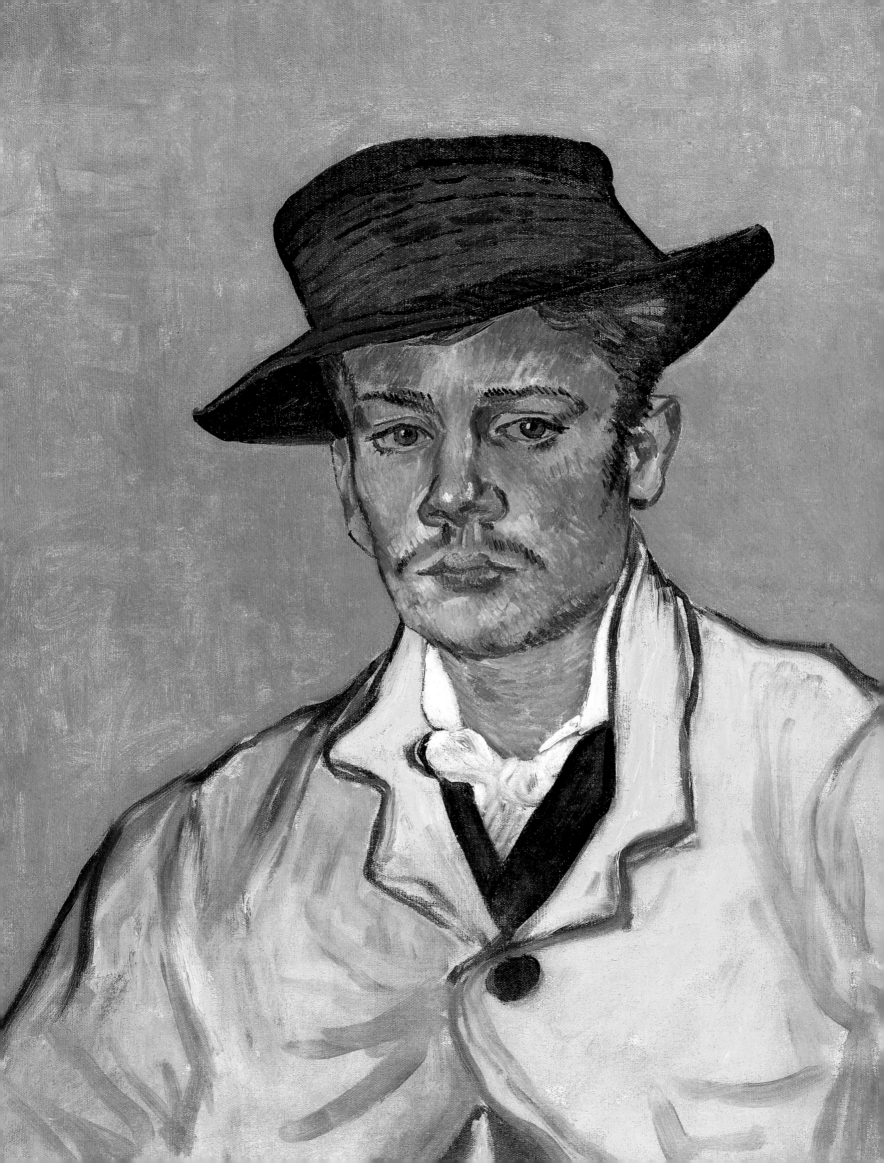

'Of course it's true that in the dark I may mistake a blue for a green, a blue-lilac for a pink-lilac, for you cannot rightly distinguish the quality of a hue. But it is the only way to get rid of the conventional night scenes with their poor sallow whitish light, whereas a simple candle already gives us the richest yellows and orange tints.'

After painting the café on the square by night, Vincent decided to tackle the Trinquetaille bridge. He wrote to his friend the Belgian painter Eugène Boch:

'And lastly a study of the Rhône – of the town lighted with gas reflected in the blue river. Over it the starry sky with the Great Bear – a sparkling of pink and green on the cobalt-blue field of the night sky, whereas the lights of the town and its ruthless reflections are red-gold and bronzed green.'

Popular imagination has left us an image of Vincent van Gogh painting at night, a ring of candles on his straw hat. It could be true

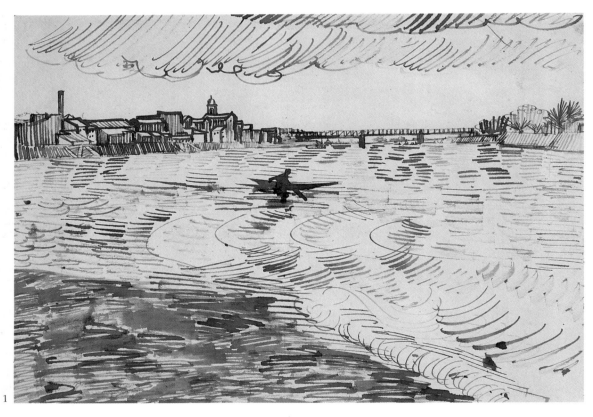

Drawn with a reed pen, *The Rhône* estuary derives from a lingering romantic imagery and has veiled affinities to certain of Delacroix' drawings

'It amuses me enormously to paint night scenes and effects and night itself on the spot. This week I have done absolutely nothing but paint and sleep and eat my meals. That means sessions of twelve hours and six hours and so on, and then sleeps of twelve hours at a stretch too.'

1 *The Rhône*, 1888
Reed pen & ink, 22.5 x 34.5 cm
Staatliche Graphische Sammlung, Munich

2 *Starry night over the Rhône*, 1888
Oil on canvas, 72.5 x 92 cm
Private collection, Paris

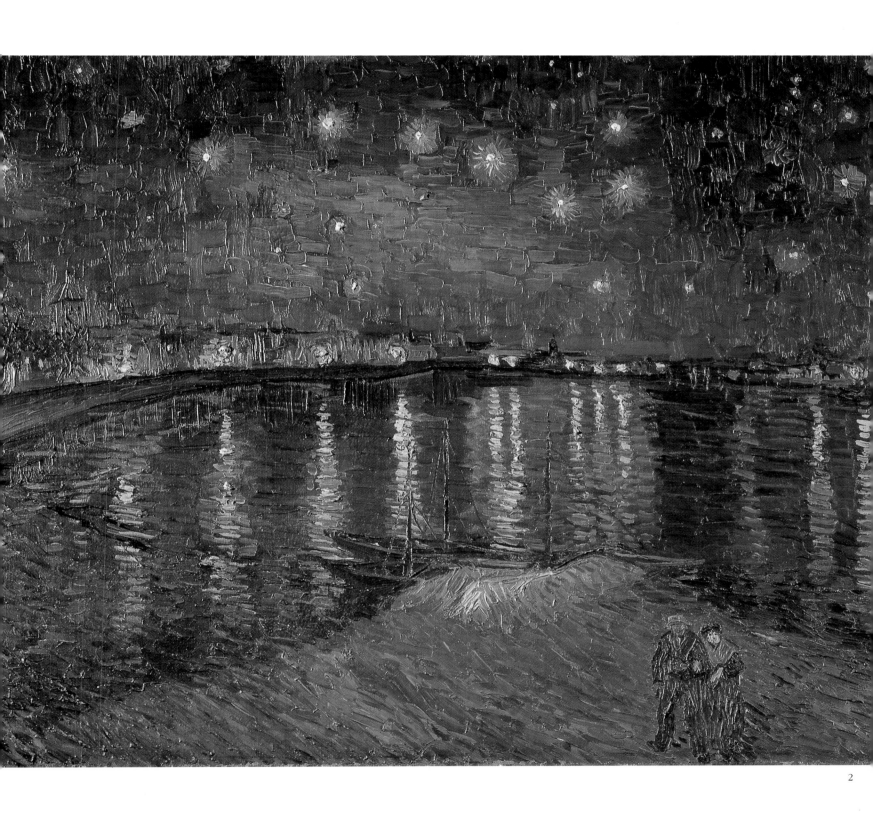

2

Suffering from loneliness, Vincent asked his friends to send him their portraits. He received three: one of Laval, one of Emile Bernard who included Gauguin in his self-portrait, and lastly one of Gauguin, dedicated to Vincent and showing a picture of Emile Bernard on the wall. Gauguin included an explanatory letter with his painting:

'I feel the need to explain what I have tried to do. The features of a powerful and ill-dressed bandit like Jean Valjean who has his own nobility and inner gentleness. Hot blood suffuses the face and the tones of the forge hearth surrounding the eyes show the fiery lava that burns in the painter's soul. The drawing of the eyes and nose resembling the flowers on Persian carpets sums up an art that is abstract and symbolic. The background appropriate to a young girl with its childlike flowers is there to attest to our artistic purity. And as for Jean Valjean, oppressed by society, outlawed on account of his love, his strength, is he not a mirror image of an Impressionist today?'

Vincent remained sceptical as to the symbolism that should attach to a self-portrait:

'That . . . gave me absolutely the impression of its representing a prisoner . . . Gauguin looks ill and tormented in his portrait . . . one can confidently put that down to his determination to make a melancholy effect, the flesh in the shadows has gone a dismal blue. . . . The Gauguin is of course remarkable, but I very much like Bernard's picture. It is just the inner vision of a painter, a few abrupt tones and a few dark lines, but it has the distinction of a real Manet. The Gauguin is more studied, carried further. . . . So now at last I have a chance to compare my painting with what the comrades are doing. My portrait, which I am sending to Gauguin in exchange, holds its own, I am sure of that. I have written to Gauguin in reply to his letter that if I might be allowed to stress my own personality in a portrait, I had done so in trying to convey in my portrait not only myself but an Impressionist in general, had conceived it as the portrait of a bonze, a simple worshipper of the eternal Buddha. And when I put Gauguin's conception and my own side by side, mine is as grave, but less despairing.'

'The third picture this week is a portrait of myself, almost colourless, in grey tones, against a background of pale malachite'

1 *Self-portrait*, 1888, Emile Bernard
Oil on canvas, 46 x 55 cm
van Gogh Foundation, Amsterdam

2 *Self-portrait*, 1888, Paul Gauguin
Oil on canvas, 43 x 54 cm
van Gogh Foundation, Amsterdam

3 *Self-portrait*, 1888
Oil on canvas, 62 x 52 cm
van Gogh Foundation, Amsterdam

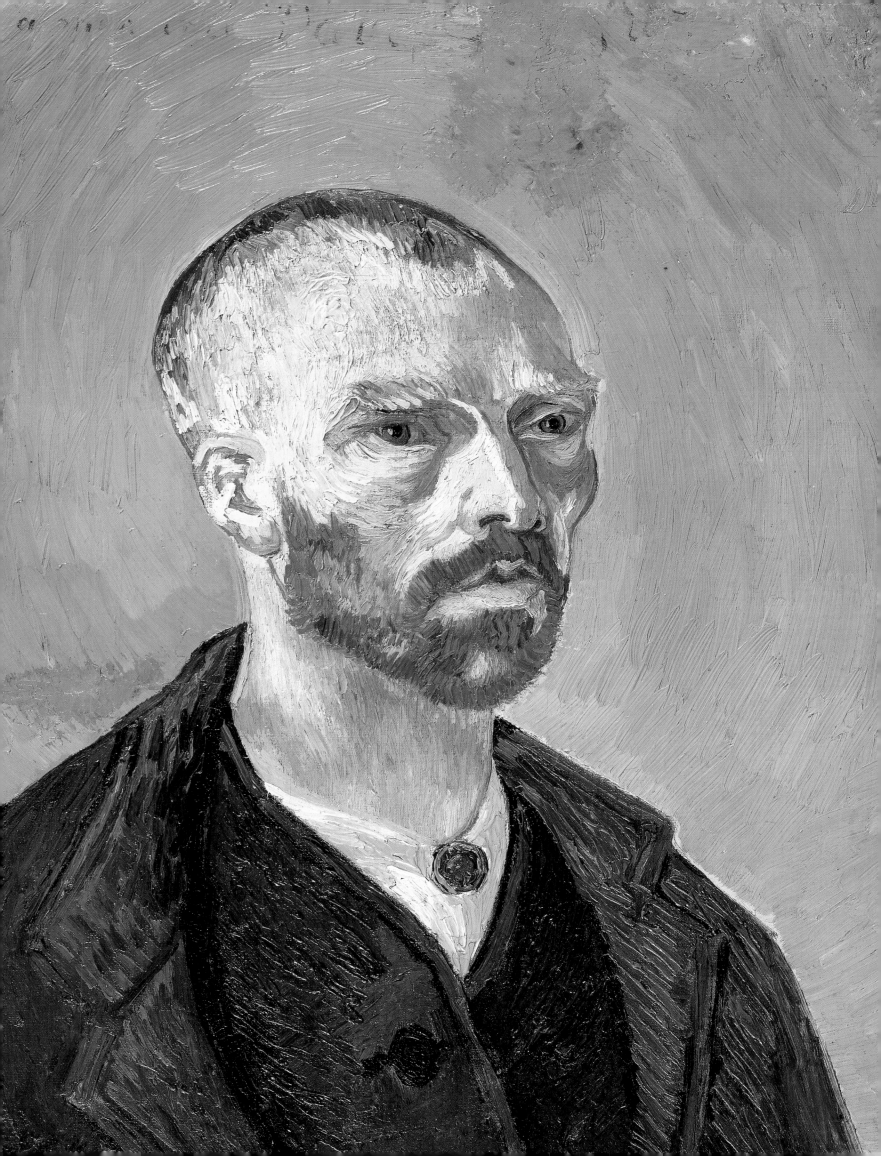

I am at last sending you a little sketch to give you an idea of the direction my work is taking. For I got down to it again today. My eyes are still tired, but I have finally got a new idea in mind so here is the sketch. Still a size 30 canvas. This time it's quite simply my bedroom, only what makes it is the colour, its simplification giving everything more style, suggesting rest or sleep in general. In short it should be restful to the mind or rather the imagination to look at the picture. The walls are pale violet. The floor is red-tiled. The wood of the bed and chairs is the yellow of fresh butter, the sheets and pillow cases very light lime. The cover is scarlet. The window green. The wash-stand orange-tinted, the basin blue. The doors lilac. And that is all – nothing in this shuttered room.

The amplitude of the furniture also has to convey the feeling of unbroken sleep. The portraits on the wall and a mirror and a hand-towel and a few clothes. The frame – as there is no white in the picture – will be white. This is my revenge for the forced rest I have been made to take. I will work on it further the whole of tomorrow, but you can see how simple the idea is. Shade is banished, no shadows cast, it is coloured in tones as plain and pure as the crépons. This will be in contrast with *The Coach to Tarascon* and *The Night Café* for example. I won't write to you long, because I want to get going very early in the morning with the first light, to finish my painting.'

At last a letter arrived bringing the good news. Gauguin was coming.

'Gauguin has written to say he has already sent off his trunk and promising to arrive around the twentieth of this month, which means in a few days. I'm pleased about this, venturing to think it will do both of us good. This bedroom is a little like the still life of *romans parisiens* with yellow, pink, green covers – you remember. But I think the workmanship is more masculine and simpler. No dotting, no hatching, nothing but plain colours, which nonetheless tone in. I don't know what I'll embark on next, as my eyes are still tired. And at moments like these, following on hard work, or more than hard work, I feel my head is empty too, to boot.'

'Well, I enormously enjoyed doing this interior of nothing at all, of a Seurat-like simplicity'

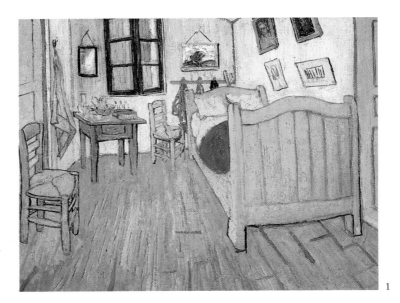

1

In the first version, Vincent featured his own portraits of his friend Eugène Boch and of 2nd Lieutenant Milliet. His joy at living in the yellow house was to be short-lived. This scene, taken from a film of Vincent Minelli's, could nonetheless be close to the truth. The local people, taking Vincent for a madman, demanded his internment

1 *Vincent's bedroom in Arles*, 1888
Oil on canvas, 72 x 90 cm
van Gogh Foundation, Amsterdam

2 *Vincent's bedroom in Arles*, 1888
Oil on canvas, 56.5 x 74 cm
Musée du Louvre, Paris

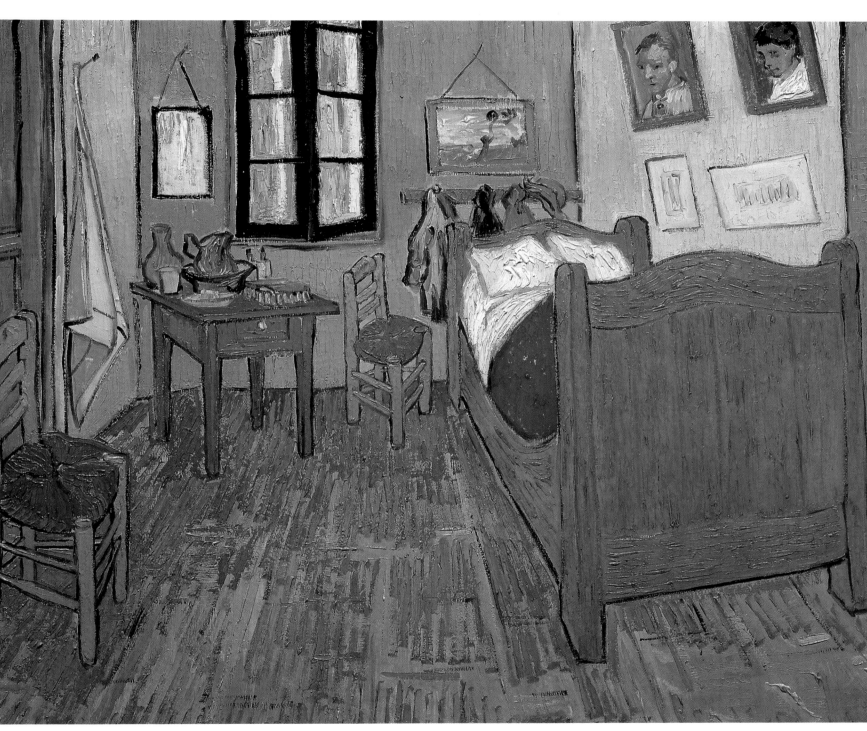

*I*n Brittany Paul Gauguin was the recognised leader of the Pont-Aven school. Although deep in debt and ailing, he was reluctant to go down to the Midi, a wholly unknown Dutch painter to be his sole companion. In Pont-Aven, he experimented and each of his disciples followed him with great interest. He dreamt of leaving for Martinique, which had enchanted him on an earlier voyage, but lacking the money he remained in Brittany. Meanwhile he kept Vincent abreast of his work:

'I have just finished a religious painting, badly done, but interesting to do and pleasing to me. I wanted to give it to the church at Pont-Aven. Of course they didn't want it. . . . Breton women gathered to pray. Clothes of very deep black. Luminous head-dresses, blue-yellow and very severe. The cow under the tree is very small in relation to real life and is kicking. For me the scenery and struggle in this picture exist only in the eyes of the people at prayer following the sermon, that is why there is a contrast between the people as they naturally are and the struggle in a setting that is unnatural and out of proportion.'

He, who was held out as the master of the abstract, had one day confided to his friend Schuffenecker:

'A piece of advice: do not paint too closely to nature. Art is an abstraction, take it from nature while dreaming in its presence and think more of the creation that will result, that is the only way to rise towards God in doing as our Divine Master, creating.'

On his arrival in Arles, Gauguin had with him a painting by Emile Bernard, Bretonne dans un champ, *which gave Vincent an opportunity to study his friend's latest work and apply its techniques to a typical Arlesian subject.*

'Gauguin, in spite of himself and in spite of me, has more or less proved to me that it is time I was varying my work a little. I am beginning to compose from memory, and all my studies will still be useful for that sort of work, recalling to me things I have seen.'

'Painting as it is now promises to become more subtle, more music and less sculpture, in short it promises colour. Would that it keep its promises'

The sermon that the congregation have just heard described Jacob's struggle with the angel. This picture of Gauguin's, exhibited in Brussels, became an example of Symbolism, mixing the real and the imaginary in its subject matter, using contrasting colours

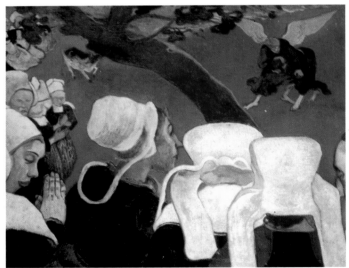

1

1 *Vision after the sermon (Jacob's struggle with the angel),* Gauguin, 1888
Oil on canvas, 73 x 92 cm
National Galleries of Scotland, Edinburgh

2 *The Dance Hall,* 1888
Oil on canvas, 65 x 81 cm
Musée du Louvre, Paris

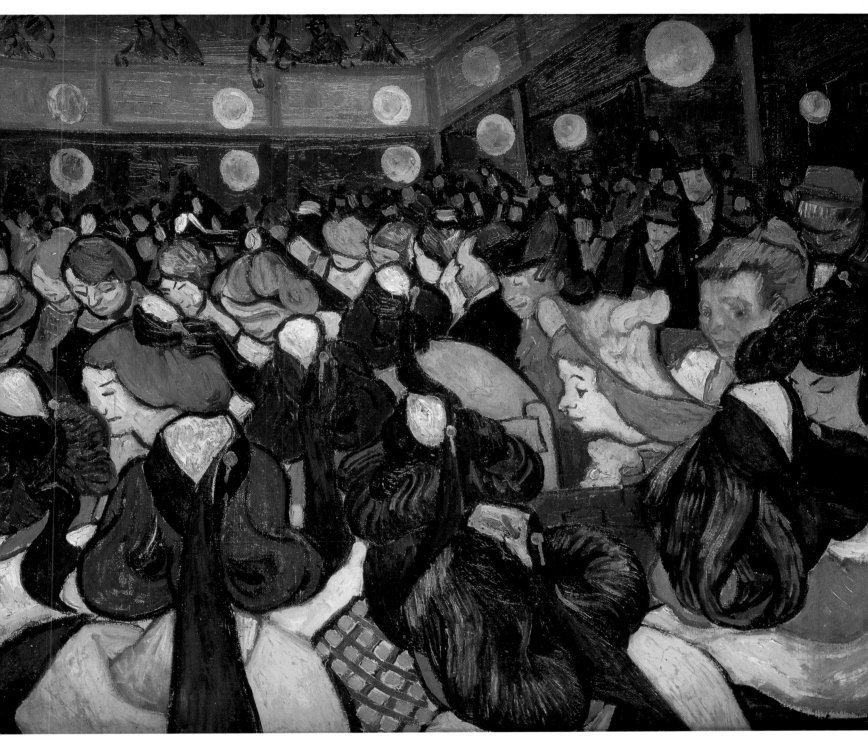

Vincent achieved a synthesis of the studies of Emile Bernard and Gauguin. His painting *The Dance Hall* is in the spirit of the Pont-Aven school, visible in the arrangement of the coifs, the Cloisonnist structure

On 23 October 1888, before dawn, Gauguin got out of the train at Arles station. In the night café where he waited for sunrise, the owner, after scrutinising his face for some while, exclaimed: 'You're his mate, I recognise you!' Ginoux, the owner, had doubtless seen the self-portrait that Gauguin had sent Vincent. All around the place Lamartine Vincent had been heard to talk of nothing but his project of a communal household, of the arrival, ever awaited and ever deferred, of the first painter, Gauguin. And now, at last, he was there. This Utopia was not exactly what Gauguin himself had in mind. Before leaving for Arles, he had written to his friend Schuffenecker:

'Rest assured, however much Theo van Gogh may love me, he is not going to rush to feed me in the Midi for the sake of my blue eyes. He made his calculations in the Dutch cold.'

He had come down to the Midi from a sense of obligation to Theo:

'Van Gogh has just taken me for 300 francs' worth of pottery. So I'm leaving at the end of the month for Arles where I think I'll stay a long time, in the hope that that period will enable me to work without financial anxieties, until he manages to launch me.'

He never spoke of joy at his reunion with Vincent. Vincent reassured his brother:

'He is very interesting as a man, and I am wholly confident we will do many things together. He will probably produce a great deal here, and I hope perhaps I will too.'

A few days later his optimism was unaffected:

'As for myself, I am very happy to have such a good companion as Gauguin.'

Soon work began on the motif. Their subject was the same, but the two painters did not portray it from the same point of view. Gauguin was bored of Pont-Aven and spoke only of the islands he had seen in the course of his many voyages.

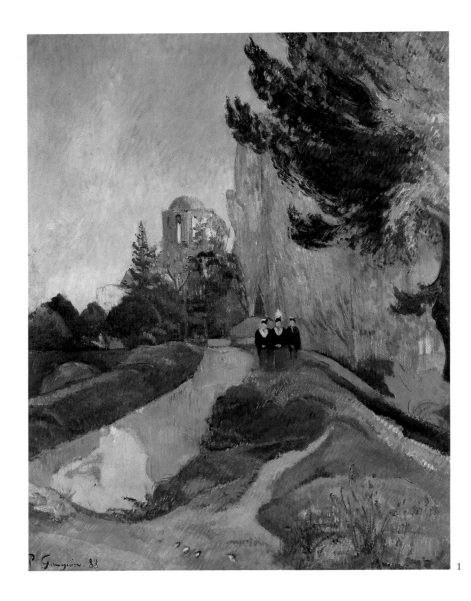

1

To paint the Roman way, *Les Alyscamps,* Gauguin took up a position outside the avenue. From where he stood, Saint-Honorat emerged from the trees in the background. His figures, betraying a touch of nostalgia, are in Breton costume. Installed on the other side, Vincent painted from a higher position. He had set up his easel on the embankment, two metres high, separating the Roman way from the Craponne canal. There is a touch of Daumier in Vincent's figures

1 *Les Alyscamps,* Gauguin, 1888
Oil on canvas, 92 x 73 cm
Musée d'Orsay, Paris

2 *Les Alyscamps,* 1888
Oil on canvas, 73 x 92 cm
Kröller-Müller Foundation, Otterlo

Following pages:
1 *L'Arlésienne,* 1888
Oil on canvas, 90 x 72 cm
Metropolitan Museum, New York

2 *In the café,* 1888
Oil on canvas, 73 x 92 cm
Pushkin Museum, Moscow

3 *L'Arlésienne,* 1890
Oil on canvas, 65 x 54 cm
Museu de Arte, São Paulo

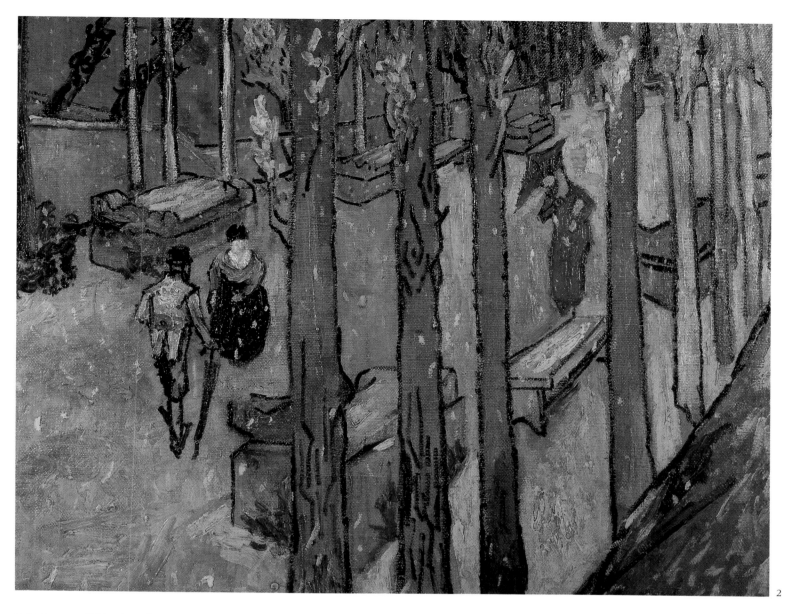

'I think you will like the falling leaves that I have done. It is some poplar trunks in lilac cut by the frame where the leaves begin. The tree-trunks are lined like pillars along an avenue where there are rows of old Roman tombs of a blue lilac right and left. And then the soil is covered with a thick carpet of yellow and orange fallen leaves. And they are still falling like flakes of snow. And in the avenue, little black figures of lovers. The upper part of the picture is a bright green meadow, and no sky, or almost none. The second canvas is the same avenue but with an old fellow and a woman as fat and round as a ball'

'Our discussions tend to be about the terrible subject of a certain group of painters'

I n the evenings Vincent and Gauguin went out into the town:

'Now something that will interest you – we have made some excursions to the brothels, and it is probable that in the end we shall often go and work there. At the moment Gauguin is working on a canvas of the same night café I painted too, but with figures seen in the brothels. It promises to turn out beautiful.'

If Vincent sounded enthusiastic, the same was not true of Gauguin who did not feel much at ease in his Arlesian surroundings:

'I have also done a café, which Vincent likes very much and I like less. In the end, this is not my scene and the local colour, vulgar as it is, does not suit me. Above, red paper, three prostitutes. One, her head bristling with curl papers, the second, back view in a green shawl. The third in a bright red shawl, on the left a man asleep, Bichard. In the foreground a fairly well-worked figure, l'Ar-lésienne, in a black shawl, with white voile at the front. A marble table. Running across the picture, a band of blue smoke, but the figure in the foreground is much too proper . . .'

Friends of Vincent's posed for this picture. Madame Ginoux, the wife of the café owner, in the foreground; the zouave, who sat for Vincent on a number of occasions; and the recognisable postman Roulin always will-ing to be of service. Gauguin was to do a preliminary drawing for a painting. Vincent tossed off his painting in under an hour.

'At last I've an Arlésienne, a figure dashed off in an hour, the background pale citron, the face grey, the clothes black, black, black, of raw Prussian blue. She is leaning upon a green table and seated on an armchair of orange-coloured wood.'

Vincent painted two versions of the portrait of Mme Ginoux and it is hard today to tell which was done in three-quarters of an hour. What is certain is that his astonishing facility must have exasperated Gauguin who worked long on his canvases. Vincent was to produce a version of l'Arlésienne in Saint-Rémy after Gauguin's preliminary drawing.

'Here is a portrait painted in three-quarters of an hour'

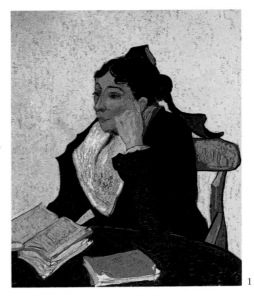

1

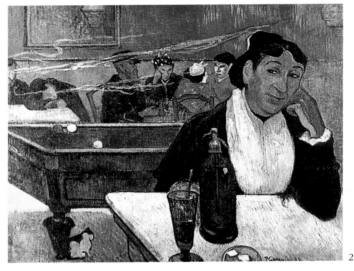

2

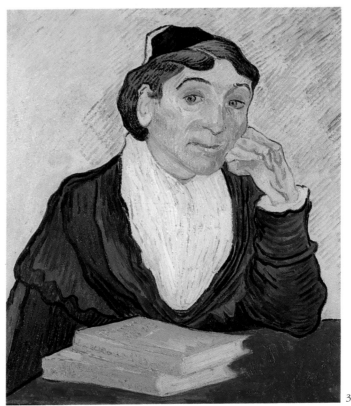

3

4 *L'Arlésienne*, 1888
Oil on canvas, 93 x 74 cm
Musée du Louvre, Paris

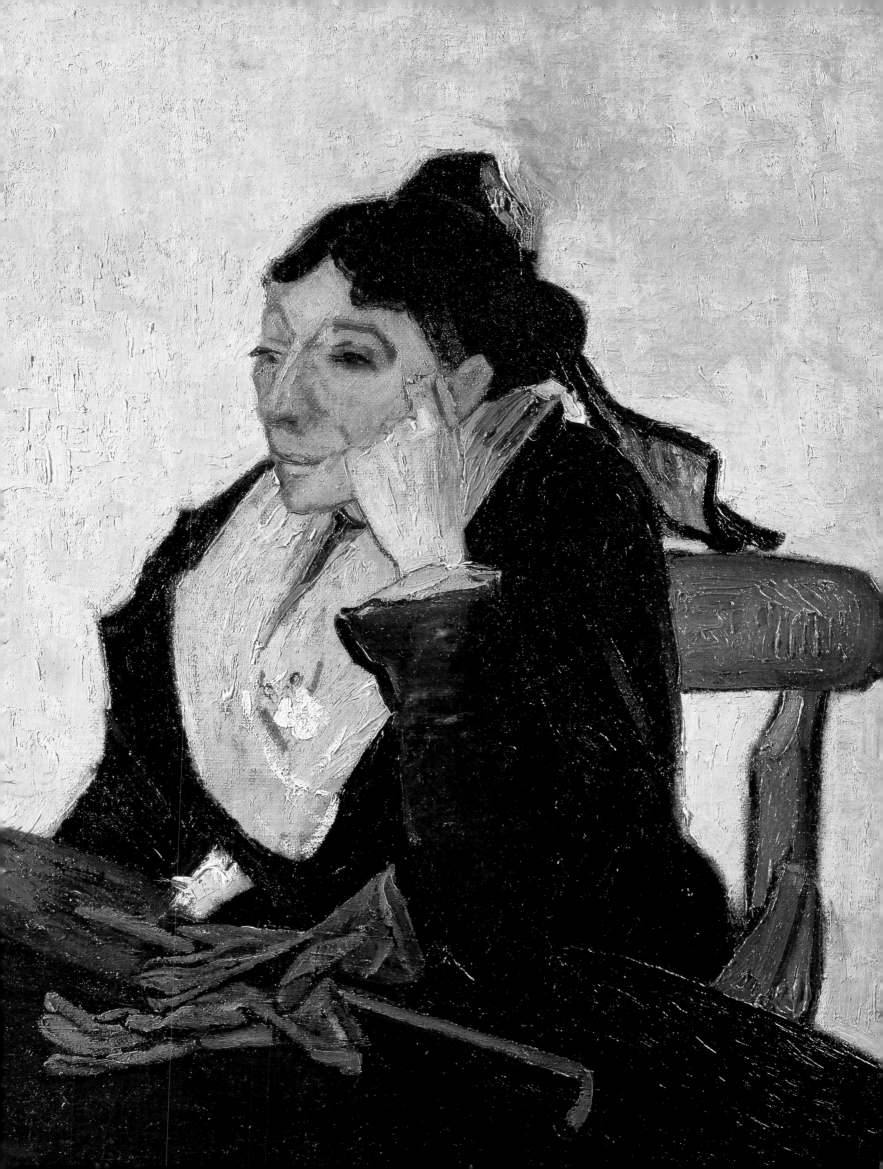

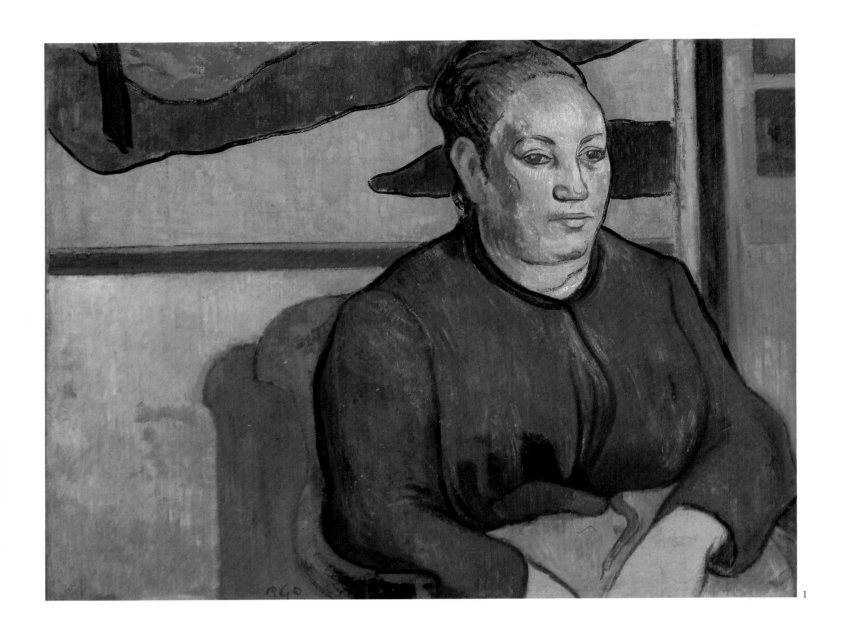

'Portraits of people in the light of a gas lamp,
it certainly seems to me it can be done'

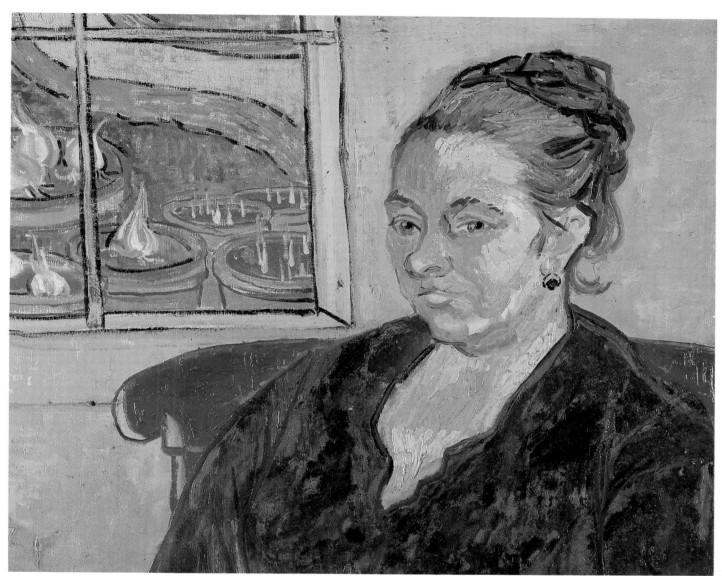

2

Everyone in the Roulin family had had their portrait painted by Vincent except Mme Roulin. Finally she sat for him and for Gauguin. The two men painted their portraits in December, both shut away in the studio. 'Our days are spent in working, always working, the evenings we are exhausted and go to the café, then to bed at a civilised hour after! Such is life.' Gauguin began to lose patience, he found everything 'so small, so mean . . . the landscape and the people'. Keeping to his own smooth finish, he hated Vincent's way of thickly laying on the paint. He didn't like Monticelli and failed to win Vincent over to Degas. Vincent saw Daumier everywhere, Gauguin tended more to Puvis de Chavannes. Into his portrait of Mme Roulin, Gauguin inserted one of his paintings, *Les Arbres bleus,* strongly influenced by Cloisonnism. Vincent, on the other hand, added a window and a garden to soften the portrait.

1 *Madame Roulin,* 1888, Gauguin
Oil on canvas, 49 x 62 cm
Art Museum, St Louis

2 *Madame Roulin,* 1888
Oil on canvas, 54 x 65 cm
Oskar Reinhart Collection, Winterthur

Vincent, too diffident, never asked Gauguin to sit for him. Instead he painted his chair, as a form of discreet homage. The tension between the two men was marked. Gauguin, a painter owing much to will-power, in contrast to Vincent, a painter of passion and intuition. Gauguin, like Theo's Parisian friends, criticised Vincent for painting too rapidly, but this was Vincent's chosen way of working.

'Fortunately for me, I know well enough what I want, and am basically utterly indifferent to the criticism that I work too hurriedly . . . the last two studies are odd enough. Size 30 canvases, a wooden rush-bottomed chair all yellow on red tiles against a wall (daytime). Then Gauguin's armchair, red and green night effect, walls and floor red and green again, on the seat two novels and a candle, on thin canvas with a thick impasto.'

Gauguin, however, had Vincent sit for him. He chose to portray him painting the sunflowers he so loved.

'I had the idea of doing a portrait of him at work on a still life of sunflowers which he so loved. And when the portrait was done, he said to me "It is clearly myself, but myself gone mad."'

As a final token of gratitude before he left for Paris, Gauguin gave the painting to Theo:
'From a literal point of view it is perhaps not very like him but there is something there of his inner self, so if you have no objection keep it, unless of course it doesn't please you.'

The two painters then paid a visit to the museum at Montpellier. Something that should have proved a diversion, managed to come between them. On their return the arguments grew acrimonious:

'Gauguin and I talked a lot about Delacroix, Rembrandt, etc. Our arguments are terribly electric, sometimes we come out of them with our heads as exhausted as a used electric battery.'

The following letter shows how the situation deteriorated:

'I think myself that Gauguin was a little out of sorts with the good town of Arles, the little yellow house where we work, and especially with me.'

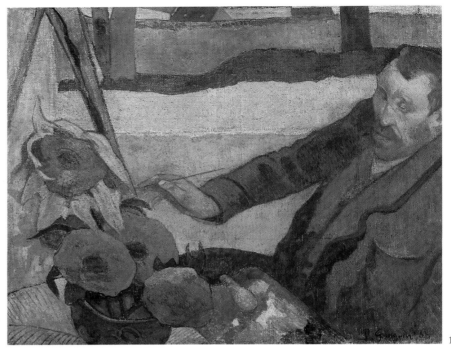

2

These two large still lifes, painted by Vincent on a vast canvas bought by Gauguin on his arrival in Arles, serve as a pertinent comment on the characters of the two men. In the first picture, life in its simplicity, a box full of onions in the background. In the second, a comfortable armchair, on which rest two books, representing the learning of the self-educated man: the armchair is that of Gauguin, whose spirit of awareness brought illumination as a candle brings light.
The two paintings gave Vincent an opportunity to transpose the light and shade effects he had so admired in Rembrandt's work, though his range of colour seems to be directly inherited from Delacroix: 'I think of Rembrandt the more because he cannot figure in my studies'

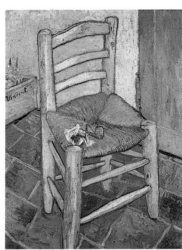

2

'It is certainly myself, extremely tired and charged with electricity as I was at that time . . .'

1 *Vincent van Gogh painting sunflowers*, 1888, Gauguin
Oil on canvas, 73 x 92 cm
van Gogh Foundation, Amsterdam

2 *Vincent's chair with his pipe*, 1888
Oil on canvas, 92 x 73 cm
National Gallery, London

3 *Gauguin's armchair*, 1888
Oil on canvas, 90.5 x 72 cm
van Gogh Foundation, Amsterdam

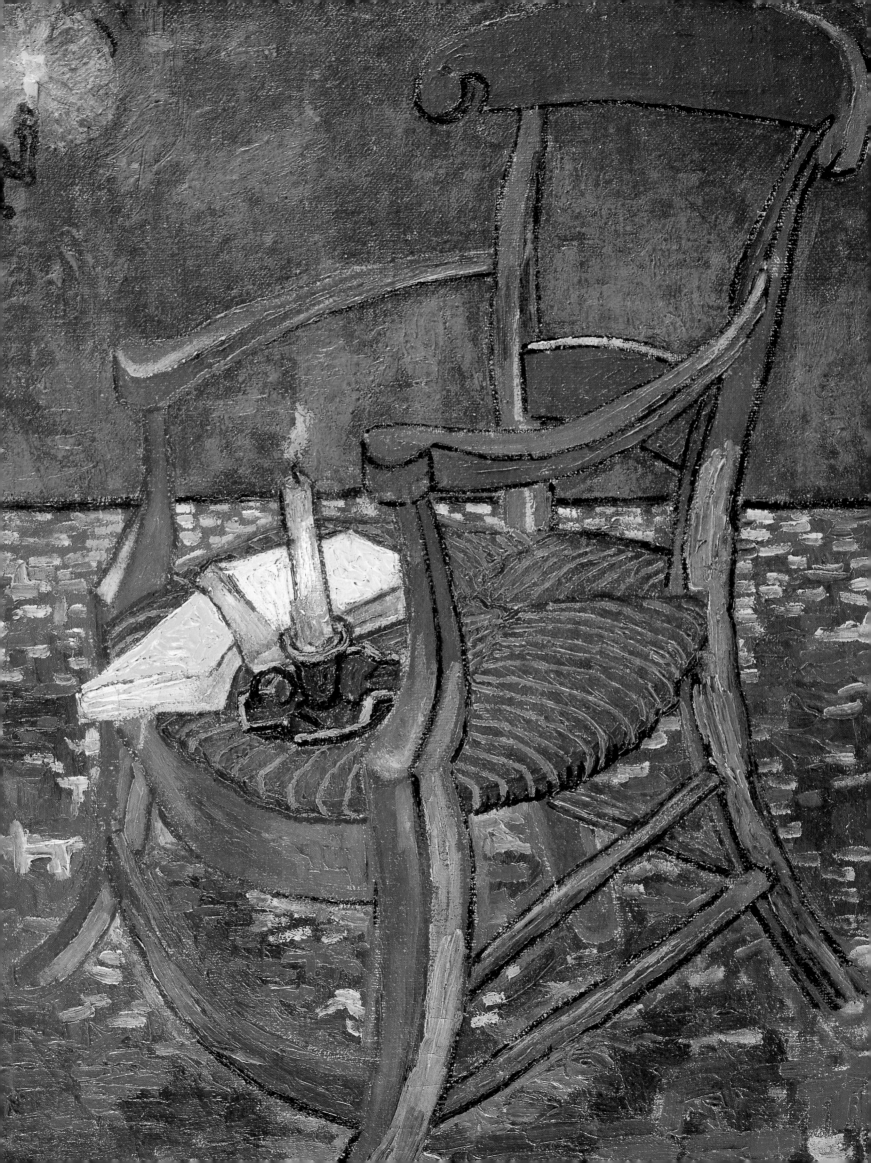

Gauguin:

'Between two beings, he and I, one a volcano, the other at boiling point too, but inwardly so, there was, as it were, a conflict building up.'

The conflict came to a head. Gauguin tried to impose on Vincent a new style of painting:

'He achieved only gentle, unfinished, monotone harmonies; the sound of the bugle was lacking. I undertook to bring enlightenment, which was easy for me, because I found a rich and fertile ground. From that day, my van Gogh made astonishing progress.'

However Gauguin found that his pupil did not entirely live up to these boasts. He wrote to Theo:

'I would be much obliged if you could send me a proportion of the money from the pictures sold. All in all, I am forced to return to Paris. Vincent and I simply cannot live cheek by jowl without trouble because of the incompatibility of our temperaments and he and I both need calm for our work. He is a man of remarkable intelligence, whom I hold in high esteem and leave with regret, but I repeat, it is necessary.'

Gauguin's departure, as Theo's marriage drew near, proved a terrible shock. Once again Vincent saw all his hopes dashed to the ground. The weeks he had spent decorating the yellow house, Gauguin's room, his unremitting efforts to achieve perfection, his constant dearth of models, his loneliness, all contributed to a depression. Vincent was unable to endure the reality of his present situation: nobody could bear to live with him. His dream of a studio in the Midi was to disappear with Gauguin, who recounted:

'When evening came, I snatched some dinner and felt a need to go out alone for some air in the scent of the flowering laurels. I had virtually crossed place Victor-Hugo when I heard a familiar little step come up behind me in rapid fits and starts. I turned at the very moment that Vincent hurled himself at me, a naked razor in his hand. My look at that instant must have been fairly powerful because he stopped short and, lowering his head, went running back towards the house.'

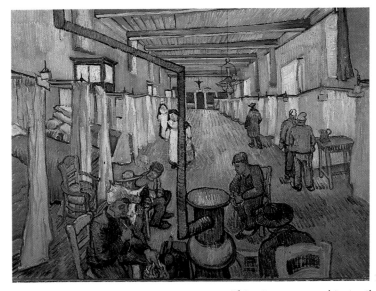

This picture, started in April 1889, shortly before he left Arles, was completed from memory by Vincent at the asylum of Saint-Paul-de-Mausole. Vincent drew his inspiration from Gustave Doré

The young house physician, Dr Rey, treated Vincent at the Arles hospital. He quickly came to sympathise with the painter and agreed to sit for him. The doctor's mother hated the portrait Vincent did of him and relegated it to an attic. It was then used to fill in a gap in the hen-house. Now it is in the Pushkin Museum in Moscow

'My dear friend Gauguin, I take advantage of my first outing from hospital to write you a few words of deep and sincere friendship'

1 and detail on right
Hospital in Arles, 1889
Oil on canvas, 74 x 92 cm
Oskar Reinhart Collection, Winterhur

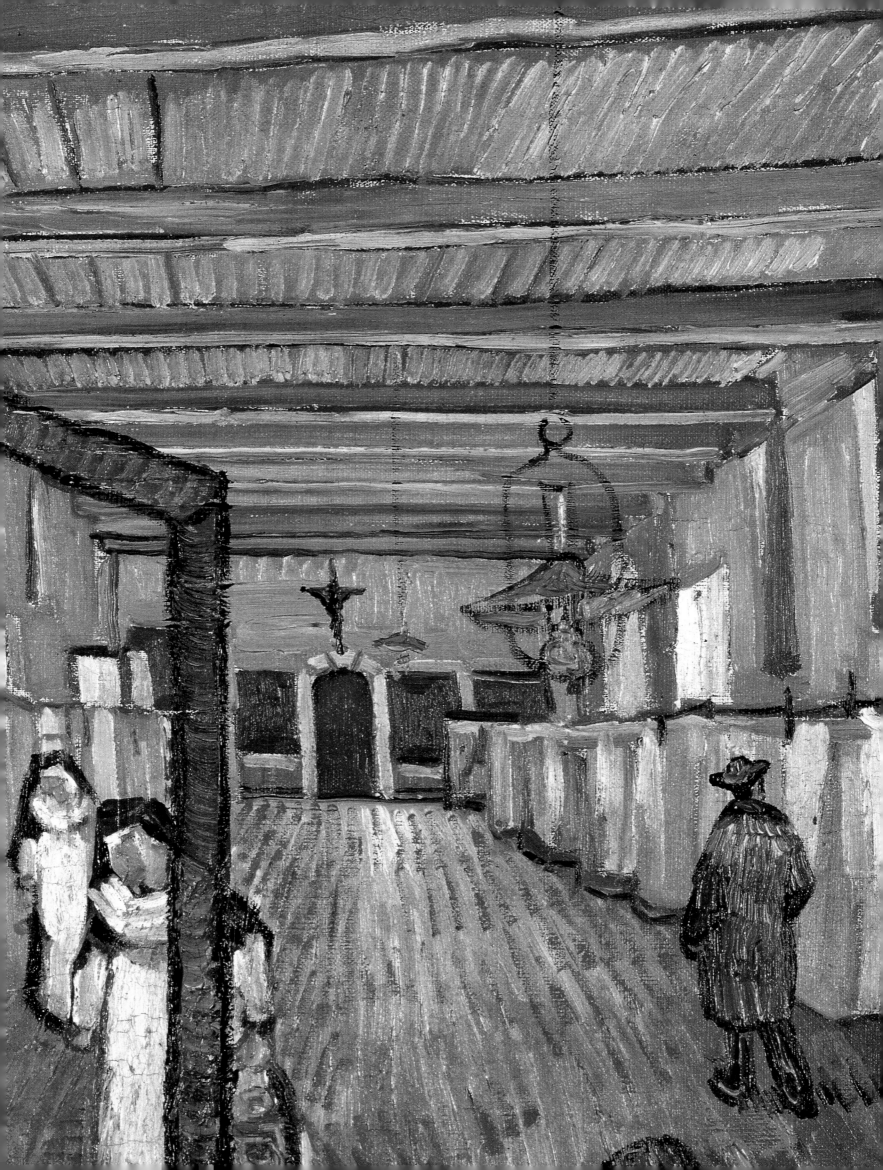

When Gauguin returned to the yellow house the following morning to collect his belongings, he found a swarm of people. He entered the house and two gendarmes asked him what had happened. Gauguin knew nothing. Back in his room, Vincent had been seized by a fit of madness. To punish himself for all his failures, he had cut off his ear lobe in an expiatory self-mutilation. Having tried to stop the bleeding, he had wrapped up the morsel of flesh and taken it to Gaby (Rachel), a prostitute in a brothel. She had fainted. The gendarmes had been called ... Gauguin, panic-stricken, insisted Vincent be taken to hospital. He sent a telegram to Theo, asking him to come without delay, then left for Paris. In the hospital Vincent was shut into a cell. Theo came to Arles and contacted a pastor, so critical in the doctor's eyes was Vincent's condition. Two days later he returned to Paris. Vincent thought he might be confined. Dr Rey, who attended him, let himself be persuaded by the postman Roulin and allowed Vincent to go out in the daytime to work; but Vincent had to return daily to hospital for his dressing to be changed. All his neighbours and friends came to see him. Roulin, after one of his visits, wrote to Theo: 'My friend Vincent is completely cured. . . . Now he is free in the hospital, we walked for over an hour in the courtyard, he is very healthy in spirit, I do not know how to account for the severe restraints they have placed on him, depriving him of the visits of his best friends.' Vincent returned to his work and wrote to Theo:

'Perhaps I shall not write you a very long letter today, but anyway a line to let you know that I got back home today. I do so regret that you had all that trouble for such a trifle. Forgive me, who am after all probably the primary cause of it all.'

But he was soon seized by fresh hallucinations and thought he was being poisoned. He had to be admitted to hospital again. On his discharge, he found there had been a change of attitude among the local people. Vincent aroused fear. A petition called for his confinement. After Roulin's departure to Marseilles, Vincent was left to struggle alone against the hostility of the Arlesians. He asked his brother to take charge of the formalities required for his admission to an asylum.

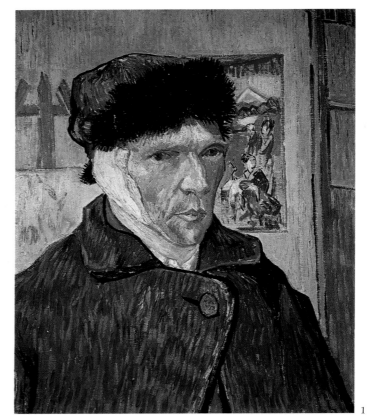

1

Back in his studio, Vincent painted two self-portraits with a bandaged ear. The first was a chromatic demonstration which displays all the complementary colour pairings. The second, reproduced above, shows him paler, more serene. He has again associated himself with the Japanese prints he so loved

'I hope I have had no more than the simple passing madness of an artist'

'If the police had protected my liberty by stopping the children and also the grown-ups from gathering round my house and clambering up to the windows as they've done (as if I were a strange beast), I would have remained calmer; in any case, I have done no one any harm'

1 *Self-portrait with a bandaged ear*, 1889
Oil on canvas, 60 x 29 cm
Courtauld Institute Gallery, London

2 *Hospital garden, Arles*, 1889
Oil on canvas, 73 x 92 cm
Oskar Reinhart Collection, Winterthur

*'And for the time being I wish to remain in confinement
as much for my own peace of mind as for other people's'*

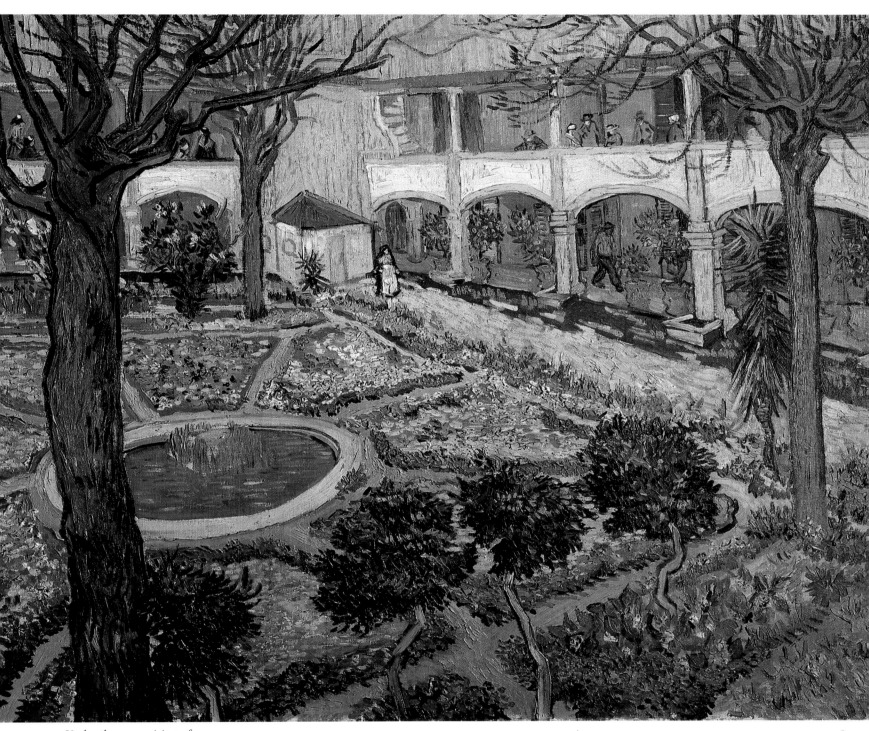

Under the supervision of
Dr Rey, Vincent painted the
hospital garden. Rey and the
other doctors respected
Vincent's work: 'M. Rey came to
see my painting with two of his
doctor friends, and they
understood incredibly quickly
what complementary colours
are'

2

On 8 May 1889, Vincent left Arles and his yellow house accompanied by Pastor Salles. They went to the asylum of Saint-Paul-de-Mausole, two kilometres from Saint-Rémy-de-Provence, near the ruins of Glanum in the heart of the Alpilles. Vincent explained his own case to Dr Peyron. The director, a former doctor in the navy and a worthy fellow but with no knowledge whatsoever of nervous complaints, gave him no definite therapy. He carefully noted on van Gogh's admission sheet: 'This patient

Saint Rémy

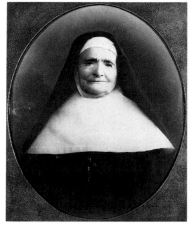

Sister Epiphane

On 8 May 1889, Vincent, accompanied by Pastor Salles, arrived at the asylum of Saint-Paul-de-Mausole, near Saint-Rémy-de-Provence. He was admitted by Dr Peyron who formulated his diagnosis and prescribed a vague treatment. The care of his soul fell to the mother superior, Mme Deschanel, Sister Epiphane in religious life. She doubtless sat for the *Pietà* Vincent painted at the asylum after Delacroix

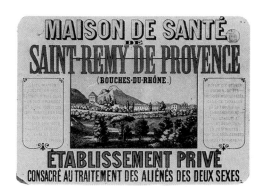

comes from the hospital in Arles which he entered following an acute attack of mania which occurred suddenly, accompanied by hallucinations of sight and of hearing which terrified him. During this attack, he severed his left ear, but he has only a very vague recollection of all this.' Dr Peyron concluded his diagnosis by adding that, in his opinion, the patient suffered from epileptic fits at frequent intervals and that a period of observation was essential. Theo and Johanna, his young wife, sent letters of encouragement from Paris. Vincent, who spent nearly a year voluntarily confined to his prison, wrote moving letters to his brother which the loyal Theo always answered. In his letters he entertained Vincent with tales of the artistic life of Paris, of new ideas, so that Vincent should not feel abandoned; above all, that he should not feel lonely. Vincent reassured him: 'I wanted to say to you that I think I did well to come here; above all, on seeing the reality of a mad person's life, a variety of crazy types, I lose my vague fear, my terror of the thing. And little by little will be able to consider madness an illness like any other.' While the crises in Arles occurred between the engagement and the marriage of Theo, those in Saint-Rémy coincided with the announcement of Johanna's pregnancy, the imminence of the delivery and birth, as if each time that Theo lived his own life a part of his affection must inevitably be withdrawn from Vincent.

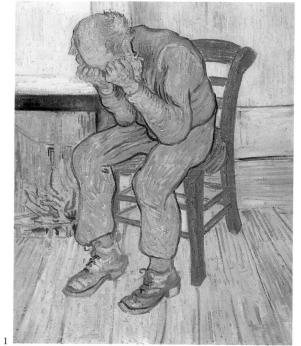

1

1
At Eternity's Gate, an old man collapsed on a chair, is a subject to which Vincent often returned. In his youth he had drawn an exhausted peasant woman in the same position

2
In *Saint-Paul's hospital,* Vincent deliberately reduces the importance of the institution. He exaggerates the pine tree towering in the foreground, so that it seems to reach out of the canvas from a background of harsh blue sky

1 *At Eternity's Gate,* 1890
Oil on canvas, 81 x 65 cm
Kröller-Müller Foundation, Otterlo

2 *Saint-Paul's hospital,* 1889
Oil on canvas, 58 x 45 cm
Musée d'Orsay, Paris

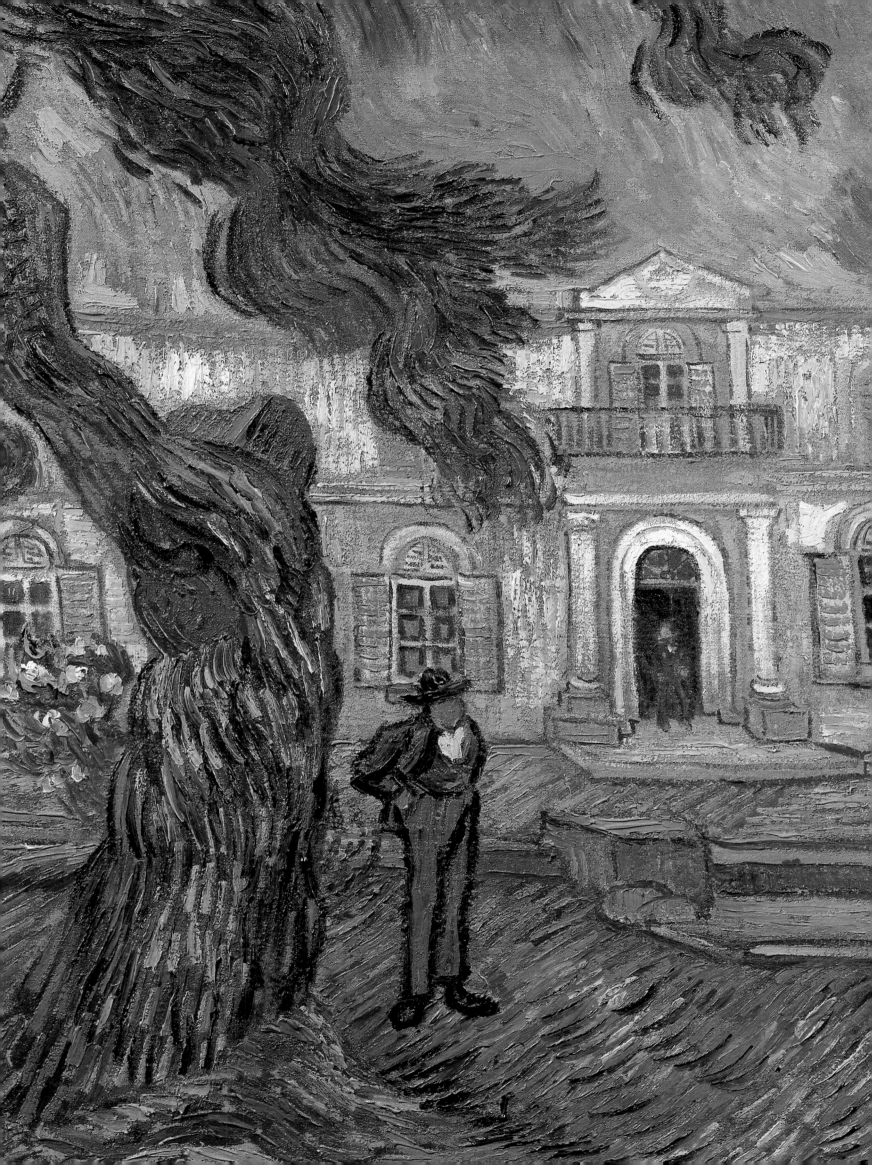

The period in the asylum bore its first fruits: a regular life, meals at set times and a long bath twice a week seemed to restore Vincent. He returned to painting. He was not yet allowed to go out, but he could paint in the garden. He wrote to Theo, two weeks after his arrival: 'Since I have been here, the deserted garden, planted with large pines beneath which the grass grows tall and unkempt and mixed with various weeds, has sufficed for my work, and I have not yet gone outside. However the country round Saint-Rémy is very beautiful and little by little I shall probably widen my field of endeavour.'

He practised his drawing and painted the magnificent irises which grew randomly on the edge of the flowerbeds in the men's quarter. With acute sensibility, he painted these flowers of an intense blue, an almost pure colour. One can observe a connection between Vincent's illness and his output. A certain substance in the blue betrays imminent crisis. Still suffering the torment of his arrival at Saint-Rémy, Vincent painted irises, trapped, like himself, in the frame of the picture. The sense of suffocation he felt translated itself into a bed of flowers without any sky. The following year, in May 1890, a few days before leaving Saint-Rémy to go back to the Paris area and the rest of the world, Vincent returned to the same theme, but this time handled it in a more reconciled manner. He chose to juxtapose yellows and blues, in memory of Georges Seurat who had taught him the secret of complementary colours. This mastery was a demonstration of his perfect mental equilibrium: 'Things are going better at the moment, the horrible crisis has passed like a thunderstorm and I am at work here, putting the finishing touches with calm and uninterrupted fervour. I have a painting in hand . . . ; a purple bouquet (going as far as carmine and pure Prussian blue), standing out against a brilliant citron-yellow background, with other yellow tones in the vase and the stand on which it rests, is a work of disparate and extreme complementary colours which excite by their opposition.'

'I always feel remorseful – enormously so – when I think of my work, so little in accordance with what I should like to have done'

1/2
In the loneliness of his cell, Vincent painted still lifes, featuring irises, bouquets of flowers, gathered in the courtyard of the men's quarters to be shut away like himself behind bars. In the play of shades of colour, the proportions of the table, the asymmetrical representation of the vase, he returned to the manner of his Arlesian sunflowers. Then he drew the fountain in the courtyard, awaiting the day when he could at last go free

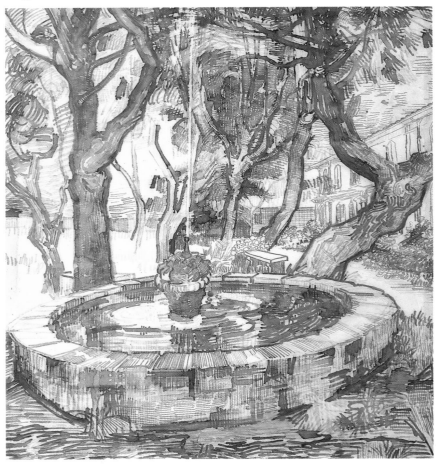

1 *Fountain in the garden of Saint-Paul's hospital,* 1889
Reed pen & India ink, 45 x 48 cm
van Gogh Foundation, Amsterdam

2 *Irises,* 1890
Oil on canvas, 92 x 73.5 cm
van Gogh Foundation, Amsterdam

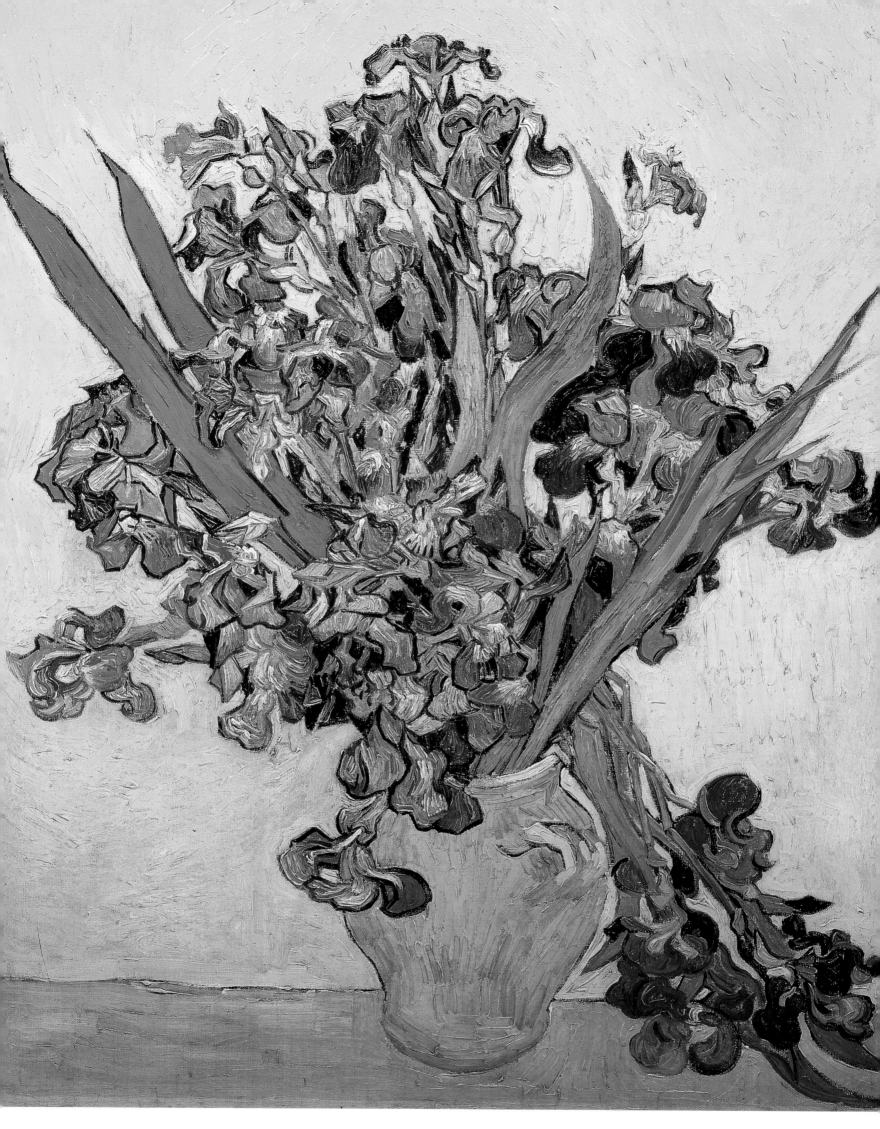

The company of the other inmates seemed to reassure Vincent as to his own condition. He wrote to Theo: 'I gather from others that during their attacks they have also heard strange sounds and voices as I did, and that in their eyes too things seemed to be changing. And that lessens the horror that I retained at first of the attack I have had, and which, when it comes on you unawares, cannot but frighten you beyond measure. Once you know that it is part of the disease, you take it like anything else. If I had not seen other lunatics close up, I should not have been able to free myself from dwelling on it constantly ... I really think that ... once you are conscious of your condition and of being subject to attacks, then you can do something yourself to prevent your being taken unawares by the suffering or the terror.'

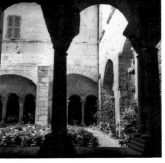

1/2
Theo wanted to know what life his brother led in the asylum. Vincent painted the corridor leading to his room, the vestibule giving on to the courtyard and its window. The heavy outlines and hatchings, the dull range of colour, are probably due to the subject rather than a deliberate interpretation of Vincent's tending towards Expressionism.

' ... all the empty rooms, the great corridors'

He reassured himself, and doubtless reassured Theo, describing to him those more wretched than himself: ' ... these poor souls do absolutely nothing ... they have no other daily distraction than to stuff themselves with chick peas, beans, lentils, and other groceries and merchandise from the colonies in fixed quantities and at regular hours ... the fear of madness is leaving me to a great extent, as I see at close quarters those who are affected by it ...'

What saved him was his painting. It kept his mind sharp and alert: 'Extreme enervation is, in my opinion, what most of those who have been here for years suffer from. Now my work will preserve me from that to a certain extent.'

Vincent grew rapidly accustomed, however, to his austere surroundings. He portrayed his closed world on canvas and by 25 June 1889 already had twelve pictures in hand. Striving to communicate his emotions, he painted his universe, comprised of long passages, corridors closed by heavy grilles. Given permission to go to Arles to collect some of his belongings, he hoped to see Dr Rey and Pastor Salles there. Unfortunately neither of those men was in town and Vincent had to leave without catching sight of them. A few days after his return to the hospice, he had an attack while he was painting. This attack was followed by a long torpor which lasted until the end of August 1889.

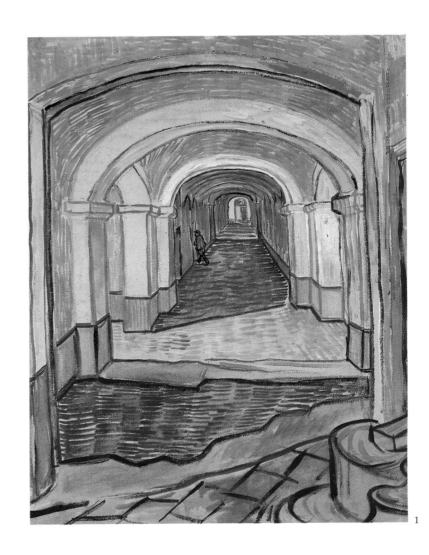

1 *A passage at Saint-Paul's hospital*, 1889
Black chalk & gouache on pink Ingres paper,
61.5 x 47 cm
Museum of Modern Art, New York

2 *The vestibule of Saint-Paul's hospital*, 1889
Black chalk & gouache on pink Ingres paper,
61 x 47 cm
van Gogh Foundation, Amsterdam

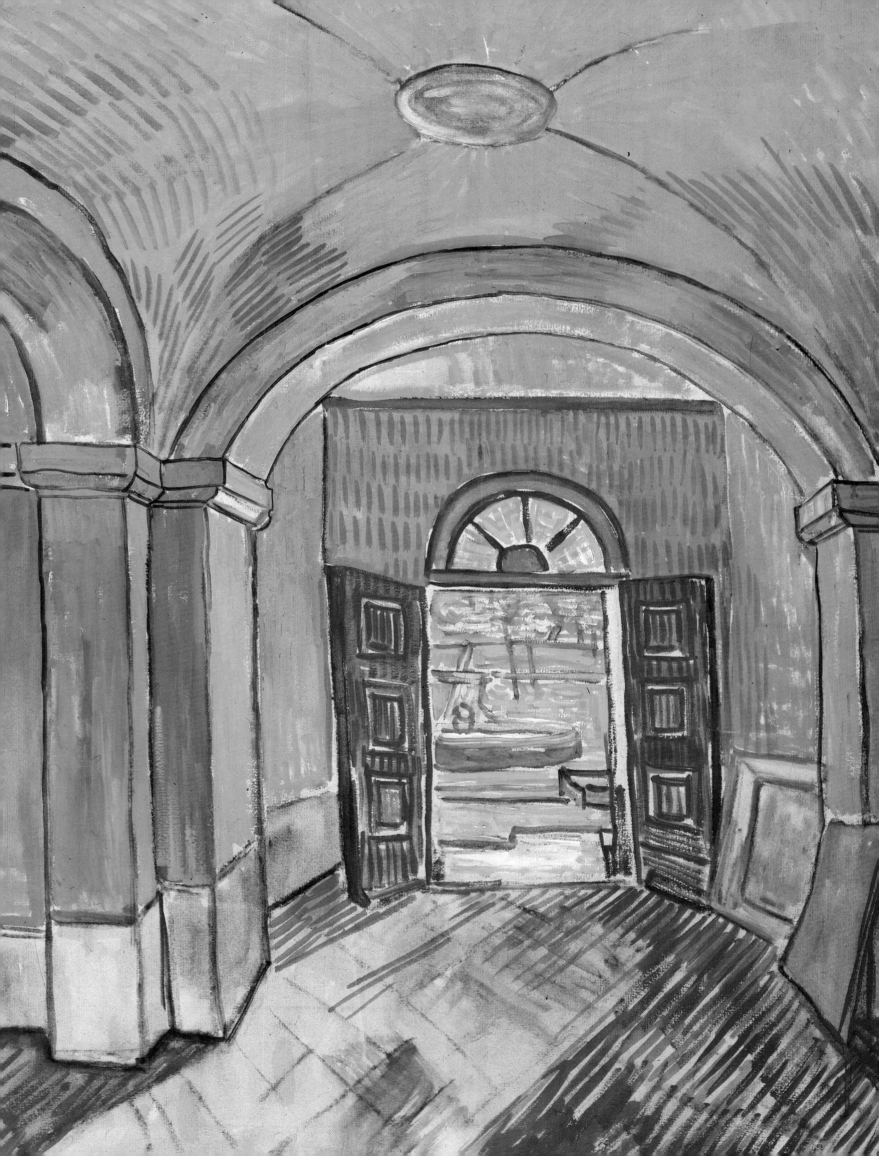

From his prison, Vincent wrote long letters to Theo, as if to fill the silence that invaded the studio as soon as the scratching of brush on canvas went quiet. The asylum, which he had initially expected to prove salutary, gradually became like a boarding house. . . . 'One has rented a room from them for a specified time and they get well paid for what they provide and that is absolutely all.' Now it was clear to him that he would not be cured at Saint-Rémy. In a sullen, almost weary, frame of mind he wrote to his brother in September 1889 to say that a fresh attack was threatening. In three months perhaps it would strike him down, leave him stupefied and useless, to live off Theo's money with no painting to give in return. As if to steal a march on his affliction, as if his days were numbered, he worked: 'I am working like one actually possessed, more than ever I am in a dumb fury of work. And I think that this will help cure me. . . . Yesterday I began the portrait of the head attendant, and perhaps I shall do one of his wife too, for he is married and lives in a little house a few steps away from the establishment. A very interesting face, there is a fine etching by Legros, representing an old Spanish grandee, if you remember it, that will give you an idea of the type. He was at the hospital in Marseilles through two periods of cholera, altogether he is a man who has seen an enormous amount of suffering and death, and there is a sort of contemplative calm in his face, so that I can't help being reminded of Guizot's face – for there is something of that in this head, but different. But he is of the people and simpler. Anyway, you will see it if I succeed with it and if I make a duplicate.'

'I could stay here quite a long time; never have I been as tranquil as here and in the Arles hospice, able at last to paint a little'

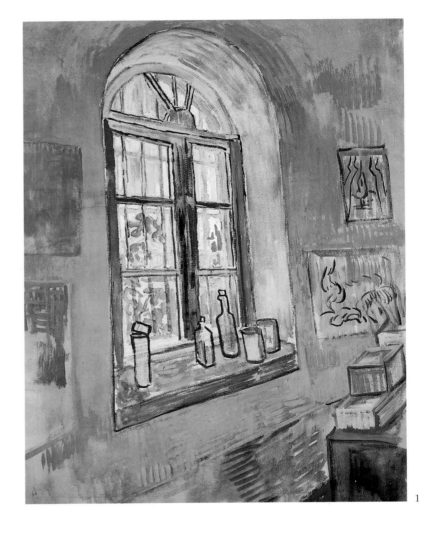

1

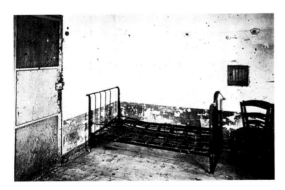

1 *Window of studio at Saint-Paul's hospital,* 1889
Black chalk & gouache on pink Ingres paper, 61.5 x 47 cm
van Gogh Foundation, Amsterdam

2 *Portrait of Trabuc,* 1889
Oil on canvas, 61 x 46 cm
Kunstmuseum, Solothurn

1/2
The third section of the triptych Vincent sent Theo was the window of his bedroom which served also as his studio. To brighten the room up, he hung his own paintings on the walls. It was here that he painted the portrait of Trabuc, a male nurse. He painted him twice, but the first version has disappeared. This is the only remaining copy, apparently executed in a single sitting: the background is a thin layer of rapid brush-strokes laid on an unprepared canvas

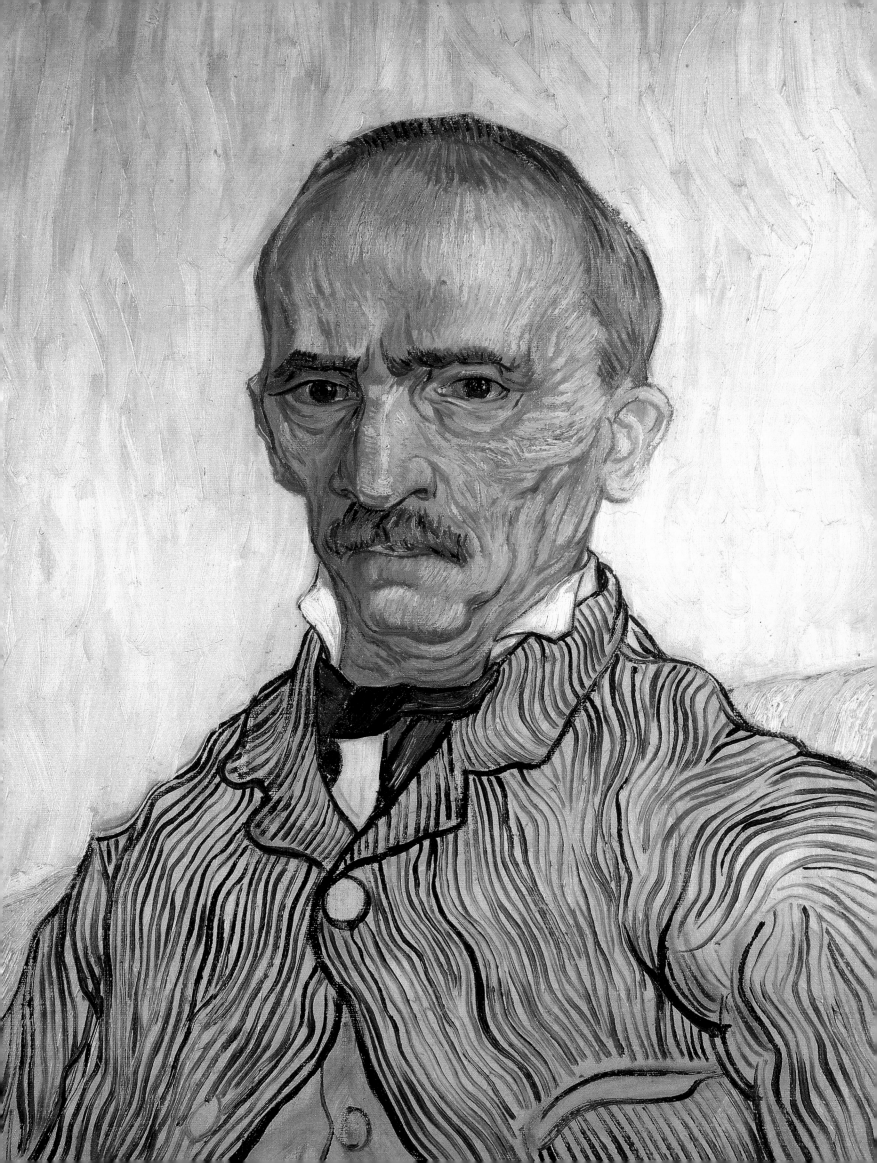

In the courtyard of the asylum, Vincent worked on the effects of the evening light. He reverted to a simpler palette, using more ochre as in the days when he first started to paint. He wrote to Theo: 'In short, you will see that in the large landscape of pines, of red ochre tones broken by a black line, there is already much more character than in previous works.' He heard from Emile Bernard who sent him a few photographs of his work and of Gauguin's.

'All my time was spent observing the character of the pines'

Everyone in Pont-Aven seemed to be painting biblical subjects of various kinds, which Vincent found disturbing: 'It is not that it leaves me cold,' he wrote to Theo, 'but it gives me a painful feeling of collapse instead of progress.' A few days later he wrote back to Emile Bernard in a peremptory manner: 'I ask you again, roaring my loudest, and calling you all kinds of names with the full power of my lungs – to be so kind as to become your own self again a little.' Then he gave him an account of his own current work: 'A view of the garden of the asylum where I am staying . . . the soil scorched by the sun, covered with fallen pine needles. This edge of the garden is planted with large pine trees, whose trunks and branches are red-ochre, the foliage green gloomed over by an admixture of black. These high trees stand out against an evening sky with violet stripes on a yellow ground, which higher up turns into pink, into green. A wall – also red-ochre – shuts off the view, and is topped only by a violet and yellow-ochre hill. Now the nearest tree is an enormous trunk, struck by lightning and sawed off. . . . This giant – like a defeated, proud man – contrasts, when considered in the nature of a living creature, with the pale smile of a last rose on the fading bush in front of him. . . . A sunbeam, the last ray of daylight, raises the somber ochre almost to orange. Here and there small black figures wander around among the tree trunks. You will realise that this combination of red-ochre, of green gloomed over by grey, the black streaks surrounding the contours, produces something of the sensation of anguish, called "noir-rouge", from which certain of my companions in misfortune frequently suffer. Moreover the motif of the great tree struck by lightning, the sickly green-pink smile of the last flower of autumn serves to confirm this impression.'

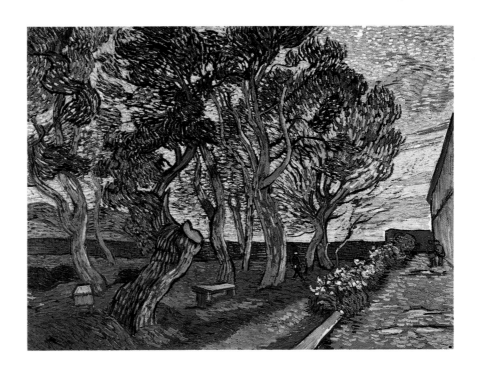

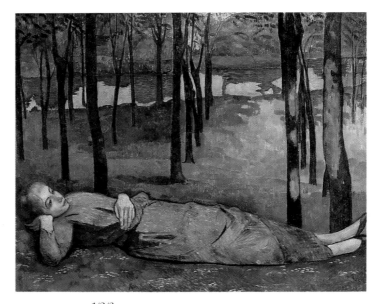

1/2/3
The subject of these two paintings is identical: ' . . . in the air, the lines that do not change and that one meets at every turn' are those of the asylum courtyard. And Vincent commented on Emile Bernard's *Madeleine au bois d'amour* (2): 'I suppose the hair is an accent of a colour tone which is necessary as a colour complementary to the pale dress, black if the dress is white, orange if it is blue. But what I said to myself was, what a simple subject, and how well he knows how to create elegance with nothing'

*'Here I am after nearly a month,
and not once have I felt the slightest desire
to be elsewhere'*

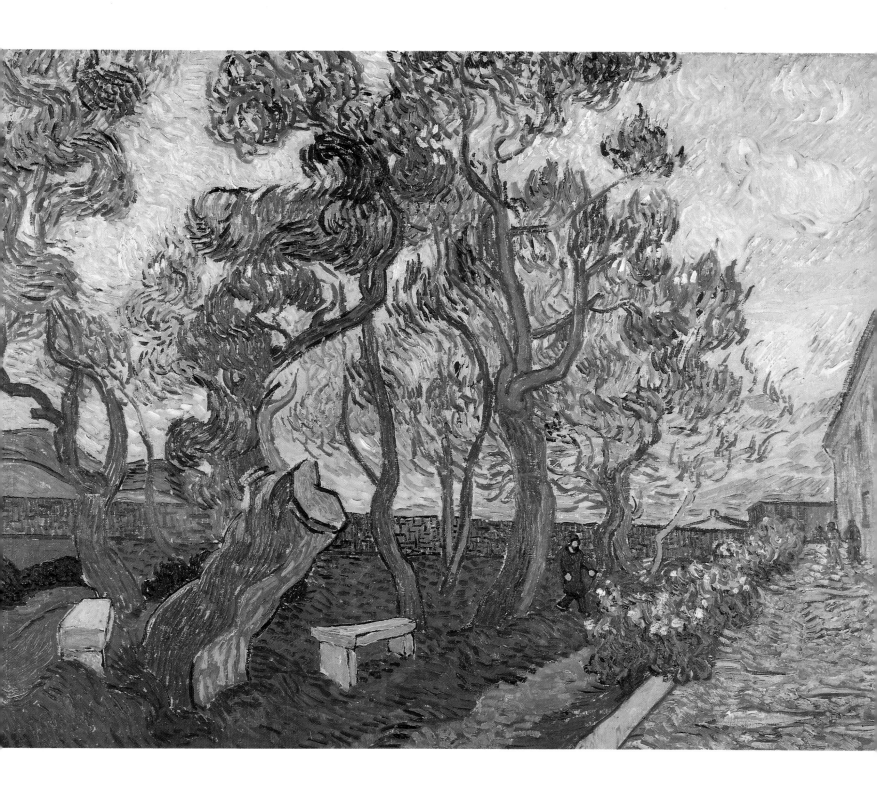

1 *Garden of Saint-Paul's hospital*, 1889
Oil on canvas, 73.5 x 92 cm
Folkwang Museum, Essen

2 *Madeleine au bois d'amour*, 1888, E. Bernard
Oil on canvas, 137 x 164 cm
Musée d'Art moderne de la ville de Paris

3 *Garden of Saint-Paul's hospital*, 1889
Oil on canvas, 71.5 x 90.5 cm
van Gogh Foundation, Amsterdam

Vincent was given permission to paint outside under the watchful eye of an attendant. It was often the worthy Trabuc who accompanied him. After passionate concentration on olive trees and sunflowers, Vincent applied the same furious energy to a series of paintings featuring cypresses, the most important of which was *Starry Night*. On his mother's seventieth birthday, he suggested sending her a painting of cypresses and wrote to his sister: 'You will soon receive, I think, the paintings I promised you.' Here again is an opportunity to observe Vincent's mental state, his equilibrium. When he painted the interior of the asylum, his palette was dominantly ochre, thus accentuating the drabness of the atmosphere, the suffering, the moroseness and the boredom. What he saw in the world outside – life – brightened his palette. The yellows became more definite, the blues more intense. Meanwhile there were harbingers of crisis: little by little the skies Vincent portrayed grew clouded, showing increasingly tortuous convolutions the more imminent the attack. After the crisis, when the inner storm had subsided, the clouds grew calm again and of an almost unbearable blue, without density, a reflection of Vincent's state of mind, restored to lucidity.

He wrote to Theo: 'I have just finished a landscape . . . a ripening cornfield boxed in by brambles and green bushes. At the far end of the field a little pink house with a tall and dark cypress standing out against the distant hills of purplish blue, and against the

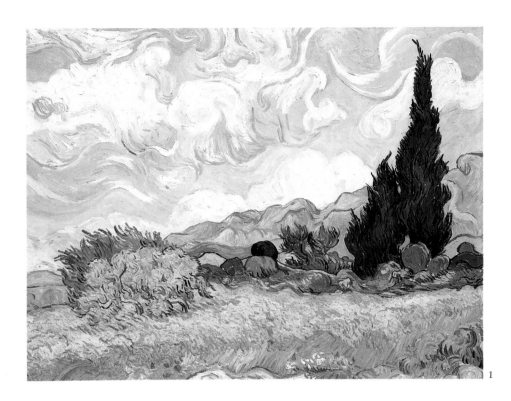

1

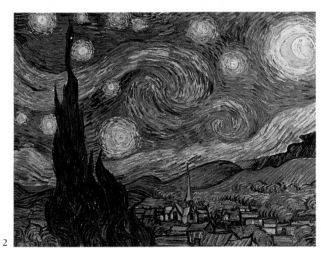

2

1/2/3
In a manner close to that of the Impressionists, Vincent painted the countryside surrounding the asylum, facing the Alpilles or turning his back on them. In *Starry Night* (2), he portrayed a village which bears more resemblance, judging by its church tower, to the villages of his youth in Holland than to those of Provence. A reminiscence of the north, this canvas is an abstraction, like those Vincent worked on with Gauguin in Arles. Indeed, Vincent wrote to Theo: 'At last I've a landscape of olive trees and also a new study of a starry sky. Without having seen the latest canvases of Gauguin and Bernard, I am fairly sure that the two I mention are in a similar spirit'

sky of myosotis blue streaked with pink, its pure tones contrasting with the yellowing ears, already heavy, in tones as warm as a crust of bread.' And he added that it was pointless for him to remain longer at the asylum. He asked Theo to arrange his return to the north. Vincent's plan was to move close to Pissarro who had been the first to appreciate his painting.

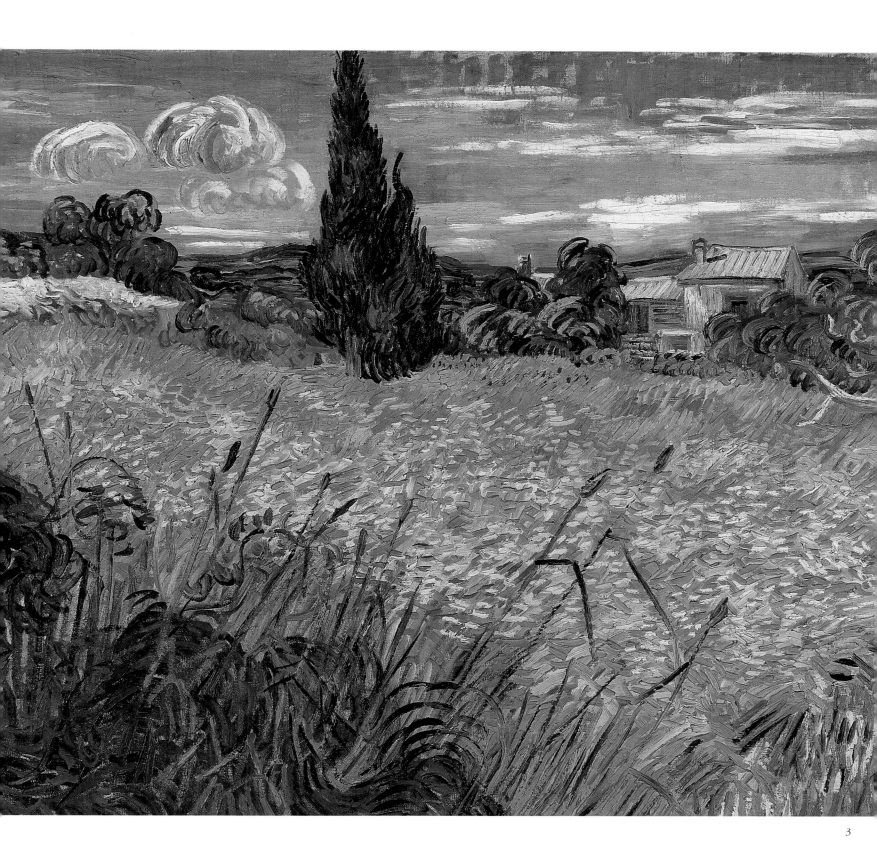

1 *Cornfield with cypresses,* 1889
Oil on canvas, 72.5 x 91. 5 cm
National Gallery, London

2 *Starry Night,* 1889
Oil on canvas, 73.7 x 92.1 cm
Metropolitan Museum of Art,
P. Bliss Bequest, New York

3 *Wheatfield,* 1889
Oil on canvas, 73.5 x 92.5 cm
Narodni Gallery, Prague

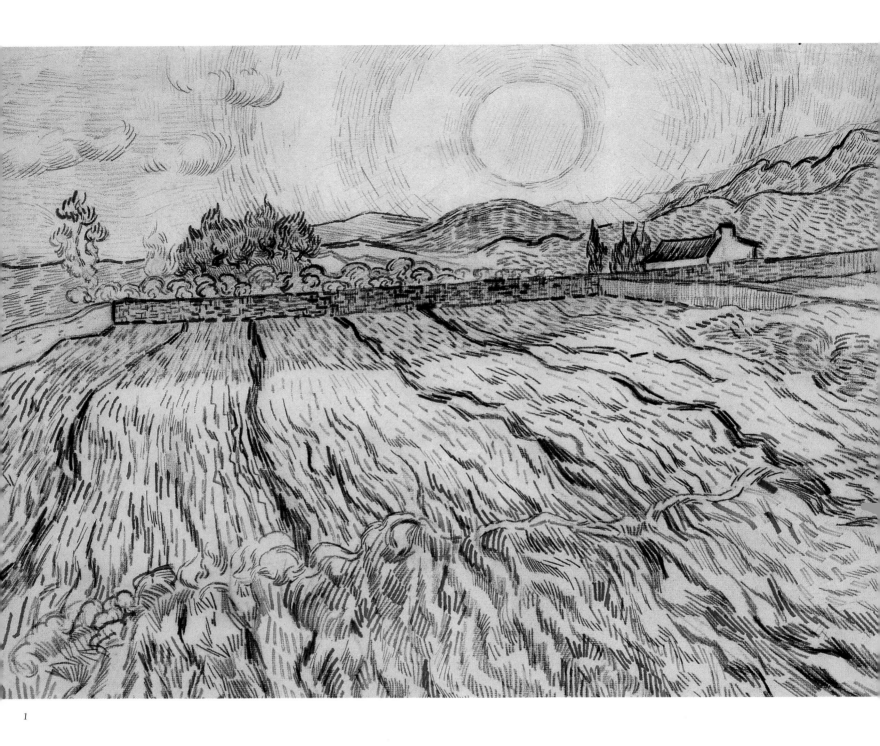

1

1 *Wheatfield*, 1889
Black chalk, red & brown pencil on paper
47 x 62 cm
Staatliche Graphische Sammlung, Munich

1
Of the twelve pictures Vincent did of this autumn landscape, only two recur as the subject of his major drawings. They were intended to be sent to Theo to enable him to assess his brother's work and prepare his submission to the exhibition of Les XX in Brussels. This drawing in black chalk displays complete technical mastery. The hatchings, fine or heavy in turn, give the composition a curvilinear rhythm culminating in the whirling form of the sun

'I have a strong feeling that the story of people is like the story of wheat, if one is not sown in the earth to germinate there, what difference does it make, one is ground to make bread'

'Through the iron bars of the window I look out on a square of corn in an enclosure, a perspective like van Goyen, over which I see the sun rise in the morning in all its glory. Besides this one – as there are over thirty empty rooms – I have another room to work in.' This was the field of corn that Vincent painted, day after day, month after month, season after season: 'Yesterday I began to work again a little – on something I see from my window – a stubble field under the plough, the contrast between the ploughed earth of purplish-blue and rows of yellow stubble, hills in the background.' Working in ink or in oil, he concentrated on this defined space, as empty as it was silent, then added to it the figure of a peasant who was both sower and reaper. This peasant had already haunted his painting in his youth. Copied after the masters Millet or Breton, or observed as a motif, the peasant early became a symbol of existence in Vincent's work. He is at the same time the harrower who prepares the field, the sower who bestows seed on the earth, the reaper who brings death, obedient to the cycle of the seasons, simultaneously victim and executioner. Vincent painted the peasant he saw through the iron bars of his window: like a voyeur, like an impotent witness, he concentrated on him to the point of obsession.

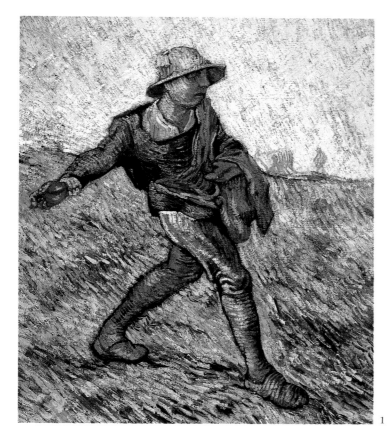

1

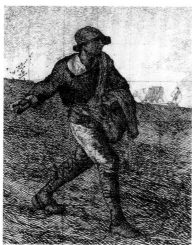

2

1/2
At Saint-Rémy Vincent produced twenty-one works after Millet. Those of *The Sower* are without doubt the most noteworthy. This copy of an etching by Paul-Edmée Le Rat, after Millet, is astonishingly faithful to the original. Vincent became a colourist and used his brush-strokes to give his painting the appearance of an etching

1 *The Sower,* 1889
Oil on canvas, 64 x 55 cm
Kröller-Müller Foundation, Otterlo

2 *The Sower,* after Millet
Woodcut
Bibliothèque nationale, Paris

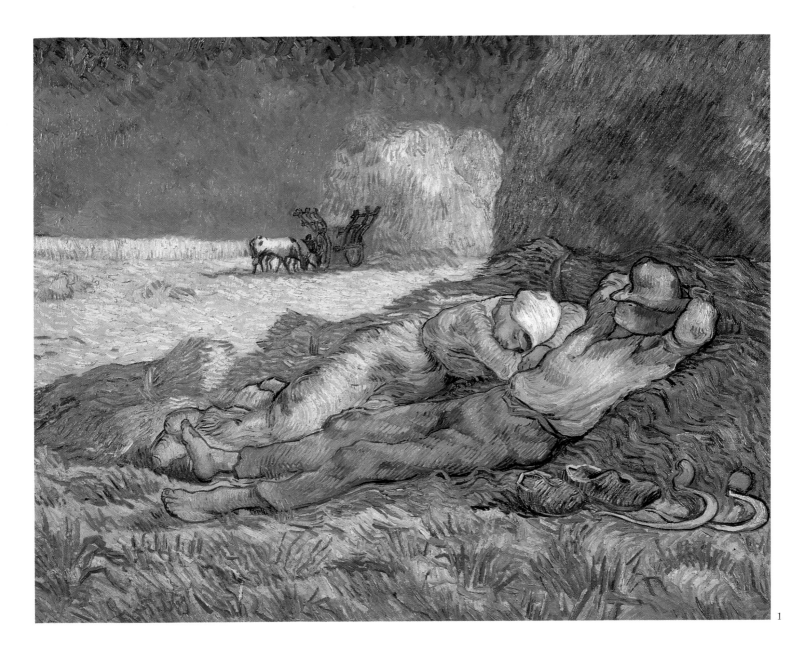

Alone among the alienated, Vincent worked and, to maintain contact with the outside world, wrote to Theo about his experiments and studies. To keep in practice and also to further his development, he copied the masters: Doré, Daumier and Delacroix. But it was Millet who most inspired him as he repeatedly copied his representations of peasants: 'I have now seven copies out of the ten of Millet's *Travaux des Champs*. I can assure you that making copies interests me enormously, and it means that I shall not lose sight of the figure, even though I have no models at the moment.' He asked his brother to send him etchings and also wood engravings. 'Although copying may be the *old* system, that makes absolutely no difference to me.' Vincent loved to return to the work of the painters who had preceded him, to take an engraving and reinterpret it in his own manner. Thus he did on his own what he would have loved others to do with him in his yellow house: work communally on a unique oeuvre. He became the colourist of Millet and Daumier, creating his own artistic lineage. 'I am going to try to tell you what I am seeking in it and why it seems good to me to copy them. We painters are always asked to compose ourselves and be nothing but composers . . . I let the black and white by Delacroix or Millet or something made after their work pose for me as a subject. And then I improvise colour on it, not, you understand, altogether myself, but searching for memories of their pictures – but the memory, "the vague consonance of colours which are at least right in feeling" – that is my own interpretation. Many people do not copy, many others do – I started on it accidentally, and I find that it teaches me things, and above all it sometimes gives me consolation. And then my brush goes between my fingers as a bow would on the violin . . .'

1 *Noon – rest from toil,* 1889
Oil on canvas, 73 x 91 cm
Musée du Louvre, Paris

2 *Noon,* 2nd plate of four hours of the day series,
Jean-François Millet
Engraving
Bibliothèque nationale, Paris

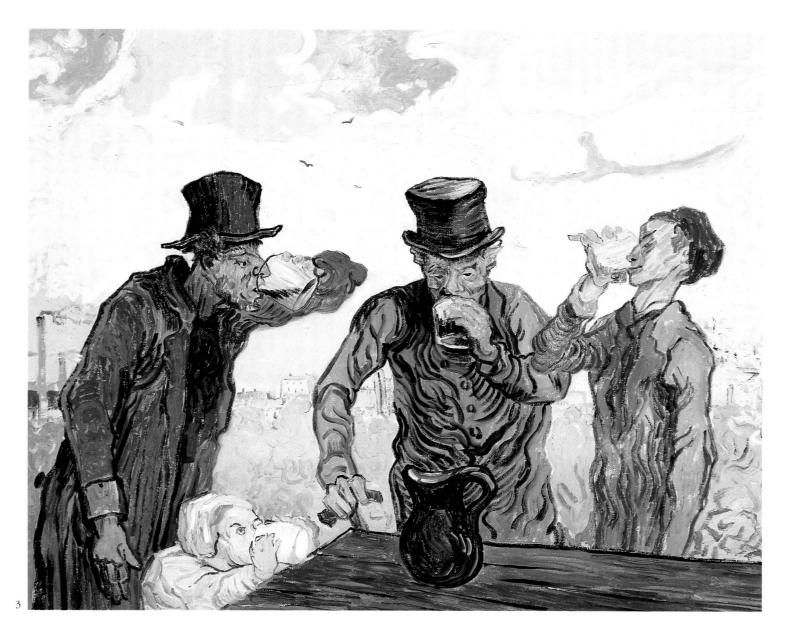

3

4

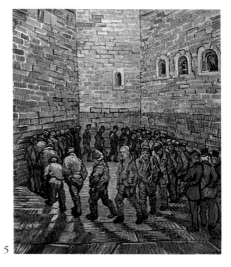

5

6

3 *The Topers,* after Daumier, 1889
Oil on canvas, 59.5 x 73.4 cm
Art Institute (J. Winterbotham Collection),
Chicago

4 *Men drinking,* Honoré Daumier
Woodcut
Metropolitan Museum of Art, New York

5 *Prison exercise yard,* after Gustave Doré,
1890
Oil on canvas, 80 x 64 cm
Pushkin Museum, Moscow

6 *Newgate, exercise yard,* Gustave Doré
Woodcut
Bibliothèque nationale, Paris

'I — mostly because I am ill at present — am
trying to do something to console myself, for
my own pleasure'

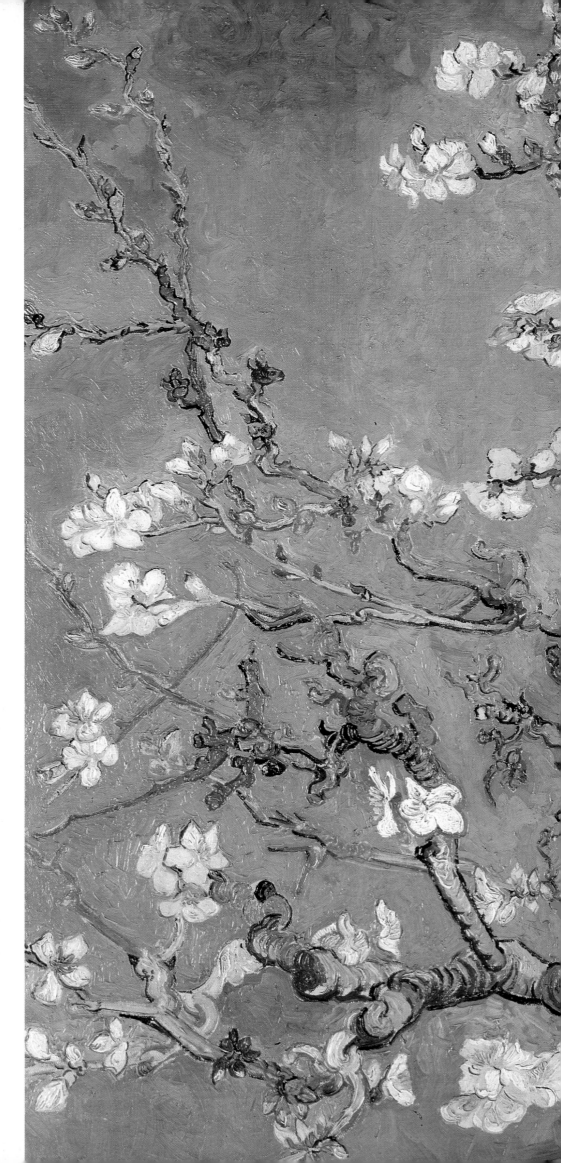

Theo approached Pissarro, hoping to arrange for his brother to stay with him. Vincent had expressed a wish for this, knowing the great artist's kindness. But the latter's wife refused to house a new and impoverished painter. Pissarro wanted to help the two brothers nonetheless and offered to put Vincent's case to Dr Gachet. Vincent, fearing the onset of another crisis, postponed his trip. The attack occurred during the end-of-the-year festivities. Was it a feeling of loneliness at a time when families gathered together (from henceforward Theo's family?) that added to his distress? On hearing of his nephew's birth on 2 February 1890, he nonetheless expressed his happiness to his brother and Johanna: 'I have today received the good news that you are at last a father.' Vincent then set to work for the sake of this child, as yet unknown to him, named after his uncle Vincent who felt unworthy of such a distinction. He wrote to his mother: 'I would have preferred Theo to name his son after Pa, whom I have been very much thinking of these days, rather than after me. But now that it's done . . .' Almond trees in flower were his present on the child's birth. Meticulously he observed the branches, and rendered them on to the blank canvas. To give the subject depth, and convey the impression of branches standing out against the sky, Vincent used two tonalities of blue which he applied with firm brushstrokes in all directions, thus recreating the consistency of the atmosphere around the almond tree's branches. This tribute to Johanna, this present to the baby, was for Vincent a symbol of the cycle of life. The almond blossomed in Provence from the end of January to the middle of February, a month in advance of other trees. This representation of its branches in flower, which he intended should lead the way to other versions, was executed in the Japanese manner. Vincent seemed satisfied with the result: 'My work was going well, the last canvas of branches in blossom – you will see that it was perhaps the best, the most patiently worked thing I had done, painted with calm and with a greater firmness of touch. And the next day, down like a brute.' A few days later, in a letter to Theo: 'I fell ill at the time I was painting almond trees in blossom. If I could have gone on working, you can tell from that I would have done others, trèes in flower. Now the blossom on the trees is nearly over. I really have no luck.'

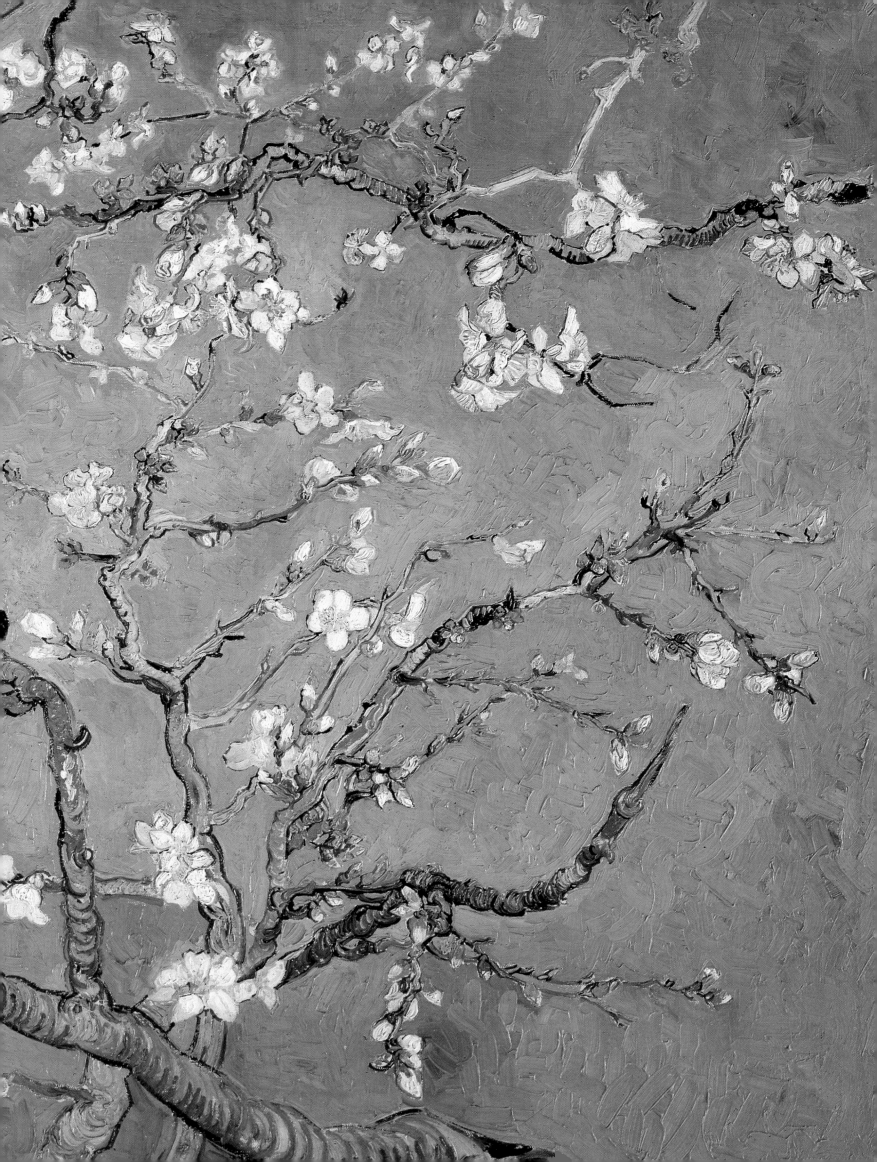

Auvers-sur-Oise

Pissarro put Theo in touch with Dr Gachet who, since 1872, had lived in Auvers-sur-Oise, a little village 34 kilometres from Paris. A specialist in homeopathy, he had written a thesis on a subject that could only prove appropriate: melancholia. He was above all else a singular personality. A friend of Renoir (he had attended Margot, his favourite model), of Manet, of Cézanne, he had lent the latter his engraving materials. Because Dr Gachet happened also to be an engraver, sculptor, painter and keen collector: he was one of the first to appreciate and support Impressionism. Vincent arrived in Auvers on 21 May 1980. The village pleased him: 'There is a great deal of colour here – but there are such pretty middle-class country houses, much prettier than Ville d'Avray, etc. to my thinking.' He met Dr Gachet straight away. The two men were immediately drawn to each other by a mutual sympathy. 'And then I have found a true friend in Dr Gachet, something like another brother, so much do we resemble each other physically and also mentally. He is a very nervous man himself and very queer in his behaviour; he has extended much friendliness to the artists of the new school, and he has helped them as much as was in his power.' He described him to his sister-in-law Johanna as 'rather eccentric, but his experience as a doctor must keep him balanced enough to combat the nervous trouble from which he certainly seems to me to be suffering at least as seriously as I.' Dr Gachet invited Vincent to his house, became his doctor, his friend and within a short time even his model. 'My friend Dr Gachet is decidedly enthusiastic about the latter portrait of the Arlesienne, which I have made a copy of for myself – and also about a self-portrait, which I am very glad of, seeing that he will urge me to paint figures, and I hope he is going to find some interesting models for me to paint. What rouses my keenest interest – much, much more than all the rest of my métier – is the portrait, the modern portrait.... So the portrait of Dr Gachet shows you a face the colour of an overheated brick, and scorched by the sun, with reddish hair and a white cap, surrounded by a rustic scenery with a background of blue hills; his clothes are ultramarine – this brings out the face and makes it paler, notwithstanding the fact that it is brick-coloured. His hands, the hands of an obstetrician, are paler than the face.' Vincent painted two portraits of the doctor, both against the same blue background and conveying the same attitude of weariness.

'He says that I need to apply myself and work hard and not brood about what I've been through'

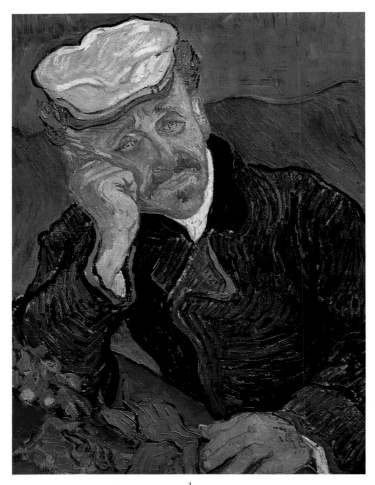

1
Dr Gachet was 61 years old when Vincent did his portrait in Auvers. Homeopathy being the doctor's speciality, he is portrayed with a digitalis plant between his fingers. In another version, Vincent added two books: *Manette Salomon* and *Germinie Lacerteux,* by the Goncourt brothers. Dr Gachet was also an avid reader

1 *Portrait of Dr Gachet,* 1890
Oil on canvas, 68 x 57 cm
Musée d'Orsay, Paris

2 *Dr Gachet's garden,* 1890
Oil on canvas, 73 x 52 cm
Musée d'Orsay, Paris

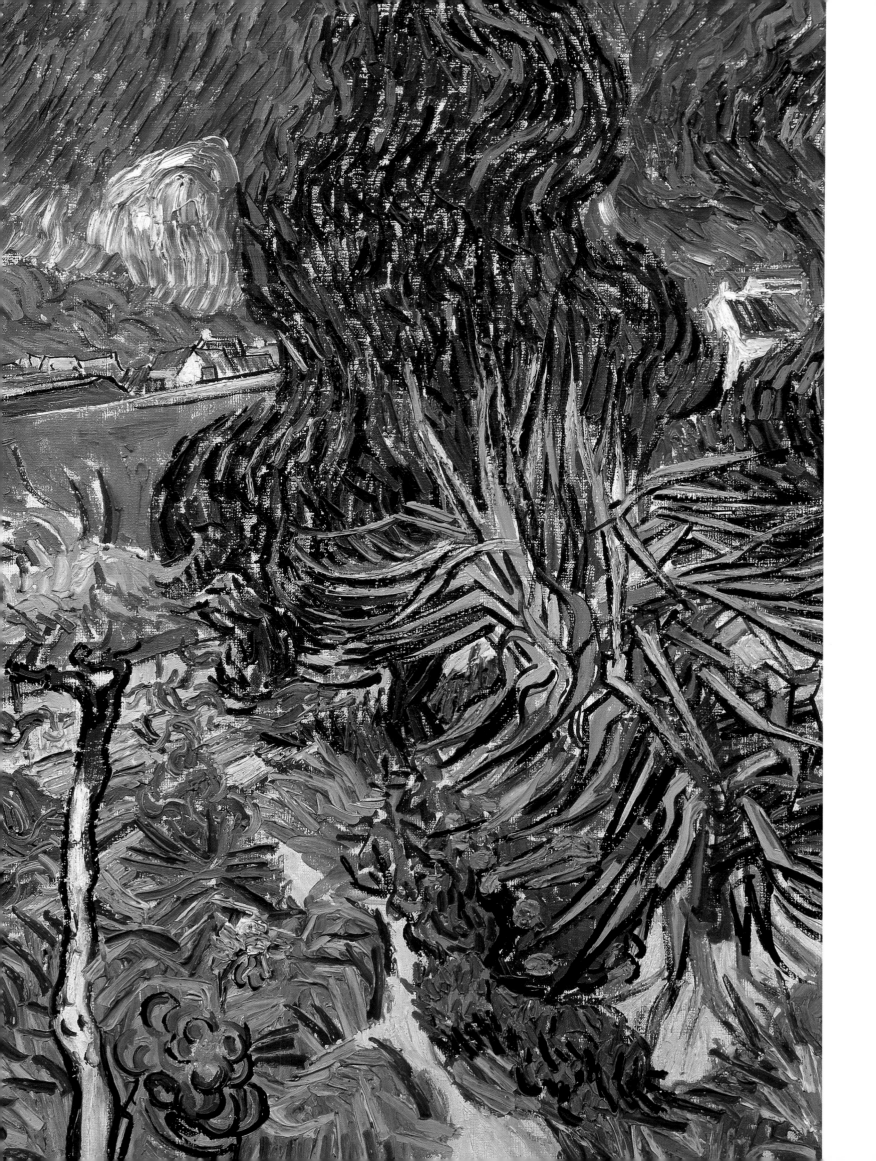

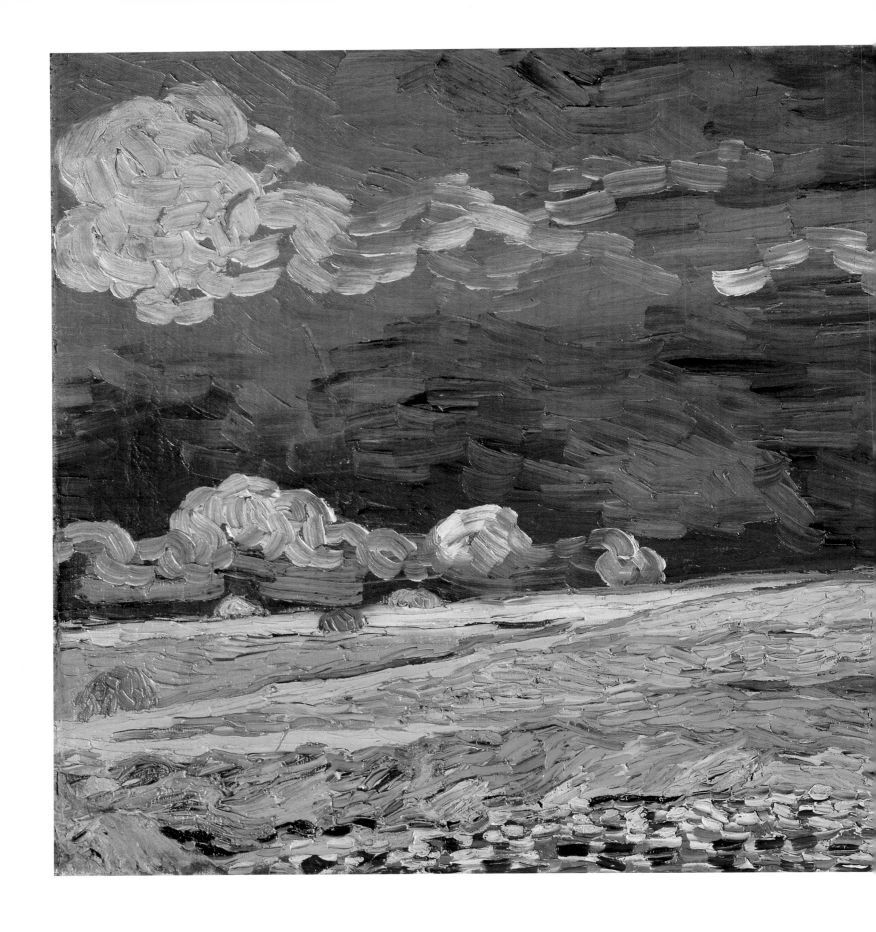

Pages 126-7:
Branches of an almond tree in blossom,
1889
Oil on canvas, 73 x 92 cm
van Gogh Foundation, Amsterdam

1 *Field under thunderclouds,* 1890
Oil on canvas, 50 x 100 cm
van Gogh Foundation, Amsterdam

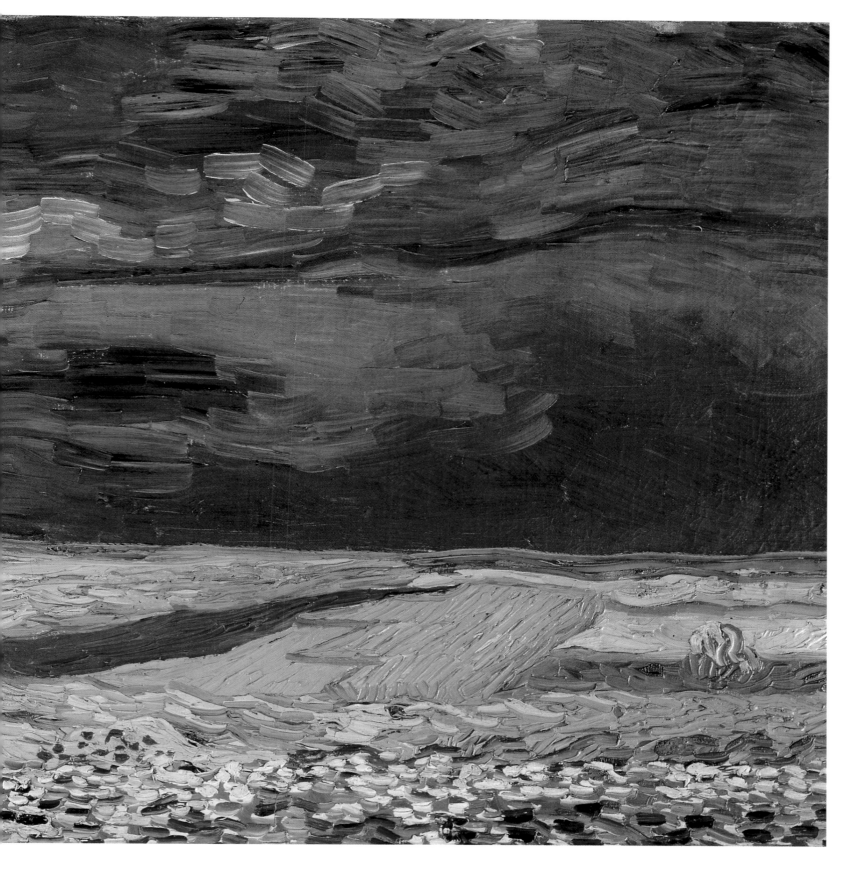

'My present, almost excessively calm frame of mind
is just the state needed to paint this'

Dr Gachet recommended the Saint-Aubin inn to Vincent. But it proved too expensive. Van Gogh took lodgings instead at a café run by the Ravoux family. He wrote to his friends the Ginoux, in Arles, asking them to send his few pieces of furniture. In the Ravoux house, place de la Mairie, he met the painter Hirschig, a Dutchman like himself. He set to work with speed. In seventy days he was to commit suicide, having painted seventy canvases. He kept Theo abreast of his work and promised himself to return to painting the figure, which had always been his preference. But, as in the past, it was landscapes that emerged from under the strokes of his brush. Wandering through the village streets, he set up his easel not far from the Ravoux's and place de la Mairie to paint a twisting and picturesque Auvers street, leading up to a stairway. Here, where man lived according to nature, where buildings were in harmony with the environment, where the road swerved so as not to disturb a stump, a tree, a rock, this tranquil countryside was bound to entrance a painter. Like an ethnologist, Vincent understood the strangeness of village life and emphasised the oddity by applying a firmer line to accentuate the road or the staircase. The figures seem to be subject to the same influence, as if Vincent had observed them the hour that the summer heat, rising from the earth, made everything appear blurred and vibrant.

In a letter to his brother dated 3 June 1890, that in which he described his newly finished portrait of the doctor, Vincent told Theo of his plan to paint a portrait of the doctor's daughter: Marguerite Gachet. The young girl had just celebrated her twentieth birthday. And this was Vincent's way of thanking the doctor for his friendship and care, particularly as he was often invited to Paul Gachet's house. Vincent very much liked this country doctor and had a regard for his painting. '. . . he will remain a friend, I should think,' So he set up his easel in the doctor's garden and worked. 'I feel that I can produce not too bad a painting every time I go to his house, and he will continue to ask me to dinner every Sunday or Monday. But till now, though it is pleasant to paint there, it is rather a burden for me to dine there, for the good soul takes the trouble to have four- or five-course dinners, which is as dreadful for him as for me – for he certainly hasn't a strong digestion. The

1
The Ravoux family's inn stood in the main square, a stone's throw from the town hall. Adeline, the daughter, was beautiful and sat for Vincent several times. She later recalled her sessions with him, saying that Vincent 'tended to be reserved by nature and in consequence rarely spoke, but he always had a little smile on his lips which sometimes, oh! very rarely, relaxed into open and happy laughter. Then Monsieur Vincent, as we all called him, suddenly became a dfferent man.' From the auberge, Vincent roamed the streets of the village looking for subjects. In *The Auvers Steps,* he found one, a composition of curves and changing levels, under a low sky. Painted in May, shortly after his arrival in Auvers, this picture captures the serenity of a moment

'I can already tell that going to the Midi did me good and helped me to see the North better'

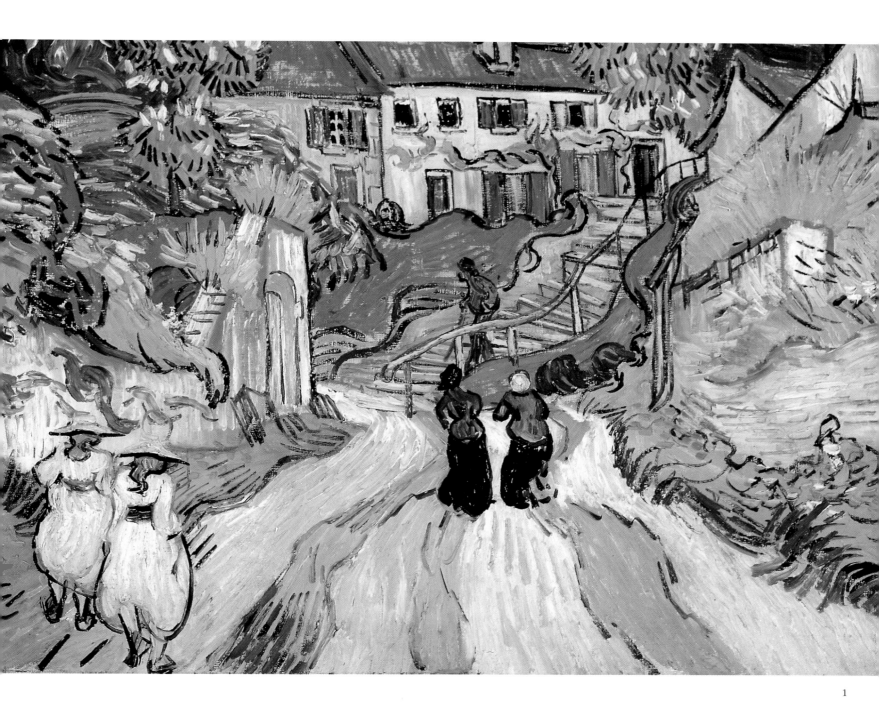

1

1 *The Auvers Steps,* 1890
Oil on canvas, 51 x 71 cm
Art Museum, St Louis

thing that has somewhat prevented me from protesting against it is that it recalls the old times to him, when there were those family dinners which we ourselves know so well.' On Sunday 8 June, Theo and Johanna accepted an invitation from the doctor. They arrived in Chaponval, a little west of Auvers-sur-Oise. Vincent insisted on taking care of his godson. He showed the baby the animals running about the doctor's garden. Vincent, delighted by this day, wrote to his mother: 'Last Sunday Theo, his wife and their child were here, and we lunched at Dr Gachet's. There my little namesake made the acquaintance of the animal world for the first time, for at that house there are eight cats, eight dogs, besides chickens, rabbits, ducks, pigeons, etc. in great numbers. But he did not understand much of it all as yet, I think. But he was looking well, and so

'I feel much surer of my brush than before I went to Arles'

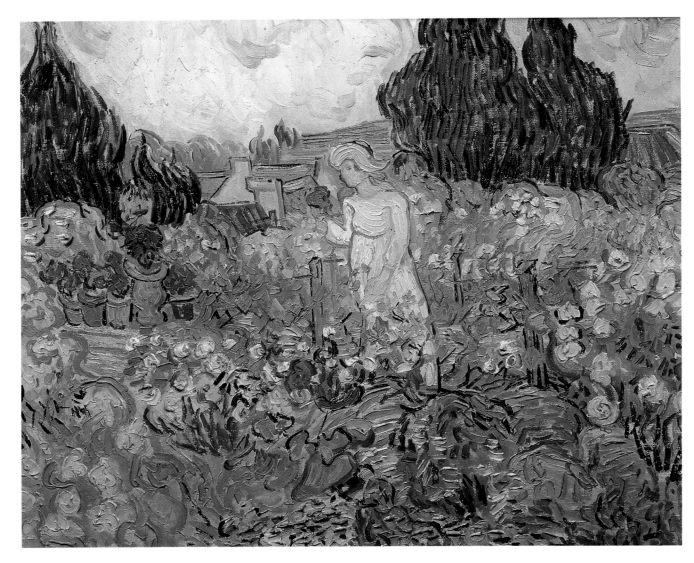

were Theo and Johanna. For me it is a very reassuring feeling to be living so much nearer to them.' The day was spent so pleasantly that Vincent forgot to paint the family portrait he had intended.

1 *Marguerite Gachet in the garden,* 1890
Oil on canvas, 46 x 55 cm
Musée d'Orsay, Paris

2 *Marguerite Gachet at the piano,* 1890
Oil on canvas, 102.6 x 50 cm
Kunstmuseum, Basle

1/2
On one of his visits to Dr Gachet, Vincent suggested doing a portrait of his daughter Marguerite, first in the garden which was in full flower, then at the piano. Vincent wrote to tell Theo that he intended to paint Marguerite again, but this was his last portrait of her

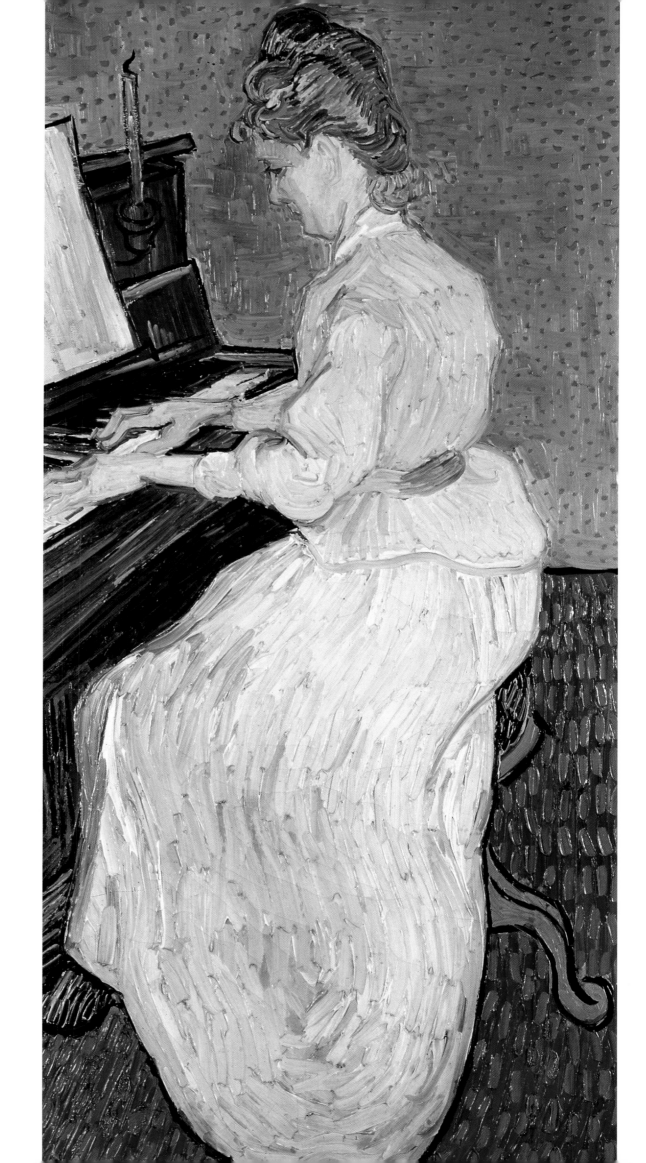

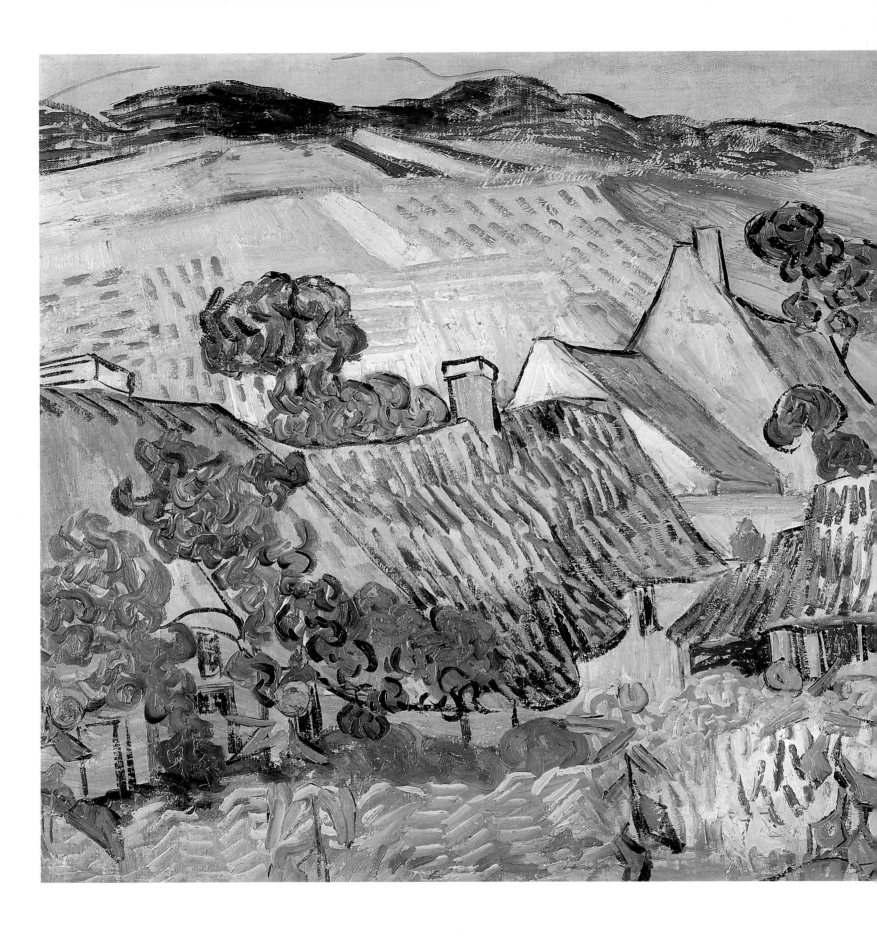

*'The outlook grows dark,
I see no happy future'*

1. *Thatched farmhouses*, 1890
Oil on canvas, 50 x 100 cm
Tate Gallery, London

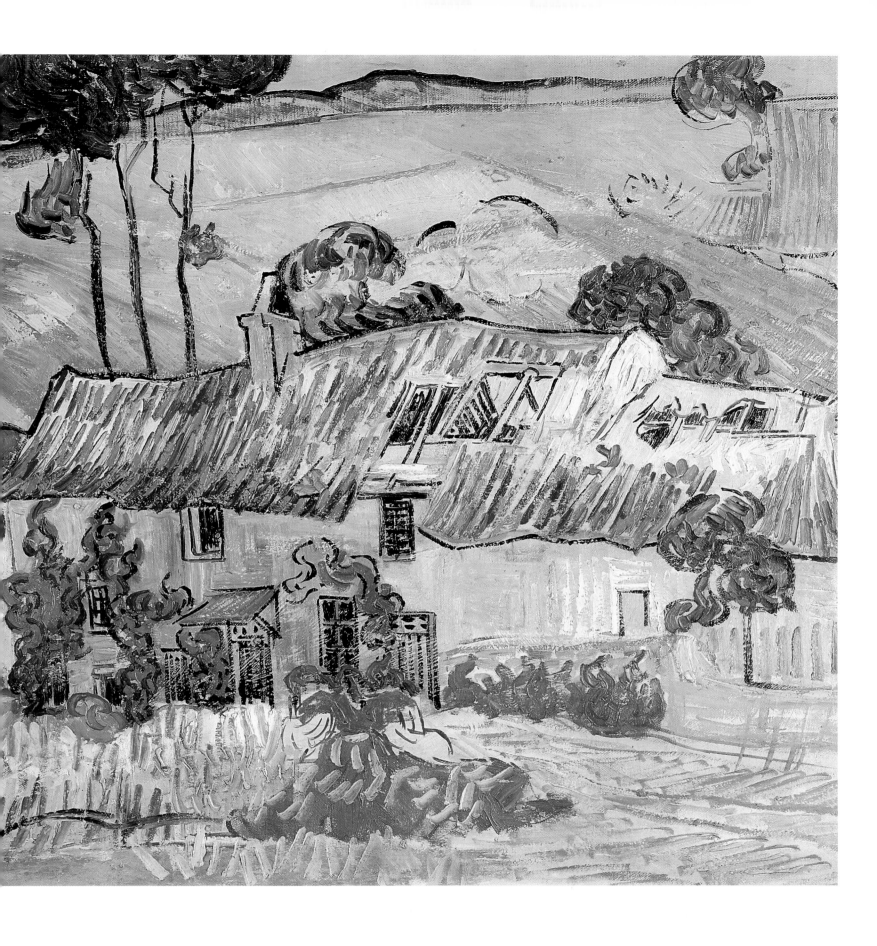

To the west of Auvers is a spot near Chaponval called Valhermeil, 'there are some superb thatched roofs here overgrown with moss and I will certainly do something with them.' The thatch of these village houses, serving families as shelter, seemed to van Gogh a part of nature itself, battered by the seasons, the wind and the rain. Viewed close up, or merging into a landscape, these dwellings were a subject to which Vincent returned on several occasions. In his own loneliness, he surrendered to the melancholy they evoked in him. The three days he had spent in Paris before coming to Auvers were now but another memory: his meeting with his sister-in-law Johanna, his nephew's visit. He had seen his own canvases, sent to Theo from the Midi day after day, the apartment cluttered with his works, on the walls, even on the furniture. The cacophony of the town, his friends rushing

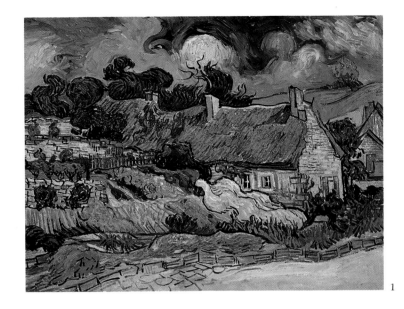

'It is seriously beautiful'

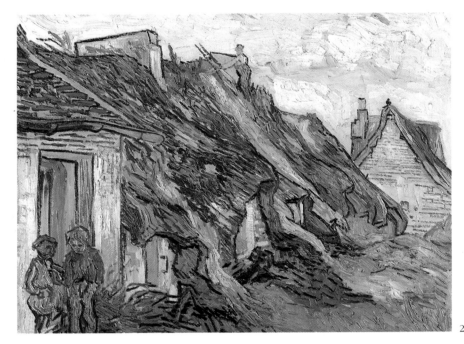

up for news, all the fragments of his life spread out by him on the floor, had left him with a sensation of unease. Here, in this peaceable countryside, he felt better. In his solitude, he wrote to Theo: 'Here one is far enough from Paris for it to be the real country, but nevertheless how changed it is since Daubigny. But not changed in an unpleasant way, there are many cottages and various modern middle-class dwellings very radiant and sunny and covered with flowers. This in an almost lush country, just at the moment when a new society is developing in the old, is not at all unpleasing; there is so much well-being in the air. I see, or think I see, in it a quiet like a Puvis de Chavannes, no factories, but lovely, well-kept greenery in abundance.'

1/2
Among the paintings Vincent did of the houses around Auvers, there are four whose particular interest is their thatched roofs. With great brush-strokes of thick paint, he applied tonalities of reddish brown streaked with green, overhung by the sky

1 and detail of right-hand page:
Thatched cottages at Montcel, 1890
Oil on canvas, 72 x 90 cm
Private collection, United States

2 *Thatched sandstone cottages at Chaponval,* 1890
Oil on canvas, 65 x 81 cm
Kunsthaus, Zurich

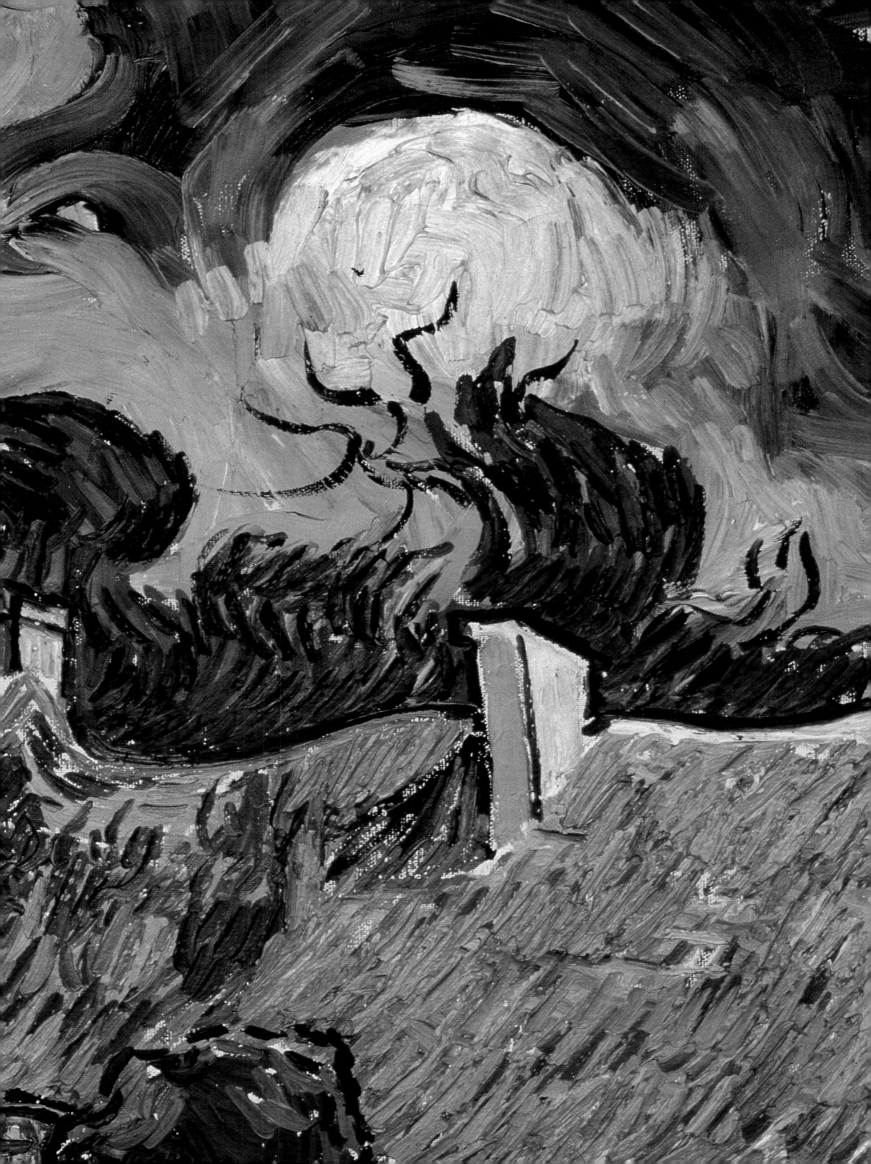

Vincent relished Auvers-sur-Oise, its simple and serious beauty. Rising early, he went out into the surrounding countryside, painted the flat open country, returned to the inn for lunch and worked in the afternoon in a back room or in Dr Gachet's house. He wandered the streets of the village in every direction, painted Daubigny's garden, thatched roofs, the bridge over the Oise, vegetable gardens. One day, Vincent installed himself by the village church. It was the view of the chancel he wanted to paint, where the form of the church grew rounded, its lines softened, not the façade, so often cold and austere in twelfth-century churches. Curiously, Vincent was returning to a subject which he had abandoned after he left the family home in Nuenen where he had painted the presbytery and the church when his father preached there. After Pa's death he had painted no more places of worship, either in Paris or in Arles. Perhaps he was receptive here to the strange appear-

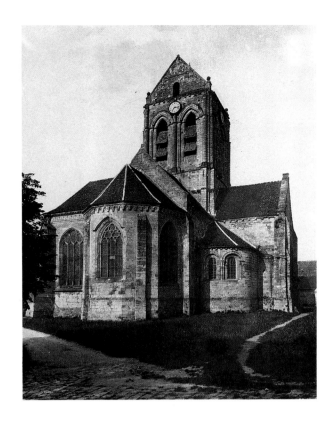

1

ance that architectural additions over the centuries seemed to have given to the church which consequently lacked any true structure or style. In choosing to paint the church facing the chancel, Vincent emphasised the circular effect, evoking a feeling of discomfort and vertigo – which gripped the artist, then the viewer, a sort of whirlwind that is reiterated in the sky. 'Apart from these I have a larger picture of the village church – an effect in which the building appears to be violet-hued against a sky of a simple deep blue colour, pure cobalt; the stained-glass windows appear as ultramarine blotches, the roof is sand with the pink glow of sunshine on it. And once again it is nearly the same thing as the studies I did in Nuenen of the old tower and the cemetery, only it is probable that now the colour is more expressive, more sumptuous.' After arriving in Auvers-sur-Oise, he never portrayed the sun as he had so often done in Arles and Saint-Rémy. Did he associate his crises with this heavenly body and fear to look straight at the sun?

1
Vincent wanted to paint the Town Hall in Auvers when the square was empty and got up very early on the morning of 14 July 1890 to do so. He had hoped Theo and his family would come to spend their holidays with him: they left the next day for Holland

'It is as I had imagined, I see violet hues wherever I look'

1 *Town Hall in Auvers on 14 July 1890*
Oil on canvas, 72 x 93 cm
Private collection, Chicago

2 *Church at Auvers-sur-Oise,* 1890
Oil on canvas, 51 x 51 cm
Musée du Louvre, Paris

2

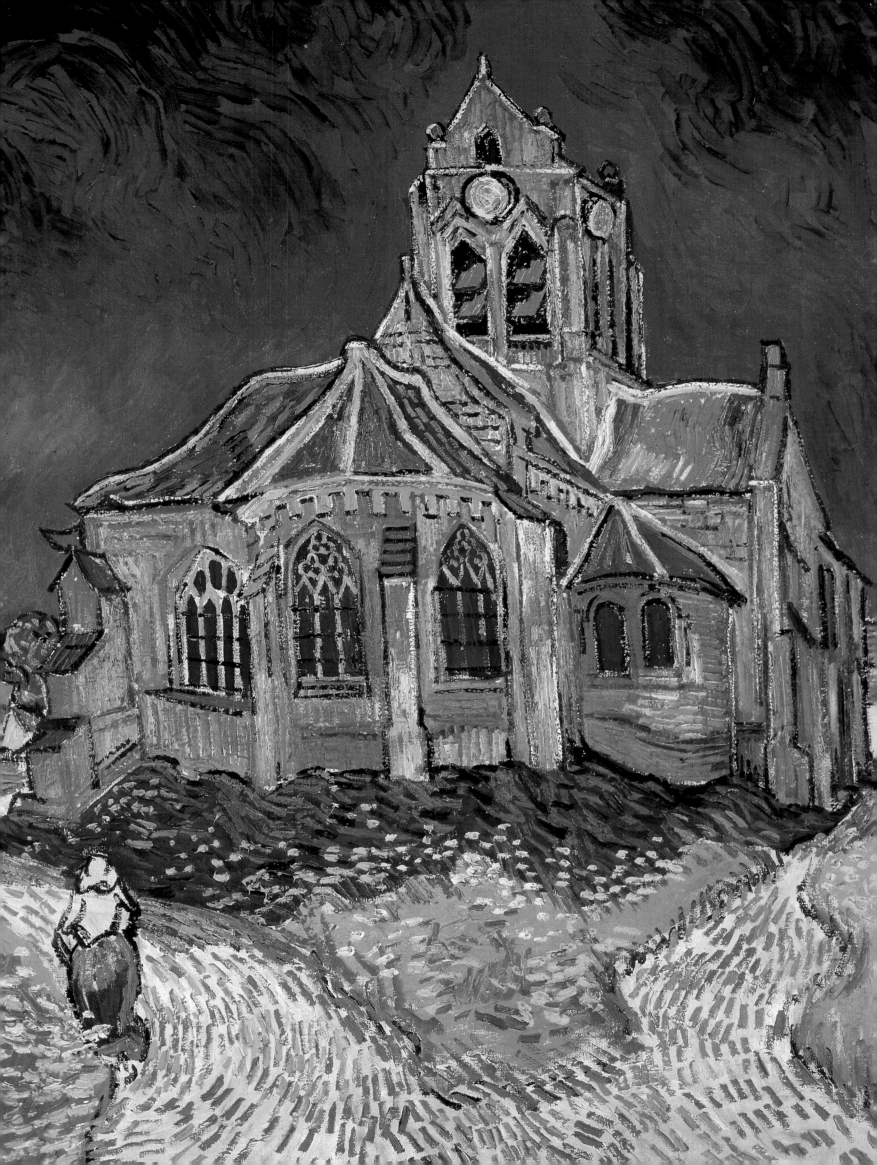

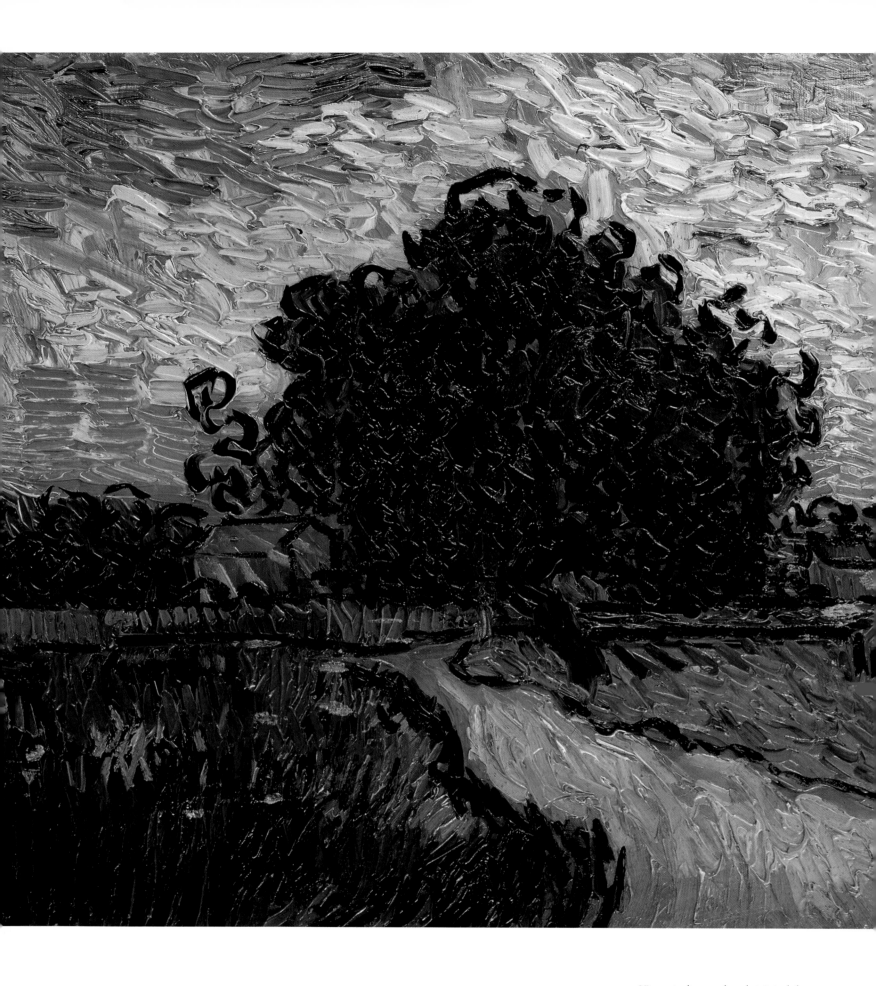

1 *Château d'Auvers,* 1890
Oil on canvas, 50 x 100 cm
van Gogh Foundation, Amsterdam

Vincent observed and painted the château d'Auvers from afar, reducing the building to a blue shape executed with rapid brushstrokes. The sunset is rendered with great dashes of yellow and red. This picture was apparently completed at a single sitting, to judge by the application of pure colour on the canvas. Vincent was never again to paint the château

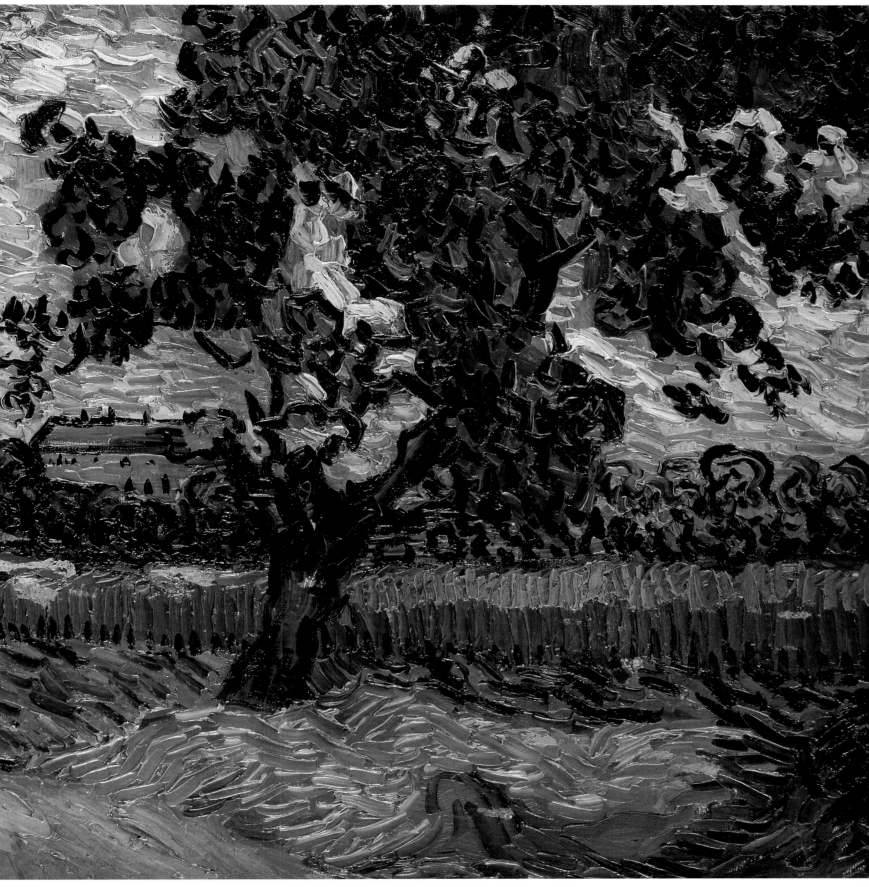

'The sun drowning everything in a pure gold light'

It was a month since Vincent had received a strange letter from Theo: 'I have, and you I hope will one day have, a wife to whom you can say these things, and as for me, whose mouth is often shut and whose head is often empty, it is through her that the seeds that probably come from afar but which were found by our beloved mother and father, will perhaps grow so that I can at least become a man and who knows if my son will live and if I will be able to help him . . .' The letter mentioned money problems, worries from which Johanna must be spared, which stung Vincent: 'I fear – not greatly, but a little nonetheless – that I am a terrible responsibility for you.' But Theo replied: 'I can see the way ahead, thanks to my dear wife. As for you, calm down.'

Vincent calmed down. He hoped that Vincent and Johanna would come to Auvers for their holidays. 'I am looking forward to doing portraits of you outside.' But they went to Holland to show their son to Moe, their son who was called Vincent. Sunday 27 July 1890: suddenly, over the wheat, the crows flew away, terrified by the report of a gun resounding over the silent countryside. Vincent had just fired: on the little-known painter, on the man 'who feels a failure'. Doubled up with pain, clutching his stomach, he managed to reach the Ravoux inn. The residents had already dined. The proprietor was outside the door with the painter Tom Hirschig, enjoying the evening air. Vincent climbed the stairs, got to his room and collapsed on the bed. Ravoux, disturbed by Vincent's strange manner and the unusual hour of his return, heard a cry. He went upstairs and found Vincent sobbing: 'I tried to kill myself, I bungled it.' Immediately Ravoux summoned Dr Gachet. The latter examined the wound, made no comment, applied a simple dressing, and went, leaving his son for a time at the wounded man's side. Ravoux and Hirschig watched over Vincent in turn until the arrival of Theo whom Dr Gachet had managed to contact via Goupil: 'I am as sorry as I can be to disturb your holiday. I think it nonetheless my duty to write to you immediately. I was summoned at nine o'clock this Sunday evening to your brother Vincent. When I got to him, I found him very ill. He has wounded himself. Not having your address which he did not wish to give me, this letter will reach you through Goupil.' Theo came by the first train on Monday.

1885: 'I confess a total faith in art, and I know as a result what I want to express in my works, and that I shall do my best to express it, whatever it may cost me'

The field

The way back
to the village

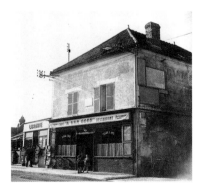

The inn

The staircase,
for the last time

1890: 'Well, my own work, I am risking my life
for it and my reason has half-foundered
because of it'

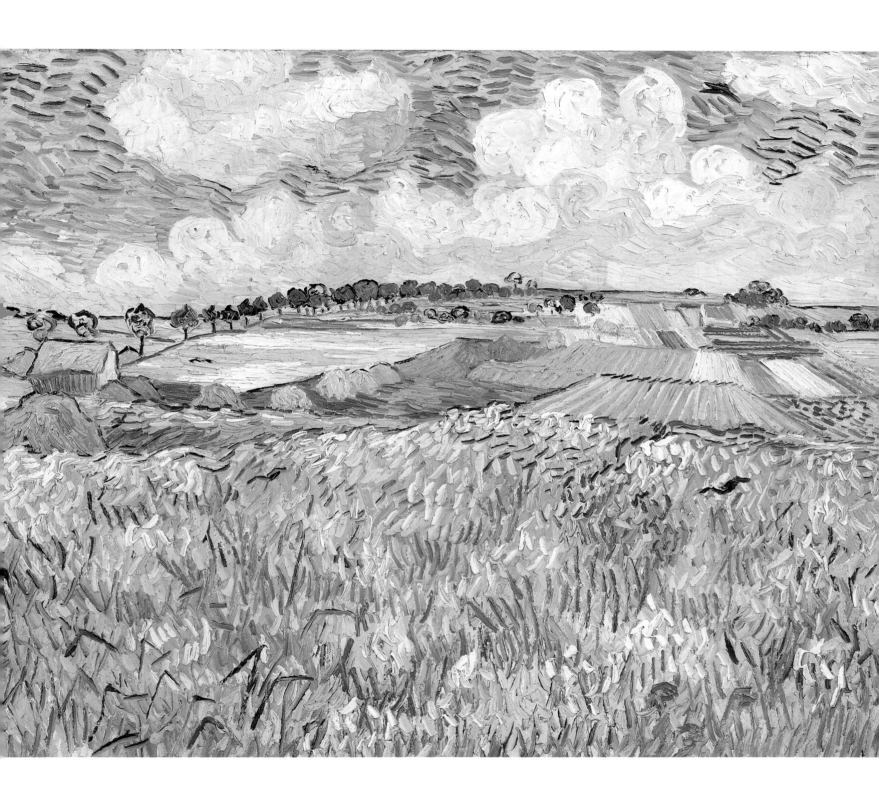

1 *The plain with farm near Auvers*, 1890
Oil on canvas, 73.5 x 92 cm
New Art Gallery, Munich

The two brothers, left to themselves, spoke in Dutch. Vincent was suffering an internal haemorrhage. No doctor attempted to relieve his pain, even less to treat him: 'I see him still on his narrow bed, in the little garret, tormented by a terrible pain,' Hirschig wrote afterwards. On 29 July 1890 Vincent van Gogh died in the middle of the night. He was thirty-seven. A few friends arrived the following day to attend his burial. The sun was pitiless. Hirschig reported: 'Yet once more, he was harder to bear than when alive. From his coffin, which was badly made, oozed a stinking liquid, everything about this man was terrible.' The curé had refused the hearse, another had had to be obtained from a neighbouring village. In Theo's pocket was a letter that his brother had never sent him, which he had just discovered: 'There are so many things I should like to write to you about, but I feel it is useless.'

1 and detail on right-hand page:
Crows in the wheatfields, 1890
Oil on canvas, 50.5 x 100.5 cm
van Gogh Foundation, Amsterdam

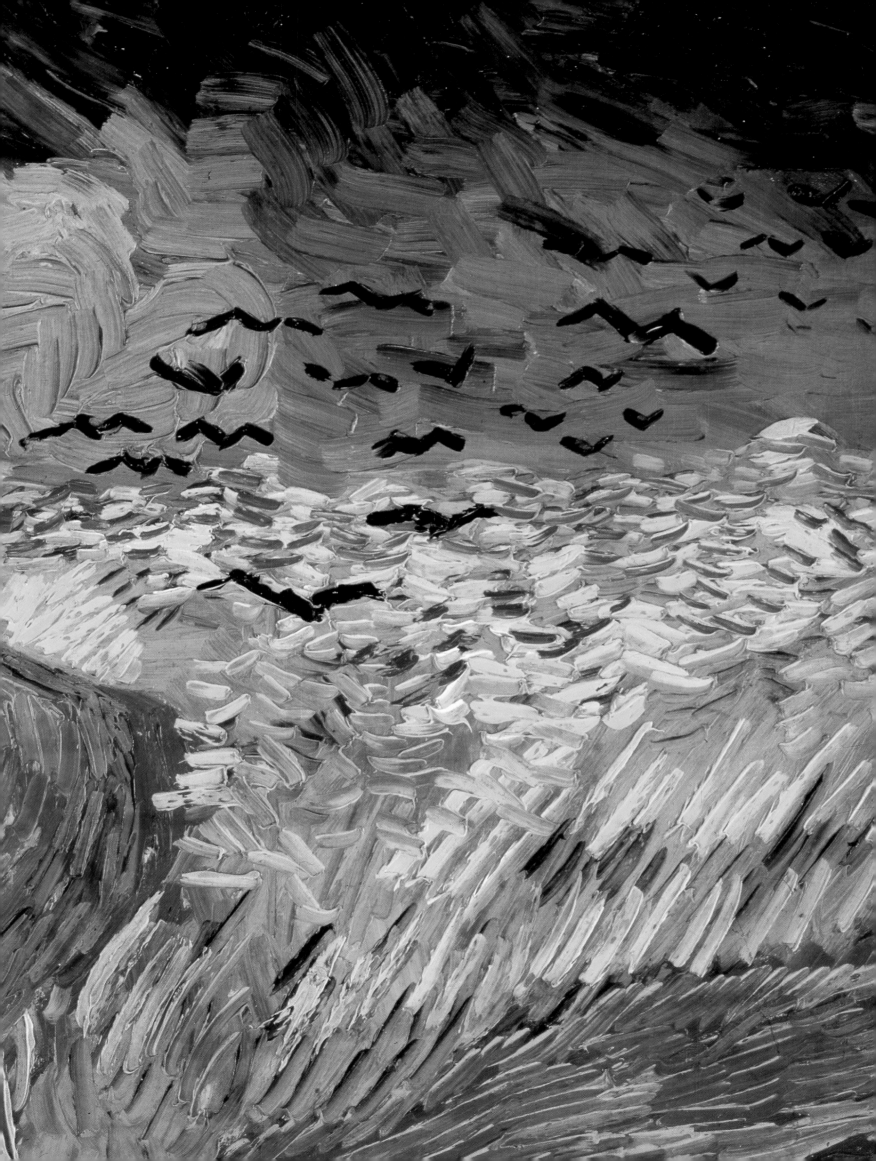

Catalogue of
essential works

1

6

11

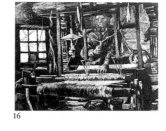
16

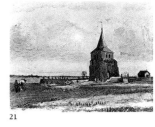
21

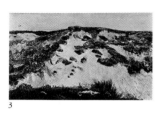
2

7

12

17

22

3

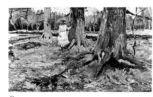
8

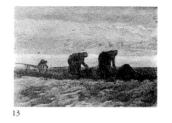
13

18

23

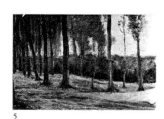
4

9

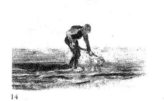
14

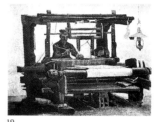
19

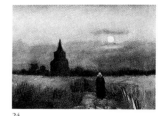
24

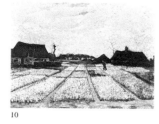
5

10

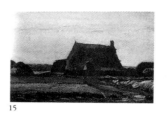
15

20

25

1 *Still life with cabage,* 1881
Paper on panel, 34.5 x 55 cm
van Gogh Foundation,
Amsterdam

2 *Beach at Scheveningen in calm
weather,* 1882
Paper on panel, 35.5 x 49.5 cm
Private collection, Netherlands

3 *The Dune,* 1882
Panel, 36 x 58.5 cm
Private collection, Amsterdam

4 *Dunes with figures,* 1882
Canvas on panel, 24 x 32 cm
Private collection, Switzerland

5 *Edge of a wood,* 1882
Oil on canvas, 34.5 x 49 cm
Kröller-Müller Foundation,
Otterlo

6 *Fisherman on the beach,* 1883
Oil on canvas, 51 x 33.5 cm
Kröller-Müller Foundation,
Otterlo

7 *Fisherman's wife on beach,* 1883
Oil on canvas, 52 x 34 cm
Kröller-Müller Foundation,
Otterlo

8 *Girl in the woods,* 1882
Oil on canvas, 39 x 59 cm
Kröller-Müller Foundation,
Otterlo

9 *A Wind-beaten tree,* 1883
Oil on canvas, 35 x 47 cm
Present owner unknown

10 *Bulb fields,* 1883
Canvas on pasteboard,
48 x 65 cm
Private collection, Virginia

11 *Farmhouses,* 1883
Canvas on pasteboard,
36 x 55.5 cm
van Gogh Foundation,
Amsterdam

12 *Footbridge across a ditch,* 1883
Oil on canvas, 46 x 34 cm
Private collection, Ohio

13 *Two women digging, and a
wheelbarrow,* 1883
Oil on canvas, 27 x 35.5 cm
van Gogh Foundation,
Amsterdam

14 *Peasant burning weeds,* 1883
Panel, 30.5 x 39.5 cm
Private collection, Netherlands

15 *The Hut,* 1883
Oil on canvas, 37 x 55.5 cm
Private collection, Nertherlands

16 *The Weaver: facing front,* 1884
Oil on canvas, 48 x 61 cm
Boymans-van Beuningen
Museum, Rotterdam

17 *The Weaver,* 1884
Oil on canvas, 61 x 85 cm
Museum of Fine Arts, Boston

18 *Pollarded birches,* 1884
Oil on canvas, 43 x 58 cm
Private collection, Paris

19 *The Weaver,* 1884
Oil on canvas, 70 x 85 cm
Kröller-Müller Foundation,
Otterlo

20 *The Weaver,* 1884
Oil on canvas, 55 x 79 cm
Wildenstein Art Gallery, London

21 *Old tower in the cemetery at
Nuenen, with a ploughman,* 1884
Oil on canvas, 34.5 x 42 cm
Kröller-Müller Foundation,
Otterlo

22 *The Weaver,* 1884
Oil on canvas, 61 x 93 cm
Kröller-Müller Foundation,
Otterlo

23 *The Ox-cart,* 1884
Oil on canvas, 57 x 82.5 cm
Kröller-Müller Foundation,
Otterlo

24 *Old tower in the fields,* 1884
Oil on canvas, 35 x 48 cm
Brook Street Galleries, London

25 *Shepherd,* 1884
Oil on canvas, 67 x 126 cm
Present owner unknown

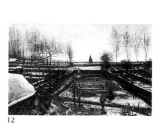
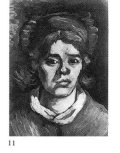
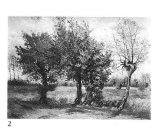

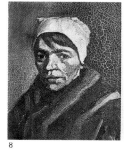
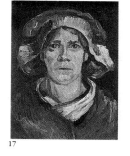

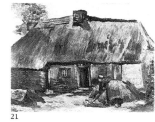

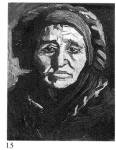
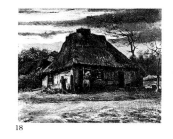
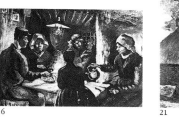

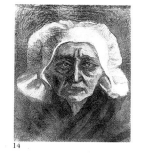
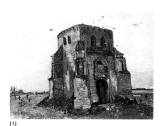
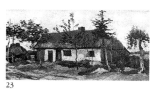
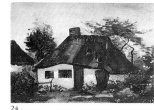

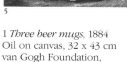

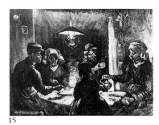

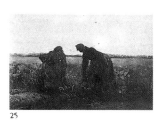

1 *Three beer mugs,* 1884
Oil on canvas, 32 x 43 cm
van Gogh Foundation,
Amsterdam

2 *Autumn landscape with four
trees,* 1885
Oil on canvas, 64 x 89 cm
Kröller-Müller Foundation,
Otterlo

3 *Lane of poplars near Nuenen,*
1885
Oil on canvas, 78 x 97.5 cm
Boymans-van Beuningen
Museum, Rotterdam

4 *Bowls and bottles,* 1885
Oil on canvas, 39.5 x 56 cm
van Gogh Foundation,
Amsterdam

5 *Two jars,* 1885
Oil on canvas, 58 x 85 cm
Private collection, Switzerland

6 *Still life with straw hat and
pipe,* 1885
Oil on canvas, 36 x 53.5 cm
Kröller-Müller Foundation,
Otterlo

7 *Study of hands,* 1885
Oil on canvas, 29.5 x 19 cm
Private collection, The Hague

8 *Peasant woman with white cap,*
1885
Oil on canvas, 38 x 30 cm
Present owner unknown

9 *Still life with clogs,* 1885
Oil on canvas, 39 x 41 cm
Kröller-Müller Foundation,
Otterlo

10 *Station at Eindhoven,* 1885
Oil on canvas, 15 x 26 cm
Kröller-Müller Foundation,
Otterlo

11 *Peasant woman,* 1885
Oil on canvas, 44 x 30.5 cm
van Gogh Foundation,
Amsterdam

12 *Garden of the presbytery at
Nuenen,* 1885
Oil on canvas, 53 x 78 cm
Present owner unknown

13 *Head of an old peasant
woman,* 1885
Oil on canvas, 37.5 x 28 cm
Kröller-Müller Foundation,
Otterlo

14 *Head of an old peasant
woman,* 1885
Oil on canvas, 36.5 x 29.5 cm
Municipal Museum, Wuppertal

15 *The Potato Eaters,* 1885
Oil on canvas, 72 x 93 cm
Kröller-Müller Foundation,
Otterlo

16 *The Potato Eaters,* 1885
Oil on canvas, 65 x 92 cm
Private collection, Cherbourg

17 *Head of a peasant woman
with a white cap,* 1885
Oil on canvas, 41 x 31.5 cm
Thannhauser Art Gallery, New
York

18 *Cottage at nightfall,* 1885
Oil on canvas, 64 x 78 cm
van Gogh Foundation,
Amsterdam

19 *Old church tower at Nuenen,*
1885
Oil on canvas, 63 x 79 cm
van Gogh Foundation,
Amsterdam

20 *Country cemetery at Nuenen
in the snow,* 1885
Oil on canvas, 30 x 41.5 cm
Priv coll, Greece

21 *Cottage with peasant woman
digging,* 1885
Oil on canvas, 30.5 x 40 cm
Private collection, Winnipeg

22 *Cottage and figure with goat,*
1885
Oil on canvas, 60 x 85 cm
Hist of Art Inst, Frankfurt

23 *The cottage,* 1885
Oil on canvas, 35.5 x 67 cm
Private collection, New York

24 *The cottage,* 1885
Oil on canvas, 44 x 59.5 cm
Present owner unknown

25 *Two peasant women digging,*
1885
Oil on canvas, 41 x 56 cm
Present owner unknown

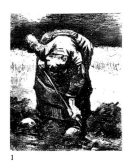

1

6

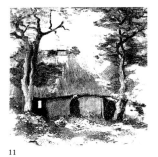

11

16

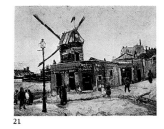

21

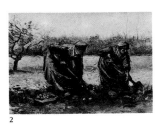

2

7

12

17

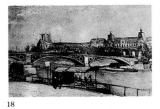

22

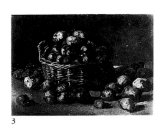

3

8

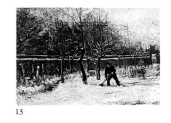

13

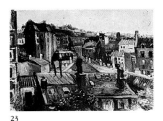

18

23

4

9

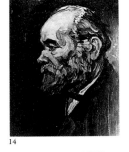

14

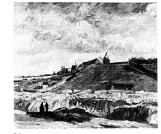

19

24

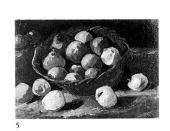

5

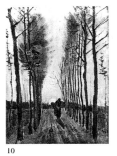

10

15

20

25

1 *Peasant woman digging,* 1885
Oil on canvas, 42 x 32 cm
Barber Institute, Birmingham

2 *Two peasant women digging potatoes,* 1885
Oil on canvas, 31.5 x 42.5 cm
Kröller-Müller Foundation, Otterlo

3 *Basket with potatoes,* 1885
Oil on canvas, 44.5 x 60 cm
van Gogh Foundation, Amsterdam

4 *Basket with apples,* 1885
Oil on canvas, 43 x 59 cm
van Gogh Foundation, Amsterdam

5 *Basket with apples,* 1885
Oil on canvas, 33 x 43.5 cm
van Gogh Foundation, Amsterdam

6 *Four birds' nests,* 1885
Oil on canvas, 38.5 x 46.5 cm
van Gogh Foundation, Amsterdam

7 *Three birds' nests,* 1885
Oil on canvas, 33 x 42 cm
Kröller-Müller Foundation, Otterlo

8 *Bowl with potatoes,* 1885
Oil on canvas, 44.5 x 57 cm
Private collection, Groningen

9 *Autumn landscape,* 1885
Oil on canvas, 64 x 87 cm
Private collection, London

10 *Autumn lane at dawn,* 1885
Oil on canvas, 46 x 33 cm
Kröller-Müller Foundation, Otterlo

11 *Cottage behind trees,* 1885
Oil on canvas, 47.5 x 46 cm
Present owner unknown

12 *Wheatsheaves,* 1885
Oil on canvas, 46 x 30 cm
Kröller-Müller Foundation, Otterlo

13 *Presbytery garden under snow,* 1885
Oil on canvas, 59 x 78 cm
Norton Simon Foundation, California

14 *Head of an old man,* 1885
Oil on canvas, 44 x 33.5 cm
van Gogh Foundation, Amsterdam

15 *Female torso,* 1886
Oil on canvas, 40.5 x 27 cm
van Gogh Foundation, Amsterdam

16 *Female torso,* 1886
Oil on canvas, 47 x 38 cm
van Gogh Foundation, Amsterdam

17 *Female torso,* 1886
Oil on canvas, 41 x 32.5 cm
van Gogh Foundation, Amsterdam

18 *Bridge of the Carrousel and the Louvre,* 1886
Oil on canvas, 31 x 44 cm
Priv coll, Los Angeles

19 *Terrace at the Tuileries,* 1886
Oil on canvas, 27.5 x 46 cm
Sterling and Francine Clark Art Institute

20 *Public garden in Paris,* 1886
Oil on canvas, 37.5 x 45.5 cm
Private collection, USA

21 *Moulin le Radet,* 1886
Oil on canvas, 38.5 x 46 cm
Kröller-Müller Foundation, Otterlo

22 *Montmartre,* 1886
Oil on canvas, 32 x 41 cm
van Gogh Foundation, Amsterdam

23 *Rooftops in Paris,* 1886
Pasteboard, 30 x 41 cm
van Gogh Foundation, Amsterdam

24 *Montmartre,* 1886
Oil on canvas, 56 x 62 cm
van Gogh Foundation, Amsterdam

25 *Montmartre,* 1886
Pasteboard, 22 x 16 cm
van Gogh Foundation, Amsterdam

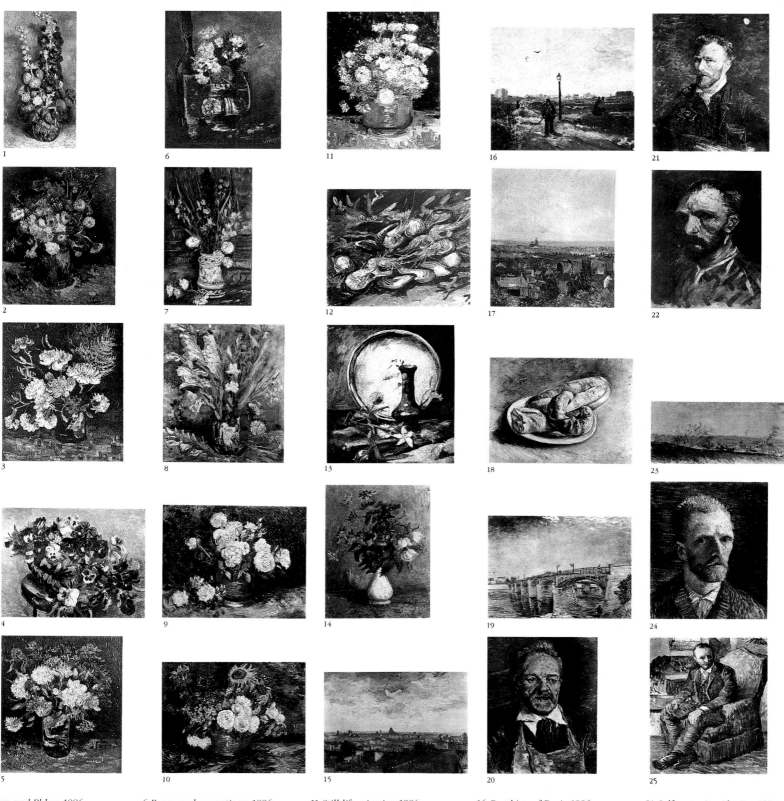

1 *Asters and Phlox,* 1886
Oil on canvas, 61 x 46 cm
van Gogh Foundation,
Amsterdam

2 *Still life: zinnias and
geraniums,* 1886
Oil on canvas, 63 x 46 cm
National Gallery of Canada

3 *Vase with carnations,* 1886
Oil on canvas, 46 x 38 cm
Private collection, New York

4 *Bowl with pansies,* 1886
Oil on canvas, 46 x 55 cm
van Gogh Foundation,
Amsterdam

5 *Still life: carnations,* 1886
Oil on canvas, 46 x 37.5 cm
Stedelijk Museum, Amsterdam

6 *Roses and carnations,* 1886
Oil on canvas, 40 x 32 cm
Kröller-Müller Foundation,
Otterlo

7 *Vase with gladioli,* 1886
Oil on canvas, 65 x 40 cm
Present owner unknown

8 *Vase with gladioli,* 1886
Oil on canvas, 48.5 x 40 cm
van Gogh Foundation,
Amsterdam

9 *Still life: peonies and roses,*
1886
Oil on canvas, 59 x 71 cm
Kröller-Müller Foundation,
Otterlo

10 *Still life: sunflowers and other
flowers,* 1886
Oil on canvas, 50 x 61 cm
Städtische Kunsthalle, Mannheim

11 *Still life: zinnias,* 1886
Oil on canvas, 61 x 45.5 cm
Present owner unknown

12 *Mussels and shrimps,* 1886
Oil on canvas, 27 x 34 cm
van Gogh Foundation,
Amsterdam

13 *Still life: plate, vase and
flowers,* 1886
Oil on canvas, 54 x 45 cm
Museu de Arte, São Paulo

14 *White vase with roses and
other flowers,* 1886
Oil on canvas, 37 x 25.5 cm
Present owner unknown

15 *View of Paris,* 1886
Oil on canvas, 54 x 72 cm
van Gogh Foundation,
Amsterdam

16 *Outskirts of Paris,* 1886
Oil on canvas, 46.5 x 54.5 cm
Present owner unknown

17 *View of Paris from
Montmartre,* 1886
Oil on canvas, 44.5 x 37 cm
Private collection, West Germany

18 *Still life with croissants,* 1887
Oil on canvas, 31.5 x 40 cm
van Gogh Foundation,
Amsterdam

19 *Pont d'Asnieres,* 1887
Oil on canvas, 53 x 73 cm
Private collection, New York

20 *Portrait of Père Tanguy,* 1887
Oil on canvas, 47 x 38.5 cm
Ny Carlsberg Glyptotek,
Copenhagen

21 *Self-portrait with pipe,* 1887
Oil on canvas, 61 x 50 cm
van Gogh Foundation,
Amsterdam

22 *Self-portrait: ¾ to the left,* 1887
Pasteboard, 19 x 14 cm
van Gogh Foundation,
Amsterdam

23 *Factories seen from a hillside
in moonlight,* 1887
Oil on canvas, 20.5 x 46 cm
van Gogh Foundation,
Amsterdam

24 *Self-portrait,* 1887
Oil on canvas, 41 x 33 cm
van Gogh Foundation,
Amsterdam

25 *Alexander Reid,* 1887
Pasteboard, 41 x 33 cm
Private collection, Oklahoma

 1

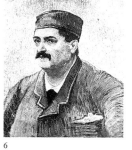 6

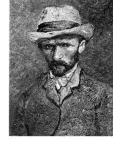 11

 16

 21

 2

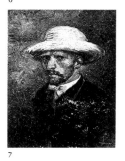 7

 12

 17

 22

 3

 8

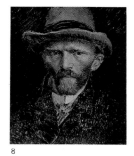 13

 18

 23

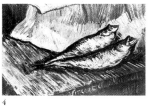 4

 9

 14

 19

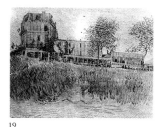 24

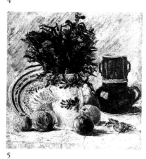 5

 10

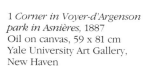 15

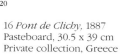 20

 25

1 *Corner in Voyer-d'Argenson park in Asnières*, 1887
Oil on canvas, 59 x 81 cm
Yale University Art Gallery, New Haven

2 *View in Voyer-d'Argenson park in Asnières*, 1887
Oil on canvas, 32.5 x 42 cm
van Gogh Foundation, Amsterdam

3 *Avenue in Voyer-d'Argenson park in Asnières*, 1887
Oil on canvas, 55 x 67 cm
Priv coll, New York

4 *Still life: two herrings*, 1887
Oil on canvas, 33 x 47 cm
Private collection, France

5 *Vase, flowers, coffee pot and fruit*, 1887
Oil on canvas, 41 x 38 cm
Municipal Museum, Wuppertal

6 *Man in a skullcap*, 1887
Oil on canvas, 65.5 x 54 cm
van Gogh Foundation, Amsterdam

7 *Self-portrait with straw hat*, 1887
Pasteboard, 19 x 14 cm
van Gogh Foundation, Amsterdam

8 *Self-portrait with grey felt hat*, 1887
Pasteboard, 41 x 32 cm
Stedelijk Museum, Amsterdam

9 *Banks of the Seine*, 1887
Oil on canvas, 32 x 45.5 cm
van Gogh Foundation, Amsterdam

10 *The Seine*, 1887
Oil on canvas, 55 x 65 cm
Private collection, Paris

11 *Self-portrait with grey felt hat*, 1887
Pasteboard, 19 x 14 cm
van Gogh Foundation, Amsterdam

12 *The skull*, 1887
Oil on canvas, 42.5 x 30.5 cm
van Gogh Foundation, Amsterdam

13 *Riverside walk near Asnières*, 1887
Oil on canvas, 49 x 66 cm
van Gogh Foundation, Amsterdam

14 *Pont de la Grande Jatte*, 1887
Oil on canvas, 32 x 40.5 cm
van Gogh Foundation, Amsterdam

15 *Pont de Clichy*, 1887
Oil on canvas, 55 x 46 cm
Priv coll, New York

16 *Pont de Clichy*, 1887
Pasteboard, 30.5 x 39 cm
Private collection, Greece

17 *Undergrowth*, 1887
Oil on canvas, 46 x 38 cm
van Gogh Foundation, Amsterdam

18 *Wheatfield with lark*, 1887
Oil on canvas, 54 x 64.5 cm
van Gogh Foundation, Amsterdam

19 *Restaurant de la Sirène at Asnières*, 1887
Oil on canvas, 51.5 x 64 cm
Present owner unknown

20 *View from Montmartre*, 1887
Oil on canvas, 81 x 100 cm
van Gogh Foundation, Amsterdam

21 *Voyer-d'Argenson park*, 1887
Oil on canvas, 75.5 x 113 cm
van Gogh Foundation, Amsterdam

22 *Factories at Asnières seen from quai de Clichy*, 1887
Oil on canvas, 54 x 72 cm
City Art Museum, St Louis

23 *Factory at Asnières*, 1887
Oil on canvas, 46.5 x 54 cm
Barnes Foundation, Merion

24 *Restaurant at Asnières*, 1887
Oil on canvas, 19 x 26.5 cm
van Gogh Foundation, Amsterdam

25 *Vase with lilacs, anemones and daisies*, 1887
Oil on canvas, 46.5 x 36.5 cm
Priv coll, Switzerland

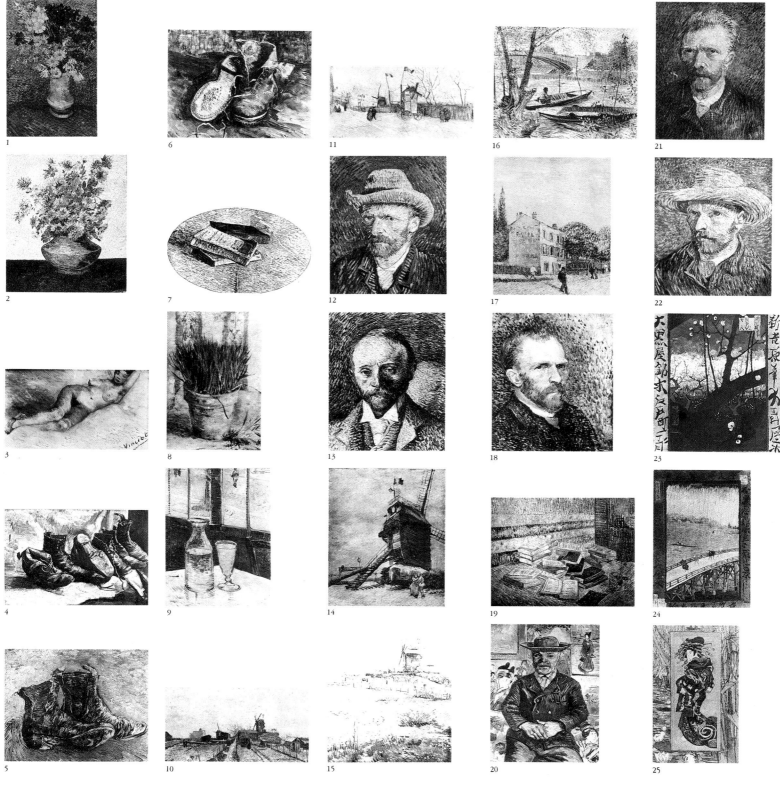

1 *Vase with daisies and anemones,* 1887
Oil on canvas, 61 x 38 cm
Kröller-Müller Foundation, Otterlo

2 *Cornflowers,* 1887
Oil on canvas, 46 x 36 cm
Private collection, New York

3 *Nude woman reclining,* 1887
Oil on canvas, 24 x 41 cm
Priv coll, Switzerland

4 *Three pairs of shoes,* 1887
Oil on canvas, 49 x 72 cm
Fogg Art Museum (gift of M. Wertheim), Cambridge, Mass

5 *A pair of shoes,* 1887
Pasteboard, 33 x 41 cm
van Gogh Foundation, Amsterdam

6 *A pair of shoes,* 1887
Oil on canvas, 34 x 41.5 cm
Baltimore Museum, Baltimore

7 *Still life: three books,* 1887
Oil on oval canvas, 31 x 48.5 cm
van Gogh Foundation, Amsterdam

8 *Pot with chives,* 1887
Oil on canvas, 32 x 22 cm
van Gogh Foundation, Amsterdam

9 *Absinthe,* 1887
Oil on canvas, 46.5 x 33 cm
van Gogh Foundation, Amsterdam

10 *View of kitchen gardens in Montmartre,* 1887
Oil on canvas, 43 x 81 cm
van Gogh Foundation, Amsterdam

11 *A corner of Montmartre,* 1887
Oil on canvas, 35 x 64.5 cm
van Gogh Foundation, Amsterdam

12 *Self-portrait in a grey felt hat,* 1887
Oil on canvas, 44 x 37.5 cm
van Gogh Foundation, Amsterdam

13 *Alexander Reid,* 1887
Pasteboard, 41.5 x 33.5 cm
Private collection

14 *Moulin de la Galette,* 1887
Oil on canvas, 61 x 50 cm
Museo Nacional de Bellas Artes, Buenos Aires

15 *Moulin de la Galette,* 1887
Oil on canvas, 46 x 38 cm
Carnegie Inst (gift of Sarah Mellon Scaife family), Pittsburgh

16 *Fishing in spring,* 1887
Oil on canvas, 49 x 58 cm
Art Institute, Chicago

17 *Restaurant Rispal in Asnières,* 1887
Oil on canvas, 72 x 60 cm
Private collection, New York

18 *Self-portrait,* 1887
Oil on canvas, 41 x 33 cm
van Gogh Foundation, Amsterdam

19 *French novels with a rose,* 1887
Oil on canvas, 73 x 93 cm
Private collection, Baden

20 *Portrait of Père Tanguy,* 1887
Oil on canvas, 65 x 51 cm
Private collection, Athens

21 *Self-portrait,* 1887
Oil on canvas, 46.5 x 35.5 cm
E. G. Bührle, Zurich

22 *Self-portrait,* 1887
Oil on canvas, 41 x 31.5 cm
Metropolitan Museum of Art, New York

23 *Japonaiserie,* after Hiroshige, 1887
Oil on canvas, 55 x 46 cm
van Gogh Foundation, Amsterdam

24 *Japonaiserie,* after Hiroshige, 1887
Oil on canvas, 73 x 54 cm
van Gogh Foundation, Amsterdam

25 *Japonaiserie,* after Kesaï Yeisen, 1887
Oil on canvas, 105 x 61 cm
van Gogh Foundation, Amsterdam

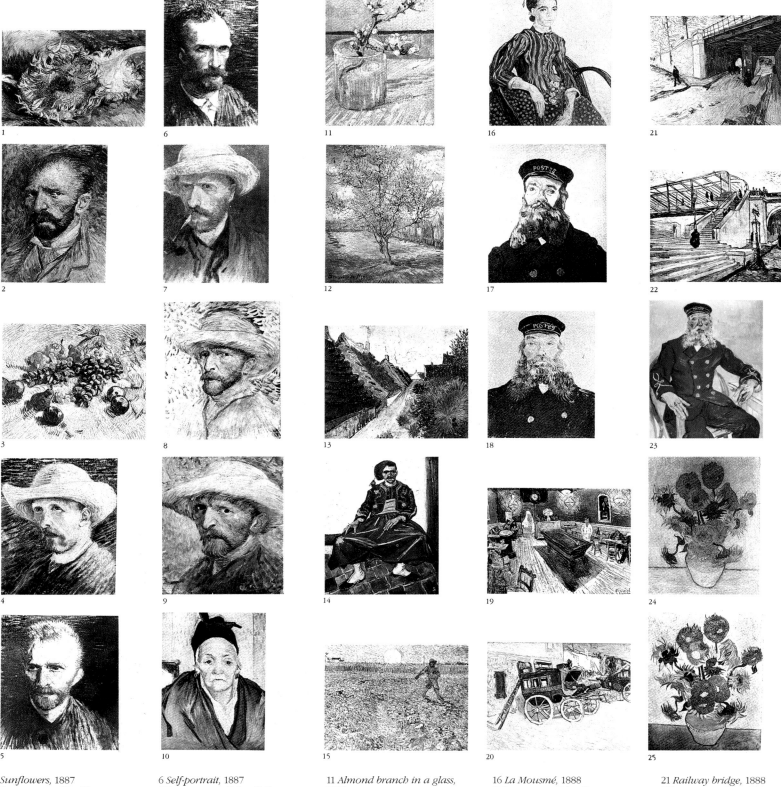

1 *Sunflowers,* 1887
Oil on canvas, 43 x 61 cm
Metropolitan Museum of Art,
New York

2 *Self-portrait,* 1887
Oil on paper, 34.5 x 25.5 cm
Kröller-Müller Foundation,
Otterlo

3 *Still life: apples, grapes and
pears,* 1887
Oil on canvas, 44 x 58.7 cm
Art Inst, Chicago (gift of Kate L.
Brewster)

4 *Self-portrait,* 1887
Oil on canvas, 42 x 31 cm
van Gogh Foundation,
Amsterdam

5 *Self-portrait,* 1887
Oil on canvas, 41 x 33 cm
van Gogh Foundation,
Amsterdam

6 *Self-portrait,* 1887
Oil on canvas, 43.5 x 31.5 cm
van Gogh Foundation,
Amsterdam

7 *Self-portrait,* 1887
Oil on canvas, 41.5 x 31 cm
van Gogh Foundation,
Amsterdam

8 *Self-portrait with straw hat,*
1887
Pasteboard, 41 x 33 cm
van Gogh Foundation,
Amsterdam

9 *Self-portrait with straw hat,*
1887
Oil on panel, 35.5 x 27 cm
Institute of Art, Detroit

10 *Old Arlesian woman,* 1888
Oil on canvas, 55 x 43 cm
van Gogh Foundation,
Amsterdam

11 *Almond branch in a glass,*
1888
Oil on canvas, 24 x 19 cm
van Gogh Foundation,
Amsterdam

12 *Souvenir de Mauve,* 1888
Oil on canvas, 73 x 59.5 cm
Kröller-Müller Foundation,
Otterlo

13 *Cottages at Saintes-Maries,*
1888
Oil on canvas, 36.5 x 44 cm
Present owner unknown

14 *Zouave,* 1888
Oil on canvas, 65 x 54 cm
van Gogh Foundation,
Amsterdam

15 *The Sower,* 1888
Oil on canvas, 64 x 80.5 cm
van Gogh Foundation,
Amsterdam

16 *La Mousmé,* 1888
Oil on canvas, 74 x 60 cm
National Gallery of Art,
Washington

17 *Head of Roulin the postman,*
1888
Oil on canvas, 65 x 54 cm
Kunstmuseum, Winterthur

18 *Head of Roulin the postman,*
1888
Oil on canvas, 64 x 48 cm
Private collection, Detroit

19 *Night café,* 1888
Oil on canvas, 70 x 89 cm
Yale University Art Gallery,
New Haven

20 *Tarascon coaches,* 1888
Oil on canvas, 72 x 92 cm
Private collection, New York

21 *Railway bridge,* 1888
Oil on canvas, 71 x 92 cm
Kunsthaus, Zurich

22 *Iron bridge at Trinquetaille,*
1888
Oil on canvas, 73.5 x 92.5 cm
Priv coll, New York

23 *Roulin the postman,* 1888
Oil in canvas, 81 x 65 cm
Museum of Fine Arts, Boston

24 *Sunflowers,* 1889
Oil on canvas, 100 x 76 cm
Priv coll, London

25 *Sunflowers,* 1889
Oil on canvas, 95 x 73 cm
van Gogh Foundation,
Amsterdam

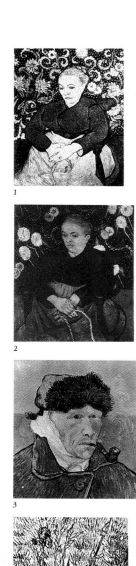

1

6

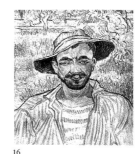

11

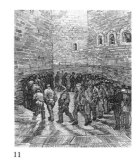

16

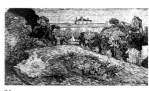

21

2

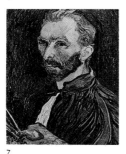

7

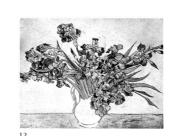

12

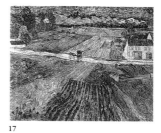

17

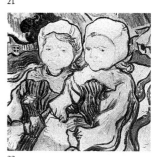

22

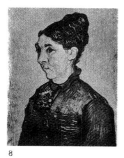

3

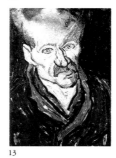

8

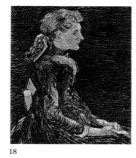

13

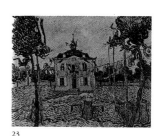

18

23

4

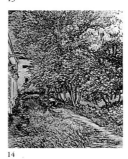

9

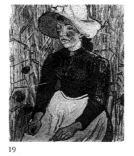

14

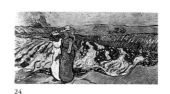

19

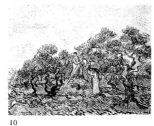

24

5

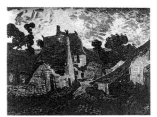

10

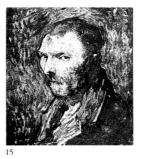

15

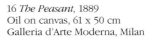

20

25

1 *La Berceuse,* 1889
Oil on canvas, 92 x 73 cm
Kröller-Müller Foundation,
Otterlo

2 *La Berceuse,* 1889
Oil on canvas, 93 x 74 cm
Private collection, London

3 *Self-portrait with bandaged ear,*
1889
Oil on canvas, 51 x 45 cm
Private collection, Chicago

4 *Iris,* 1889
Paper mounted on canvas,
62.5 x 48 cm
National Gallery of Canada,
Ottawa

5 *Two crabs,* 1889
Oil on canvas, 47 x 61 cm
Private collection, Paris

6 *Death's-head moth,* 1889
Oil on canvas, 33 x 24 cm
van Gogh Foundation,
Amsterdam

7 *Self-portrait,* 1889
Oil on canvas, 57 x 43.5 cm
Private collection, New York

8 *Portrait of Madame Trabuc,*
1889
Oil on canvas, 64 x 49 cm
Present owner unknown

9 *The Good Samaritan,* after
Delacroix, 1889
Oil on canvas, 73 x 60 cm
Kröller-Müller Foundation,
Otterlo

10 *Olive picking,* 1889
Oil on canvas, 73 x 92 cm
Kröller-Müller Foundation,
Otterlo

11 *Prison exercise yard,* after
Gustave Doré, 1889
Oil on canvas, 80 x 64 cm
Pushkin Museum, Moscow

12 *Vase with irises,* 1889
Oil on canvas, 73 x 93 cm
Metropolitan Museum of Art,
New York

13 *Patient at Saint-Rémy,* 1889
Pasteboard, 32 x 23.5 cm
van Gogh Foundation,
Amsterdam

14 *Garden of Saint-Paul's
hospital,* 1889
Pasteboard, 95 x 75.5 cm
Kröller-Müller Foundation,
Otterlo

15 *Self-portrait,* 1889
Oil on canvas, 51 x 45 cm
National Gallery, Oslo

16 *The Peasant,* 1889
Oil on canvas, 61 x 50 cm
Galleria d'Arte Moderna, Milan

17 *Landscape with carriage and
train,* 1890
Oil on canvas, 72 x 90 cm
Pushkin Museum, Moscow

18 *Portrait of Adeline Ravoux,*
1890
Oil on canvas, 67 x 55 cm
Private collection

19 *Peasant woman,* 1890
Oil on canvas, 92 x 73 cm
Private collection, Switzerland

20 *Daubigny's garden,* 1890
Oil on canvas, 53 x 104 cm
Private collection, New York

21 *Daubigny's garden,* 1890
Oil on canvas, 56 x 101.5 cm
Offentliche Kunstsammlung,
Basle

22 *Two children,* 1890
Oil on canvas, 51.5 x 51.5 cm
Musée du Louvre, Paris

23 *Town Hall in Auvers on
14 July,* 1890
Oil on canvas, 72 x 93 cm
Private collection

24 *Women walking along the
fields,* 1890
Oil on canvas, 32 x 61 cm
Marion Koogler Macnay
Art Institute, San Antonio

25 *Road at Auvers,* 1890
Oil on canvas, 73 x 92 cm
Konst Sammlingarna I
Athenenum, Helsinki

	Life of van Gogh	Principal works
1853	Vincent was born in Groot Zundert, Brabant, Netherlands	
1857	Birth of his brother Theo	
1864	Vincent went to a boarding school run by Mr Provily in Zevenbergen	
1866	Vincent was enrolled at the Hannik Institute in Tilburg; an indifferent pupil	
1869	He was employed by the Goupil Gallery in The Hague	
1872	The correspondence between the two brothers began	
1873	Vincent was transferred to the London branch of Goupil; took lodgings with Mrs Loyer in Brixton	
1874	Declared love to his landlady's daughter – and was rejected. He was transferred to the Goupil Gallery in Paris. Returned to London	
1875	Vincent returned to Paris. Read the Bible. Spent the Christmas holidays in Etten with his family	
1876	Vincent was dismissed by Boussod. Went to Etten. Worked in return for board and lodging for Mr Stokes, a teacher in Ramsgate. Became a preacher under the Revd Mr Jones. Gave his first sermon. Returned to Etten for end-of-the-year festivities	*Square at Ramsgate*
1877	Worked in a bookshop in Dordrecht. Lived with his uncle Johannes in Amsterdam to prepare for his theological examinations	
1878	Abandoned his studies. Returned to Etten. Noviciate at Flemish evangelical school in Laeken, outside Brussels. Failure again. Went to the Borinage, visited the sick and the poor, taught the Bible	
1879	He was nominated as a lay evangelical missionary in the mining district of the Borinage. He was dismissed. Set off on foot to seek the advice of Pastor Pietersen in Brussels. Stayed in Cuesmes, helped the destitute	*Coal-Shoveller*
1880	Went on foot to Courrières to see Jules Breton. Moved to Brussels. Met G. A. van Rappard. Decided to study drawing in Antwerp. Made numerous sketches of miners inspired by the techniques of Millet	*Decrucq's house, Miners, The Diggers* after Millet

Artistic and literary life	History
Victor Hugo: *Les Contemplations;* Sand: *Les Maîtres sonneurs;* Charlotte Brontë: *Villette;* Courbet: *Les Baigneuses;* Verdi: *La Traviata*	Beginning of Second Empire; Napoleon III married Eugénie de Montijo
Charles Baudelaire: *Les Fleurs du Mal;* death of Alfred de Musset and Eugène Sue; Banville: *Odes funambulesques*	Napoleon III visited Le Havre; conquest of Algeria completed; the Indian Mutiny, separation of Church and State in Mexico
Renoir: *Esméralda;* Fantin-Latour: *Hommage à Delacroix;* Manet: *Combat de taureaux;* Rodin: *L'Homme au nez cassé* refused at the Salon; Offenbach: *La Belle Hélène;* Mallarmé: *Soupir;* births of Toulouse-Lautrec and R. Strauss	Cadart founded l'Union des Artistes; law on labour unions in France; Nobel: nitroglycerine; Pasteur: pasteurisation; foundation of Red Cross; and of Société Générale in France
Renoir: *Le Cabaret de la mère Anthony;* Degas: *Scènes de steeple-chase;* Monet: *Forêt de Fontainebleau;* Offenbach: *La Vie parisienne;* Dostoevsky: *Crime and Punishment;* births of Erik Satie and Romain Rolland	Economic crisis in London: 'Black Friday'; Austro-Prussian war (Sadowa); first typewriter in United States; laying of first transatlantic telegraph cable; Mendel discovered biological mutations
Renoir: *La Grenouillère;* Manet: *Le Balcon* at the Salon; Wagner: *Das Rheingold;* Tolstoy: *War and Peace;* Flaubert: *L'Education sentimentale;* Daudet: *Les Lettres de mon moulin;* births of Matisse and Gide; deaths of Sainte-Beuve and Berlioz	Parliamentary elections in France brought Gambetta to power; opening of Suez canal; Albert discovered photogravure; Mendeleyev classified chemical elements according to their atomic weight
Monet: *Impression, soleil levant;* Bizet: *L'Arlésienne;* Zola: *La Curée;* Daudet: *Tartarin de Tarascon;* construction of de Fourvière church in Lyon; births of Skriabin, Paul Léautaud and Paul Fort	Occupation of French territory until payment of war indemnity to Germany; Baekland invented Bakelite; first psychological laboratory in Leipzig; eruption of Vesuvius
Manet: *Le Bon Bock;* Rimbaud: *Une saison en enfer;* Zola: *Le Ventre de Paris;* J. Verne: *Around the World in Eighty Days;* Tolstoy: *Anna Karenina;* Bakunin: *State and Anarchy*	Republic declared in Spain; resignation of Thiers; founding of Agfa company; birth of Santos-Dumont; death of Napoleon III
First Impressionist exhibition at Nadar's; Verlaine: *L'Art poétique;* Grieg: *Peer Gynt;* Mussorgsky: *Boris Godunov;* Rimbaud: *Les Illuminations;* Hugo: *Quatre-vingt-treize;* Barbey d'Aurevilly: *Les Diaboliques*	Alphonso III, King of Spain; child labour laws introduced in France; Disraeli Prime Minister in Britain; Cantor: first paper on the theory of sets; start of nihilism in Russia; founding of Universal Postal Union, birth of Churchill
Sisley: *La Route de Versailles;* Bartholdi: *Le Lion de Belfort;* Saint-Saëns: *Danse macabre;* Twain: *Tom Sawyer;* births of Ravel and Rilke; deaths of Bizet, Corot and Millet	Ascent of balloon, *La Zénith,* with three men on board; Barthelot: chemical synthesis; establishment of parliamentary system in France; birth of social democratic party in Germany
Renoir: *Le Moulin de la Galette;* construction of Sacré-Coeur at Montmartre; births of Brancusi, Manuel de Falla and Max Jacob; death of George Sand	Bell invented the telephone; development of four-stroke engine in Germany; Queen Victoria became Empress of India
Saint-Saëns: *Samsõn et Dalila;* Hugo: *La Légende des siècles;* births of Dufy and Van Dongen; death of Courbet; Impressionists meet at café La Nouvelle Athènes	Death of Thiers; annexation of Transvaal by Britain; Russo-Turco-Romanian war; Edison and Charles Cros: invention of gramophone
Degas: *La Danseuse sur la scène;* Gallé: first glass items; Brahms: Piano concerto No. 2; Nietzsche: *Human All-Too-Human;* deaths of Daubigny and Viollet-le-Duc	Election of Pope Leo XIII; Anglo-Afghan war; Humbert I became King of Italy; Germany: emergency law against the socialists; independence of Romania; death of Claude Bernard
Cézanne: *Le Pont de Maincy;* Daudet: *Les Rois en exil;* Ibsen: *The Doll's House;* Tchaikovsky: *Eugene Onegin;* births of Picabia and Klee; death of Daumier	Fall of MacMahon; Edison invented incandescent lamp; Pasteur: discovery of principle of vaccination; Jules Ferry became Minister of Public Education in France; birth of Einstein, Stalin and Trotsky
Monet: *La Débâcle;* Rodin: *L'Age d'airain;* Satie: *Trois Gymnopédies;* Maupassant: *Boule de suif;* Zola: *Nana;* Dostoevsky: *The Brothers Karamazov;* births of Apollinaire and Derain; deaths of Flaubert and Offenbach	Establishment of lycées for girls in France; 14 July became a French national holiday; first Boer War in South Africa; opening of Saint Gothard

	Life of van Gogh	Principal works
1881	Fell in love with his cousin Kate who rejected him; went to The Hague to live and work with his cousin Anton Mauve; first oil paintings	*Presbytery at Etten, Worn Out, Winter, Wilhelmina, The Artist's Father*
1882	Lived in The Hague with Anton Mauve; took up with Clasina Marla Hoornick (Sien); quarrelled with Mauve; period in hospital; moved to a new address with Sien and her children	*Sorrow, The Great Lady, Man with a pipe, Fish-drying barn, The Dune*
1883	Driven by poverty he left his companion, Sien, and went to Drenthe to paint; moved to Nieuw-Amsterdam; rejoined his family in Nuenen	*Woman peeling potatoes, Mother and Child, The Sand Pit, Man at work, Heath, The church at Zweeloo*
1884	Vincent set up his studio in the sacristan's house; Margot Begemann tried to commit suicide	*The church at Nuenen, The Weaver, Work in the fields, Peasant wom binding sheaves, Still life with Bible*
1885	His father died of an apoplectic fit; he visited Amsterdam and the Rijksmuseum; left for Antwerp in early winter; discovered Rubens and Japanese prints there	*The Potato Eaters, Autumn landscape, The Tower of the cathedral, S portrait, Houses in Antwerp, The Antwerp Quay, The Midwife, Brabant peasant woman*
1886	Enrolled in the Ecole des Beaux-Arts in Antwerp; in March he went to Paris, lived with Theo in rue Laval, studied at Cormon's studio; he met Toulouse-Lautrec, Bernard, Pissarro, Seurat, Signac and, above all, Gauguin; the two brothers moved to rue Lepic	*La Guingette, Venus de Milo, Cinerarias, Le Moulin de la Galette, Flow The Graveyard*
1887	Frequented Père Tanguy's shop; had a relationship with La Segatori who ran a café in avenue de Clichy where he organised an exhibition with his friends who constituted 'le petit boulevard'	*Portrait of Père Tanguy, Sunflower series, Self-portrait, Boulevard de Clic View from Vincent's room in rue Lepic, Shoes, Vase with flowers*
1888	He lived in Arles, first in the Café de l'Alcazar, then in the yellow house; visited Saintes-Maries-de-la-Mer; Gauguin joined him in October; on 23 December van Gogh had his first crisis, threatened Gauguin, then cut off his own ear	*Self-portrait at the easel, Encampment of gypsies with caravans, Dance l in Arles, The Sower, View of Arles with irises, La Charcuterie*
1889	Returned to his house, but a petition drove him away; Theo married Johanna Bonger; Vincent treated at psychiatric hospital of Saint-Paul-de-Mausole at Saint-Rémy-de-Provence, where crises alternated with periods of improvement; began his cypress series	*Noon, after Millet, Portrait of Rey, Garden of the hospital at Arles, Un Wheat, Hospital at Arles*
1890	First article in praise of Vincent's painting; birth of Vincent. Theo's son; trip to Paris to see Theo; departure for Auvers-sur-Oise to be tended by Dr Gachet; lodged with the Ravoux; shot himself on 27 July, died on 29 July, Theo at his side	*Portrait of Dr Gachet, Crows in the wheatfields, Town Hall in Auvers on July, Reminiscence of the North, Church at Auvers*

Artistic and literary life	History
Fauré: *Ballade;* Wilde: *The Happy Prince;* A. France: *Le Crime de Sylvestre Bonnard;* births of Picasso, Léger, Bartok and R.-M. du Gard; death of Mussorgsky	Assassination of Tsar Alexander II; French protectorate in Tunisia; in France: the Jules Ferry Law: secular, compulsory, free primary education; freedom of the press and of assembly; electric lighting of the Grands Boulevards
Seurat: *Lisière de bois au printemps;* Gounod: *Rédemption;* Fauré: *Requiem;* Wagner: première of *Parsifal;* Zola: *Pot-Bouille;* births of Giraudoux, Virginia Woolf and Braque	Occupation of Cairo by the British; crash of Union Générale in France; Koch discovered the tubercle bacillus; electric lighting in New York streets; birth of Roosevelt; death of Gambetta and Garibaldi
Delibes: *Lakmé;* Maupassant: *Une Vie;* Huysmans: *L'Art moderne;* Pierre Loti: *Mon frère Yves;* Nietzsche: *Thus Spake Zarathustra;* birth of Utrillo; deaths of Wagner, Smetana, Manet, Gustave Doré	Plekhanov founded Russian socialist party; French protectorate in Tonkin and Annam; anarchist demonstration by Louise Michel; Krebs: diphtheria bacillus; Koch: cholera bacillus; birth of Mussolini and Kafka; death of Karl Marx
Degas: *Les Repasseuses;* Rodin: *Victor Hugo;* Massenet: *Manon;* Daudet: *Sapho;* Huysmans: *A rebours:* Construction of Reichstag building by Wallot in Berlin; birth of Modigliani	Waldeck-Rousseau's Law allowed strikes in France; Chardonnet: artificial silk; Mergenthaller: linotype; in USA Hiram Maxim invented the machine-gun
Seurat: *La Grande Jatte;* Rodin: *La Danaïde;* Zola: *Germinal;* birth of S. Delaunay; deaths of Victor Hugo and J. Vallès	French protectorate in Madagascar; Congo established as an independent state; Pasteur discovered vaccination against rabies; Daimler petroleum engine
Degas: *Le Tub;* Bloy: *Le Désespéré;* Verdi: *Othello;* Loti: *Pêcheur d'Islande;* Zola: *L'Oeuvre;* Rimbaud: *Les Illuminations;* Stevenson: *Dr Jekyll and Mr Hyde;* unveiling of Bartholdi's Statue of Liberty in New York; birth of Kokoschka; death of Franz Liszt	First French expedition to Laos; British in Burma; Lebel invented the rifle; Hertz discovered electromagnetic waves; foundation of Pasteur Institute; death of Louis II of Bavaria
Seurat: *La Parade de cirque;* Renoir: *Les Grandes Baigneuses;* C. Claudel: *Jeune Romain;* H. Becque: *La Parisienne;* birth of Chagall, Le Corbusier, Juan Gris and Macke; death of Borodin	Formation of Indo-Chinese Union; Boulangist crisis in France; Daimler developed the carburettor; Lanston: monotype
Seurat: *Les Poseuses;* Toulouse-Lautrec: *Au cirque Fernando;* Frank: *Symphony in D minor;* Verhaeren: *Les Débâcles;* Strindberg: *Lady Julia;* construction of Eiffel Tower; births of de Chirico and Bissière; death of Labiche	William II German Emperor; internationalisation of Suez canal; Dunlop invented inner tube of tyre; first French loan to Russia
Munch: *The Frieze of Life;* Gauguin: *Le Christ jaune;* Tchaikovsky: *Queen of Spades;* Bergson: *Données immédiates de la conscience;* Verlaine: *Parallèlement;* exposition universelle in Paris; birth of Charlie Chaplin; death of Cabanel	Cecil Rhodes ruled over the diamond and gold mines of Rhodesia; first constitution in Japan; founding of the Second Internationale in Paris; Hollerith invented a punched card calculator in the United States; birth of Adolf Hitler
Redon: *Les Yeux clos;* Borodin: *Prince Igor;* Debussy *Cinq poèmes de Baudelaire;* Mascagni: *Cavalleria Rusticana;* Claudel: *Tête d'or;* Frazer: *The Golden Bough;* Wilde: *Portrait of Dorian Gray;* Aurier: 'Les Isolés: Vincent van Gogh', *Mercure de France*	Resignation of Bismarck; Anti-Trust Law in United States; Clement Ader attempted first aeroplane flight in his *Eole;* Koch: tuberculin; Branly: radiotelegraphy; birth of Charles de Gaulle

Index of Van Gogh's Works

Selective bibliography

Œuvres posthumes, A. Aurier. Mercure de France, Paris, 1893.

Vincent Van Gogh, Curt Glaser. Seeman, Leipzig, 1921.

Vincent Van Gogh, der Zeichner, Julius Meier-Graefe. Piper, Munich, 1921, 1925.

Strindberg und Van Gogh, Jaspers. Berlin, 1922.

Vincent Van Gogh, Hans Tietze. Filser, Vienna, 1922.

Vincent Van Gogh, Coquiot. Paris, 1923.

Vincent Van Gogh, Paul Colin. Rieder, Paris, 1925.

L'Epoque française de Vincent Van Gogh, La Faille. Bernheim-Jeune, Paris, 1927.

La Folie de Vincent Van Gogh, Paul Gachet. Doiteau, V. & Leroy éd., 1928.

Van Gogh, Charles Terrasse. Laurens, Paris, 1932.

Vincent Van Gogh, Hubert Wilm. Hugendubel, Munich, 1935.

Vincent Van Gogh, Jean Cassou and John Rewald, La Renaissance, 1937.

Un portrait de Vincent Van Gogh, Jean de Beuken. Balancier, Liège, 1938.

Vincent Van Gogh, Louis Hautecœur. Documents d'Art, Geneva, 1946.

Van Gogh, le suicidé de la société, Arthaud. Paris, 1947.

Vincent Van Gogh Peintures, Frank Elgar. Paris, 1947.

Vincent Van Gogh, Jacques de Laprade. Somogy, Paris, 1951.

Vincent Van Gogh, Raymond Cogniat. Paris, 1953.

Souvenirs de Cézanne et Vincent Van Gogh, Paul Gachet. Paris, 1953.

Vincent Van Gogh aux Indépendants, Paul Gachet, Paris, 1953.

La Vie de Van Gogh, Henri Perruchot. Hachette, Paris, 1955.

Vincent Van Gogh, Meyer Shapiro. Abrams, New York, 1957.

Vincent Van Gogh, Frank Elgar. Hazan, Paris, 1958.

Complete Letters of Van Gogh. Thames & Hudson, London, 1958.

Le Post-Impressionnisme, John Rewald. Albin Michel, 1961.

Vincent Van Gogh, L'Homme et son œuvre, Pierre Cabanne, Paris, 1961.

Vincent Van Gogh, sa maladie et son œuvre, Françoise Minkowska. Presse du Temps présent, Paris, 1963.

Van Gogh, Jean Leymarie. Skira, 1968.

Van Gogh, David Schapiro. Thames & Hudson, London, 1968.

Vincent Van Gogh, M. Tralbaut. Edita Lazarus, Lausanne, 1969.

The Works of Vincent Van Gogh, J.B. La Faille. Meulenhoff International, Amsterdam, 1970.

Vincent Van Gogh, R.M.N., 1971.

Van Gogh and his Art, Rosemary Treble. Galahad Books, New York, 1975.

Van Gogh, René Huyghe. Flammarion, 1977.

Van Gogh chez les gueules noires, Pierre Secrétan-Rollier. L'Age d'Homme, Lausanne, 1977.

Vincent Van Gogh, Paul Aletrino. Rizzoli, Milan, 1980.

Japonisme, Siegfried Wichmann. Chêne/Hachette, 1982.

Van Gogh: Documentary Biography, A.M. Hammaches. Thames & Hudson, London, 1982.

Les Peintres du bonheur, Yann le Pichon. Robert Laffont, Paris, 1983.

Van Gogh en Arles, R. Pickvance. Skira, 1984.

Vincent by Himself, Bruce Bernard. Orbis Publishing, London, 1985.

Van Gogh in Saint-Rémy and Auvers, R. Pickvance. Harry N. Abrams, New York.

Van Gogh, Pierre Descargues. Ars Mundi, 1987.

Van Gogh, le soleil en face, Pascal Bonafoux. Gallimard, Paris, 1987.

Van Gogh, aquarelles, gouaches et dessins. Miloslava Neumannova. Ars Mundi, 1987.

Van Gogh, Jacques Lassaigne. Cassell, London, 1988.

Vincent Van Gogh, Pierre Leprohon. J.-C. Lattès, Paris, 1988.

Van Gogh par Vincent, Pascal Bonafoux. Folio, 1988.

Gauguin, Françoise Cachin. Flammarion, 1988.

Van Gogh's Flowers, Judith Bumpus. Phaidon, Oxford, 1989.